# SIZE MATTERS

Effective graphic design for large
amounts of information

RotoVision

A RotoVision Book

Published and distributed by RotoVision SA
Route Suisse 9
CH-1295 Mies
Switzerland

RotoVision SA
Sales, Editorial & Production Office
Sheridan House, 112/116A Western Road
Hove BN3 1DD, UK

Tel: +44 (0)1273 72 72 68
Fax: +44 (0)1273 72 72 69
Email: sales@rotovision.com
Web: www.rotovision.com

10 9 8 7 6 5 4 3 2 1

ISBN: 2-88046-705-5

Designed by John and Orna Designs

Reprographics in Singapore by ProVision Pte. Ltd
Tel: +65 6334 7720
Fax: +65 6334 7721

Printing and binding in China by Midas Printing International

Acknowledgments

It would not have been possible to write this book without the
help, advice, and encouragement of all those who contributed
to its making. My thanks to you all for your cooperation and
openness, not only in discussing these projects, but also in
sharing the thoughts and processes behind them.

Special thanks to John Morgan, Ian Noble, Peter Van Dijck,
Bill Cahan, Quentin Newark, and Tim Fendley for their help
and advice; to all at RotoVision, especially Aidan Walker and
Kate Shanahan; and to Margaret and Undiyil Bhaskaran,
Karn Christensen, Liz Hancock, and Adam Fulcher for their
ongoing support and encouragement.

Picture credits

Unless otherwise noted in the caption, all pictures
kindly provided by the respective designers, companies,
and agencies.

# SIZE MATTERS

Lakshmi Bhaskaran

Effective graphic design
for large amounts of
information

**CONTENTS**

# INTRODUCTION

"Design is evaluated as
a process culminating in
an entity which intensifies
comprehension" Ladislav Sutnar, designer, b.1897

## MISSING

Structure –

* 2 websites, one with shallow hierarchy, one with deep.

Hierarchies –

Feels thin?
* Want Lucienne

Symbolism –

– Why US Immigrant Wall?
* – Shame no website showing Icons.
* – Who did 'Point it'?
– More signage?

Navigation –

* – Children's navigation, or a teen one. Something fun.

Info Design –

– Need another eg of
* – Want 1 kiosk.
* – Need some more deep/No

Economy –

* Magazine

Hans &
Roger

Top margin handwritten notes:

```
inchut 116        Symbolis minho 660
             Hierarchies        ?
No of        Inf. Design inho 824
spreads      Navigation       517        Me edited.
             Economy          ?
```

| | COMPANY | ▽ | | PRO |
|---|---|---|---|---|
| | LETTERROR | ✓563 | EUR | INTERACTIVE BOOK |
| 3 | FABRICA | ✓758 | EUR | FABRICA FILES |
| 2-3 | ATELIER WORKS | ✓790 | UK | LABOUR PARTY MANIFESTO |
| | STUDIO MYERSCOUGH | ✓570 | UK | ROCKSTYLE EXHIBITION |
| 3 | ARTIFICIAL ENVIRONMENTS | ✓995 | UK | EYE WEBSITE |
| 2 | PENTAGRAM NY | ✓621 | USA | HARLEY DAVIDSON EXHIBITIO |
| 2 | JOHN & ORNA DESIGNS | ✓ 545 | UK | tbc Regeneration photo  Cascot |
| | HENRIQUE CAYATTE | | EUR | 3000m2 EXHIBITION & SUPPL |
| 4 | OMNIFIC | ✓519 | UK | BOOK OF COMMON WORSHIP |
| 3 | JOHNSON BANKS | ✓ 331 | UK | YELLOW PAGES |
| | CAHAN ASSOCIATES | | USA | ANNUAL REPORTS |
| 2 | JOHN & ORNA DESIGNS | ✓ 908 | UK | (book with imposed house sty |
| 3 | ALAN FLETCHER | ✓633 | UK | THE ART OF LOOKING SIDEWA |
| 4 | LONDON UNDERGROUND | ✓407 | UK | TUBE MAP |
| 2 | JOHNSON BANKS | ✓461 | UK | REWIND |
| 1 | PENTAGRAM NY  A Brochure | | USA | HAND PAINTED MAPS |
| 1 | RALPH APPLEBAUM ASSOCIATES | ✓313 | USA | AMERICAN IMMIGRANT WALL ( |
| 2 | STRUKTUR DESIGN | | UK | CALENDAR |
| 1 | THE KITCHEN | ✓422 | UK | OCEAN CLUB BRAILLE SIGNAG |
| 2 | JOHN & ORNA DESIGNS | ✓ 585 | UK | BAUHAUS EXHIBITION |
| 3 | RALPH APPLEBAUM ASSOCIATES | 1021 | USA | US HOLOCAUST MEMORIAL MU |
| 3 | GETTY IMAGES | 754 | USA | GETTY WEBSITE |
| 2 | PENTAGRAM NY | 567 | USA | 42ND STREET STUDIOS |
| 4 | INTERNATIONAL MAPPING ASSOC. 678 | | USA | VENUE MAPS: ATLANTA CENTE |
| 2 | MARCUS AINLEY | 552 | UK | BBC ANNUAL REPORT |
| | ANN BURDICK | | USA | DIE FACKEL DICTIONARY |
| 3 | RED SQUARE | 470 | UK | DISRUPTION |
| | CORPORATE EDGE | | UK | BRITISH GAS BILL |
| 3 | A-Z MAP COMPANY LTD | 872 | UK | THE A-Z STORY |
| 2 | INTERNATIONAL MAPPING ASSOC. 658 | | USA | FLYTHROUGH MAPS |
| 3 | REBECCA FOSTER DESIGN | 928 | UK | PORTLAND HOSPITAL INFO LEA |
| | ALEXANDER GELMAN | 428 | USA | SUBTRACTION THEORY/LANGU |
| 2 | ACME | 423 | UK | RESTART |
| | QUICKMAP | 360 | UK | GLASGOW MAPMATE - POCKET |
| | ATELIER WORKS | 390 | UK | LEARNING JOURNEY |
| 2 | SAGMEISTER INC | 264 | USA | AIGA POSTER |

**TALKING POINTS...**

| ELLEN LUPTON | ✓ | USA | THE CURATOR |
|---|---|---|---|
| NICOLA BAILEY | ✓ | UK | THE PRODUCTION MANAGER |
| PETER VAN DYCKE | ✓ | USA | THE INFORMATION ARCHITECT |
| TBC | ✓ | | THE EDITOR |
| | | | |
| CHARLES PLATT | ✓ | USA | THE ARCHITECT |
| ~~ASK BELLA @ CAHAN~~ | | ~~USA~~ | ~~THE CLIENT~~ |

| INFO. DESIGN | 6 |
|---|---|
| ECONOMY | 6 |
| **TOTAL** | **36** |

**THE ONES I HAVE TAKEN OUT...**

| 1: STRUCTURE | signage | IAN CARTLIDGE | CARTLIDGE LEVENE | | UK | MILLENNIUM POINT, BIRMINGH |
|---|---|---|---|---|---|---|
| 2: TYPOGRAPHY | book | PETER DAVENPORT | PETER DAVENPORT | | UK | IMAGES OF THE CENTURY |
| 3: SYMBOLISM | website | DAVIS McCOMB | BBCi | | UK | BBCi WEBSITE |
| 4: NAVIGATION | book | IRMA BOOM | IRMA BOOM | 1-2 | EUR | SHV ANNIVERSARY BOOK  Sh |
| 4: NAVIGATION | guide | LUCIENNE ROBERTS | SANS + BAUM | | UK | ON PAPER EXHIBITION |
| 5: INF. DESIGN | info point | TIM FENDLEY | TIM FENDLEY | | UK | iPLUS KIOSK |
| 5: INF. DESIGN | website | PAUL HO-ON | BROADWAY.COM | | USA | www.broadway.com |
| 5: INF. DESIGN | manual | ALAN DYE | NB: STUDIO | | UK | MERCHANT HANDBOOK 2002 |
| 5: INF. DESIGN | billing | HAMISH MUIR | 8VO | | UK | THAMES WATER BILLING |
| 5: INF. DESIGN | t/table | ERIK SPIEKERMAN | ERIK SPIEKERMAN | | EUR | BUS TIMETABLES |
| 5: INF. DESIGN | calendar | VLADISAV ROSTOKA | RABBIT & SOLUTION | | EUR | "WHEEL" CALENDAR |
| 5: INF. DESIGN | website | JOHN MAEDA | MIT MEDIA LAB | | USA | ORGANIC INFORMATION DESIG |
| 6: ECONOMY | posters | WENDELIN HESS | MUELLER + HESS | | EUR | KASKADENKONDENSATOR ART |

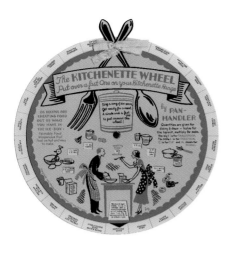 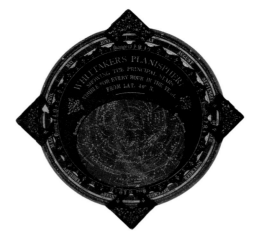 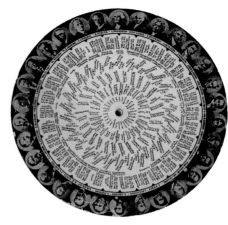

When it comes to designing large amounts of information, designers find themselves faced with a set of considerations that stretch far beyond the practical concerns of form and function: structure, hierarchies, symbolism, navigation, information design, and economy must all be carefully considered. Whether the brief is for a book or magazine, large website or exhibition, a billing system or telephone directory, the volume of material alone can often seem insurmountable. As a result, many individual designers and smaller consultancies find themselves missing out on work that, given the correct guidance, they are more than capable of handling. The aim of this book is to provide designers with a structured approach that will allow them to confidently execute large-content projects by illustrating a very broad range of examples. In turn, this will enable them to provide their clients with the level of personal service and flexibility in approach that comes from working with a small team.

By its very nature, the process of designing a large amount of information is a complex one, but as the following chapters illustrate, there are a number of issues common to this type of design that can be addressed. On the whole, designers have a natural tendency to order. The benefits of adopting a systematic approach to the way materials are cataloged, managed, and processed, not to mention scheduling and budgeting issues, should be obvious to any good designer. However, what is lacking is a practical knowledge of how to capitalize on these skills, particularly when faced with vast amounts of raw material. It is this area that **Size Matters** will address first and foremost.

Good design does not begin and end with an inspired layout. The production process is another dimension of the creative process and warrants equal consideration. Just as a house requires a solid foundation, so the systems of approach for designing large amounts of information are vital to its success.

1 By shifting the focus from the finished design to the working processes behind them, and by implementing the necessary systems in those processes right from the start, what was once an impenetrable task suddenly becomes a logical working process.

2 Having the ability to implement a successful production strategy is an art in itself and one that every designer can benefit from. And remember, nothing is ever set in stone. Design principles—from the grids used in book design to the processing of images for a large exhibition—are there to be both adopted and adapted, and the best designers know when to break the rules. Any big-content project will involve the designer receiving vast amounts of material, all of which must be logged and stored as soon as it arrives. This may seem like a rather mundane task in the early stages, but setting up a basic organizational system from the start is the only way you will be able to maintain absolute control when things get hectic later on.

3 Systems can also be integrated into the "design process" itself. Today's digital technology affords the designers the luxury of a systematic approach that can both save time and ensure continuity, such as setting up a Quark document with carefully planned style sheets. Simple though it may seem, this type of system can help the designer on a number of levels. Not only does a well-planned style sheet save time, it also provides the designer with more "creative headspace" to experiment elsewhere by automating accuracy in the later stages of a project when time is at a premium and deadlines are looming.

4 Systems can be creatively formed too, such as the "book system" devised by LettError for their Interactive Book. By adopting a modular approach, the design and aesthetics can be embedded into the system which, in turn, designs the book. On this occasion, the system IS the design.

**Opposite** Working plan for **Size Matters** detailing the process of collating and organizing the various projects for inclusion in the book

**Top, from left** The Kitchenette Wheel, Whittaker's Planisphere, and an information wheel on US Presidents (from *Reinventing the Wheel* by Jessica Helfand)

# The New-York Times.

**Above** Early edition of *The New York Times,* notable for its lack of images

# 羽幌タイムス

（昭和二十一年一月二十一日 第三種郵便物認可）

第六十五號

發行所 羽幌タイムス社
編輯兼發行人 山本庄松

購讀料 一ヶ月 三圓三十五錢
一ヶ月 三圓八十錢

（昭和二十一年七月三日 水曜日）

---

## 吏員の体育大會
### 盛夏の羽幌で擧行
#### 留支管内町村

## 噫々涙新たなる
### 英霊十七柱合同祭

## 羽幌健保で
### 保健婦 増員

## 全町の美化運動
### 一日から一齊實施

## 食糧營團機構の 改組

---

## 集ふ情熱の若人千余名
### 苫前聯合青年大會
#### 七日本校グランドに開催

## 復員促進を願ふ
### 切實な遺族の叫び
#### 羽幌でも本格運動開始

## 朝日、二股、大澤青年會で
### 舌戰火を吐く辯論會

---

### 奉納 町内會對抗野球大會
#### 祭典

開催期日　七月八日午前九時より
會場　學校グランド

主催　羽幌タイムス社
後援　町役場、体育協會、羽幌神社氏子総代

參加資格　各町内會に住居を有する者を以てチーム編成すること　但し二町内を以て一組とし編成は抽籤

申込期日　七月五日迄　本社宛

---

## 野球大會の應援に就て

---

### 羽幌神社奉納大假装行列

### 懸賞募集

賞　一等 金二百圓　二等 百五十圓　三等 百圓　四等 七十圓　五等 五十圓

審査方法　氏子の投票で決定す
向一等を投票した者には抽籤の上五十人迄一人五圓贈

集合場所　十日午前十時川北神輿宿追所前
假装規定　各自自由

羽幌神社祭典余興係

---

## 農民よ目覚めよ
### 聴け!!

今こそ吾等開放の時は至來せり

朝日青年第一回雄辯大會
農村の青年男女は何ど叫ぶか
舌端虹をはく

日時　昭和二十一年七月七日午後一時より
場所　朝日國民學校

主催　朝日青年會

---

**Above** Spread from a Japanese-language newspaper of the mid-1900s

As the nature of design studios continues to become more multi-disciplinary, graphic design becomes less of a singular task than it once was. Working with teams of people and across a wide range of media has seen the role of the designer extended to that of facilitator and collaborator, especially when working on large-content projects. Designers today find themselves regularly working alongside, and relying upon a range of specialist practitioners. As Ralph Appelbaum points out, "We came to realize that we needed to be highly collaborative with writers, and particularly people who understand narrative structure as the key to understanding how to organize our content." For example, just as the once separate roles of designer and typesetter are now often integrated, the working relationship between graphic designers and information architects is closer than ever before. While each still requires the specialist skills of the other, it is also vital to have a working knowledge of both jobs in order to function effectively. **Size Matters** has been carefully structured

to highlight the working practices of many of those practitioners who work alongside designers on large projects, providing them with the necessary insight to confidently interact across a range of disciplines. We talk to a museum curator, architect, editor, information architect, and print studio manager, each of whom offers advice, raises questions, and comments on their own personal experience of working with big content. What are their systems of approach? How do they see their role in relation to that of today's graphic designer? Who are their favorite collaborators? All of these questions are answered.

The successful design of a large amount of content is largely dependent on readability. Symbolism, economy, hierarchies, structure, navigation, and information design are all vital components in achieving optimum readability. Moreover, they can all benefit from having systems of process already in place prior to the laying out of the design. Each of these elements,

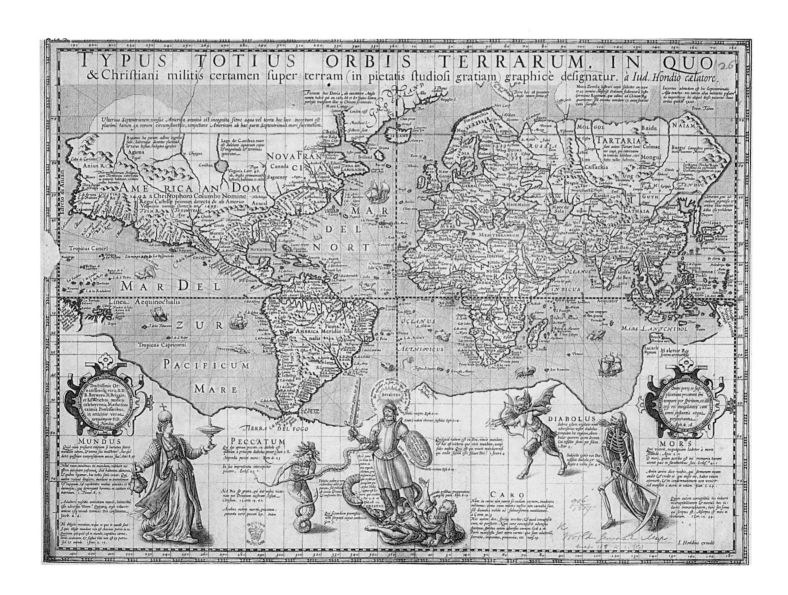

**Above** Map of the world, by Jodocus Handius, published around 1596 (by permission of the British Library)

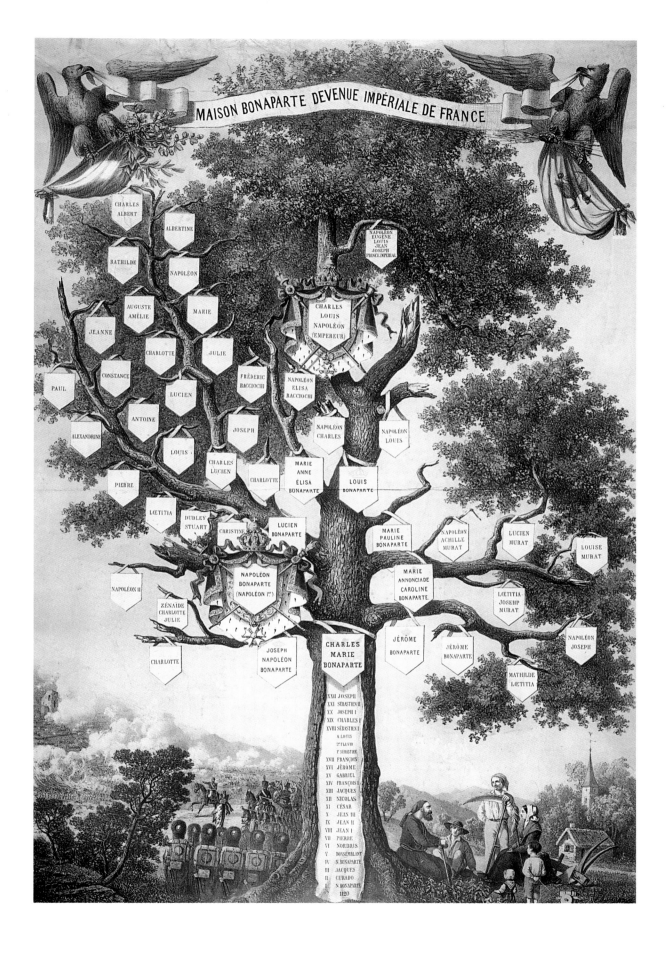

**Above** "Maison Bonaparte Devenue Imperiale de France" (Family tree from 1120 to Prince Louis Napoleon, b.1856), colored chalk lithograph c.1856 by A. Muier

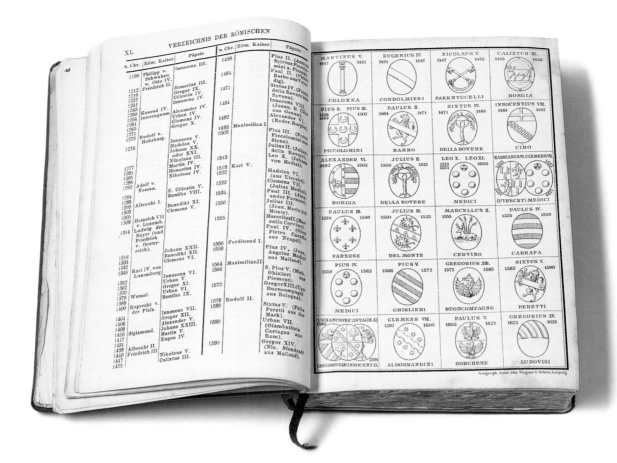

**Above** Spreads from a Victorian Baedeker guide to Italy

and how they are used within the context of large-content design, will be illustrated with exemplary projects spanning the varied and various design disciplines. Examples have been taken from a huge variety of large-content graphic design, including magazines, books, company reports, websites, billing systems, exhibitions, and large navigational systems such as city signage, public transport, and venue maps.

There is a lot to be gained from the aesthetic appreciation of good design but, as the following pages illustrate, there is more to be learned through the journey of its making.

The debate between legibility and readability is both longstanding and ongoing, and is especially relevant to the design of large-content projects. While legibility refers to the "typeform" (the individual character), readability concerns itself with the speed and ease with which a text can be read. Individual letters may be legible, but it is when they are grouped together that the issue of readability comes into play. Both legibility and readability can be affected by: internal factors (relating to the type itself) such as font, size, space, color, contrast, arrangement, and structure; and external factors (relating to the medium of presentation) such as screen, page, exhibition space, and lighting. Digital technology has allowed designers to experiment with the way text is set and shaped to such an extent that, for some, the primary function of text as a "conveyer of information" is all but forgotten. For some typographers, the fact that a typeface is illegible negates its status as a typeface at all, thus rendering the notion of illegibility redundant; for others it is a case of challenging the norm and pushing the boundaries—as does the "dissolving" font developed by Dutch design company LettError. Their Randomfont technology generates each letter separately and differently, with the result that no two letters are the same.

In terms of legibility, context is a key factor. Being aware of how the type will be read, by whom, and under what conditions are all determining factors. A telephone directory, for example, is read under very different conditions from a novel. Being alert as to why a typeface was designed and for what purpose it was intended will give a designer far greater control over their choice.

When it comes to readability, the role of the type is a central concern. What is its function? Is the type just to be read or does it serve an additional purpose? For example, although a timetable requires a high level of visual order and coherence for all audiences, a company report is more concerned with being modern and authoritative. A careful assessment of the audience is essential, and its potential variety should not be underestimated.

Challenging the reader to leave the comfort zone of familiarity is central to the debate between legibility and readability, but the appropriateness of stylistic or, as some would say, fashionable design, and indeed whether or not it is acceptable, lies in the hands of the intended audience. Nowhere is the difference between "classic" and "fashionable" typographic treatments more pertinent than in modern, big-content design. But is successfully communicated big content born of creative systems or of surface adjustments and decoration? The debate continues…

**Top** Exhibition hall in the Crystal Palace, at the Great Exhibition of 1851, London (V&A Images, The Victoria and Albert Museum, London)

# STRUCTURE

"The negative is the score, but the print is the performance" Ansel Adams, photographer, b.1902

Whether designing a book, website, or exhibition, there are a number of systems that can be implemented in the early stages in order to simplify the design process. Time schedules, grids, style sheets, and methods of cataloging information are just some of the structure-based systems highlighted in this chapter. Preparing a project for print also carries with it a set of considerations that must be decided upon prior to beginning the design process, as they will affect the end result. Most large-project content is supplied with a table of contents, listing the divisions and hierarchies of information. This is your starting point for structuring the design and will, ideally, be complete in the number of distinctions required between types of information.

Creating a comprehensive schedule of work, and constantly referring back to and updating it throughout the project, is a must. While the schedule can, and should, be updated as many times as is necessary, this does not necessarily have to affect the final deadline. What it will do, however, is enable you to keep track of your progress right from the start. This is particularly important if the size of the project is larger than you are used to. Scheduling work involves making estimations of time needed for various stages—and it is more difficult to get this right if you have no experience. An accurate record of the time taken up by various stages of work will also prove invaluable in scheduling future large projects. And since these may not come up often, don't rely on your memory alone.

While there are common systems of approach when working with big content, each designer has their own individual means of execution, and tracking the progress of a job is no different. This is very much a personal decision, as what works for one designer may be another's worst nightmare. Schedules can be created and revised on a personal level or as part of a team, as a simple spreadsheet document or—in the case of Derek Birdsall—as elaborate, hand-drawn diagrams. Visually documenting your progress is useful in showing how patterns of work develop, making it easier to predict future timings. In addition, it not only highlights any gaps or potential problems well in advance, but also allows you to step back and assess the "bigger picture," creating space for new ideas. Style sheets are an excellent and much underused means of ensuring continuity throughout a large project. The way text is styled in terms of headings, subheadings, introductory and body text can all be preset and, perhaps more importantly, globally altered later on, both saving time

and minimizing error. Multidocument layers are another incredibly useful tool, especially when dealing with larger projects or creating a document in multiple languages.

In terms of basic structure, when it comes to organizing large amounts of information on a page, screen, or other laid-out unit, using a grid, or a selection of grids, is one of the most effective means of not only organizing space, but also bringing a visual consistency to the overall design. When designing consecutive pages, screens, or exhibition information panels, using a grid matched to a subdivision of content type helps the audience navigate the types of information displayed. How strictly the grid is adhered to, of course, remains at the discretion of the individual designer. Some designers may choose to adopt a strict grid, which in turn dictates the design, while others choose to break the rules as and when the urge takes them. It is only by having the structure in place, however, that this choice is created.

There are still some designers who see grids as a constraint, but on large, complex projects a strong, carefully considered grid helps to define parameters while still providing plenty of room for flexibility. Grids also make a huge difference when it comes to the overall management of a project, whatever the medium.

Newspaper design is one area that uses the structure of a tight grid, not only to speed up the production process but also to reassure its audience. Even the most minor change in format will elicit a response (usually one of outrage) as letters to the Editor come pouring in. For the design team at Atelier Works, the Labour Party Manifesto was a vast job that could not have been completed had it not been for the strict frameworks set up prior to the layout of the project, as the content itself was only supplied at the very last minute. Conversely, in Stefan Sagmeister's "Made You Look," the uniformity of the grid, while overtly apparent, is repeatedly broken by the designer's handwritten annotations and personal comments that randomly litter the pages.

Without structure, the reality of dealing with large amounts of information means that there will be times when you simply can't see the wood for the trees. But as the following examples illustrate, implementing a clear structure as early as possible provides the space, both physically and mentally, to not only manage the information but also come up with a creative design solution as a result.

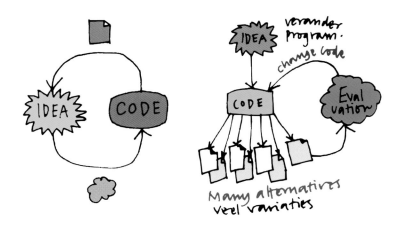

## LETTERROR BOOK LettError

Dutch design company LettError was asked to design a booklet about their work for the Charles Nypels Foundation. Rather than use a traditional desktop publishing (DTP) application, LettError's two designers, Just van Rossum and Erik van Blokland, decided to design their own by developing a "machine" that generated the entire book, including images, colors, typography, color separations, and fonts. By incorporating all the design decisions into a structured system, the system itself became the design. It may seem like a lot of work, but once the system had been set up, essentially the job was done.

"The software we developed for the LettError book did almost everything," says van Blokland. "Every item on the page has a piece of code that's responsible for it. Animation objects will generate the right frame for the right page. Text column objects figure out which piece of the content stream to show. Image objects import the EPS file. The content is written by us, the building process is described by us, but the final assembly is done by the machine." Although the design and aesthetics are embedded in the program, this does not mean that the finished design is set in stone. "We build the programs to make assemblies that we like, so if we see things we don't particularly like, we fix the code to avoid that kind of solution. The system IS the design, but we have so much control over the automation that we can tune it to do exactly what we want." The "book machine" was written in Python, an object-oriented programming language developed by Guido van Rossum. The machine is built from a large number of small programs (scripts); some of these generate the images, while others gather the text and apply the typesetting instructions. Finally, each page is saved as an EPS file. For the sake of convenience, the pages are compiled into one PDF for viewing, printing, and proofing. The LettError book could have been made any length, by increasing or decreasing the content.

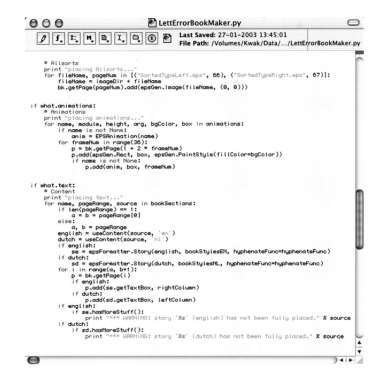

**Top** The concept of the "book machine" explained diagrammatically

**Above** Screenshot of part of the code that generates the book: all items—text streams, images, flipbook animations, page numbers, etc.—are first generated and then placed

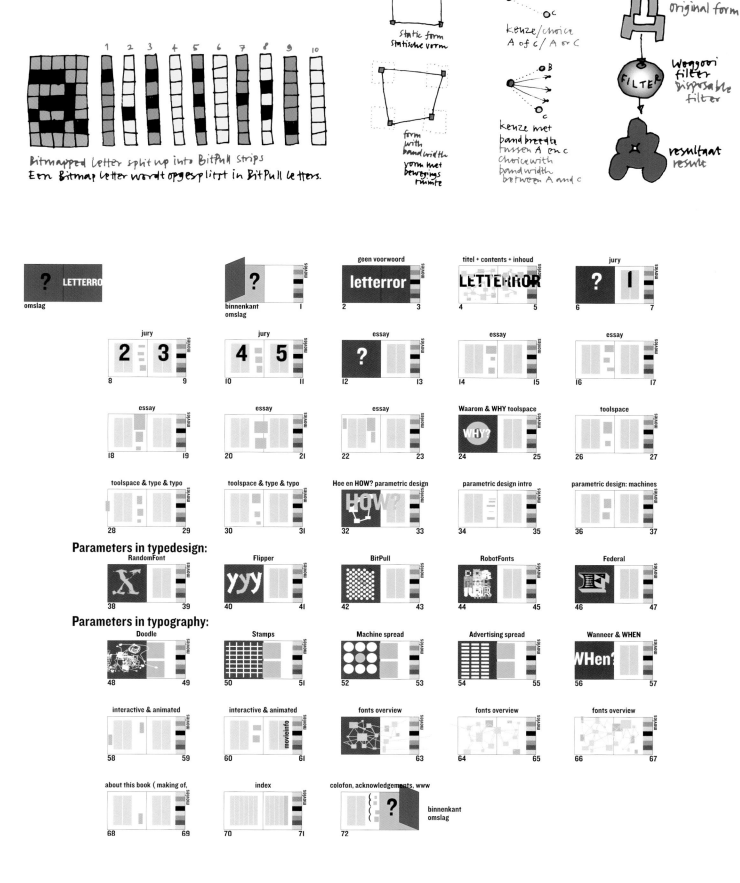

**Above** An early page plan for the book. This determines not only what content goes where, but also what code we need to write to make it work

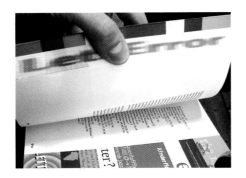
Special printing on the edge reveals a secret message on the side of the book

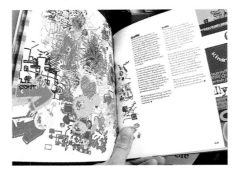
This illustrative material was all creatively rendered by remote control

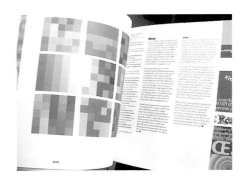
Studies in controlled, random, and semirandom (or semicontrolled) color selections

**Letterkaart / Fontmap**

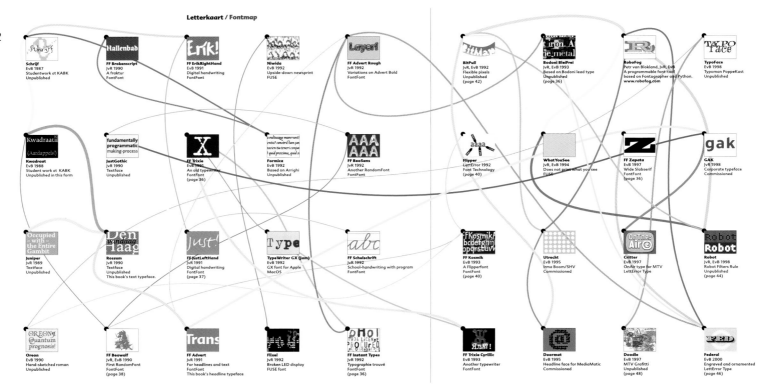

Schrijf
EvB 1987
Studentwork at KABK
Unpublished

Hallenbad
FF Brokenscript
JvR 1990
A fraktur
FontFont

Erik!
FF ErikRightHand
EvB 1991
Digital handwriting
FontFont

Niwida
EvB 1992
Upside-down newsprint
FUSE

Layeri
FF Advert Rough
JvR 1992
Variations on Advert Bold
FontFont

BitPull
JvR, EvB 1992
Flexible pixels
Unpublished
(page 42)

Bodoni BleiFrei
JvR, EvB 1993
Based on Bodoni lead type
Unpublished
(page 36)

RoboFog
Petr van Blokland, JvR, EvB
A programmable font-tool
based on Fontographer and Python.
www.robofog.com

TypoFace
EvB 1998
Typoman PoppeKast
Unpublished

Kwadraat
(Aardappels!)
Kwadraat
EvB 1988
Student work at KABK
Unpublished in this form

fundamentally programmatic
making-process
JustGothic
JvR 1990
Textface
Unpublished

X
FF Trixie
EvB 1991
An old typewriter
FontFont
(page 36)

Formica
EvB 1992
Based on Arrighi
Unpublished

AAA AAA
FF BeoSans
JvR 1992
Another RandomFont
FontFont

Flipper
LettError 1992
Font Technology
(page 40)

WhatYouSee
JvR, EvB 1994
Does not print what you see
FUSE

Z
FF Zapata
EvB 1997
Wide Slabserif
FontFont
(page 36)

gak
GAK
JvR 1998
Corporate typeface
Commissioned

Occupied – with – the Entire Gambit
Juniper
EvB 1989
Textface
Unpublished

Den Haag
Rossum
JvR 1990
Textface
Unpublished
This book's text typeface.

Just!
FF JustLeftHand
JvR 1991
Digital handwriting
FontFont
(page 37)

Type
TypeWriter GX (Jam)
EvB 1992
GX font for Apple
MacOS

abc
FF Schulschrift
JvR 1992
School-handwriting with program
FontFont

FFKosmik/ bcdefghi pqrstuv
FF Kosmik
JvR, EvB 1993
A Flipperfont
FontFont
(page 40)

Utrecht
EvB 1995
Irma Boom/SHV
Commissioned

OnThe: AirO
Critter
EvB 1997
OnAir type for MTV
LettError Type

Robot
Robot
JvR, EvB 1998
Robot Filters Rule
Unpublished
(page 44)

Oreon
Quantum prognosis!
Oreon
EvB 1990
Hand-sketched roman
Unpublished

FF Beowolf
JvR, EvB 1990
First RandomFont
FontFont
(page 38)

Trans
FF Advert
JvR 1991
For headlines and text
FontFont
This book's headline typeface

Flixel
EvB 1992
Broken LED display
FUSE font

Pho Produced
FF Instant Types
JvR 1992
Typographie trouvé
FontFont
(page 36)

FF Trixie Cyrillic
JvR 1993
Another typewriter
FontFont

Doormat
EvB 1995
Headline face for MediaMatic
Commissioned

Doodle
EvB 1997
MTV Grafitti
Unpublished
(page 48)

Federal
EvB 2000
Engraved and ornamented
LettError Type
(page 46)

A map of all fonts, their chronology, and links to other projects. The map and layout were scripted to respond to a database input

Examples of how programming can be used to alter typography

Robot fonts: hundreds of fonts generated by remote-controlled filters. All are variations on the same theme— clearly related, but all different

The advertising synthesizer generates colors, names, and products

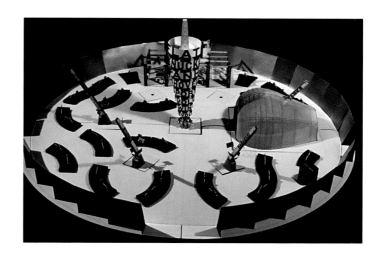

## OPEN ROAD TOUR Pentagram New York

Open Road Tour was a huge traveling exhibition celebrating Harley-Davidson's 100th anniversary. J. Abbott Miller was the creative director of the whole project from a visual standpoint, including the tent and all architectural and graphic components. The show traveled to 10 sites around the world including Atlanta, Sydney, Los Angeles, Mexico City, Tokyo, and Barcelona.

Miller first met with Harley-Davidson exactly one year before the show debuted. "It wasn't all that different from my other exhibition projects. It's more the case that it transpired over a larger geographic area," says Miller. "But if you distilled it, and maybe this is part of the lesson, if you looked at it purely from the point of view of the amount of information and artifacts, it wasn't overwhelming; it was more the implications of it, and the fact that it would be touring around the world, that made it pretty heavy."

The team approached the task in the same way as any other exhibition or book project—Miller as the lead designer working with one senior designer from a 3D perspective, one senior designer from a 2D perspective, with support on the architectural detailing and production support provided by the fabricator who produced a lot of the construction drawings. With 60,000 sq ft (5,570 sq m) of exhibits, this is the biggest exhibition Miller has designed to date, yet despite its enormous and unique scale, the size of his team and the structuring of the project did not change. "It's the same team that I work with when I do a show that's 3,000 sq ft [280 sq m]," he points out.

Due to the large scale of the exhibition, the use of models played a key role in developing the design concept. "At all times we had some form of model—from the very informal to the more formal presentation models. Each tent had its own model, but when the structures really became complex we made a model of the individual structures within the tents." These 1/8in (3mm) and

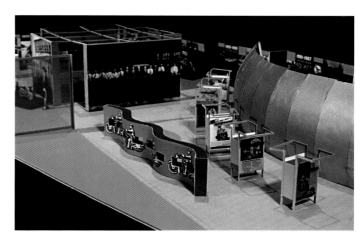

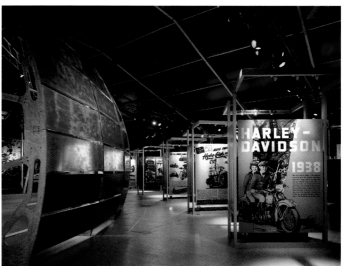

Top An overview of one of the models used to design the exhibition

Middle/bottom Each of the main tents had its own model, but the complexity of the project often meant creating additional models of the individual structures within the tents

¼in (6mm) scale models were also used to show the client. "That was really important because that was all they could see of our exhibit. There were a few renderings but it was mostly the models.

"No matter how big the project gets, the individual experience of a visitor stays at the same scale," concludes Miller. "You have to design for the user/reader, not the crowd. This creates an interesting tension in the design: physically, it has to accommodate many people, but the scale of interaction is small and constant."

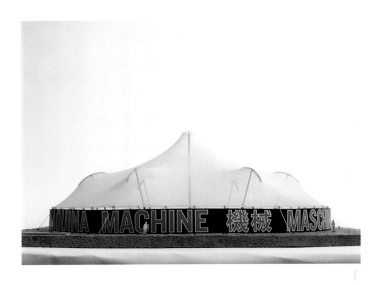

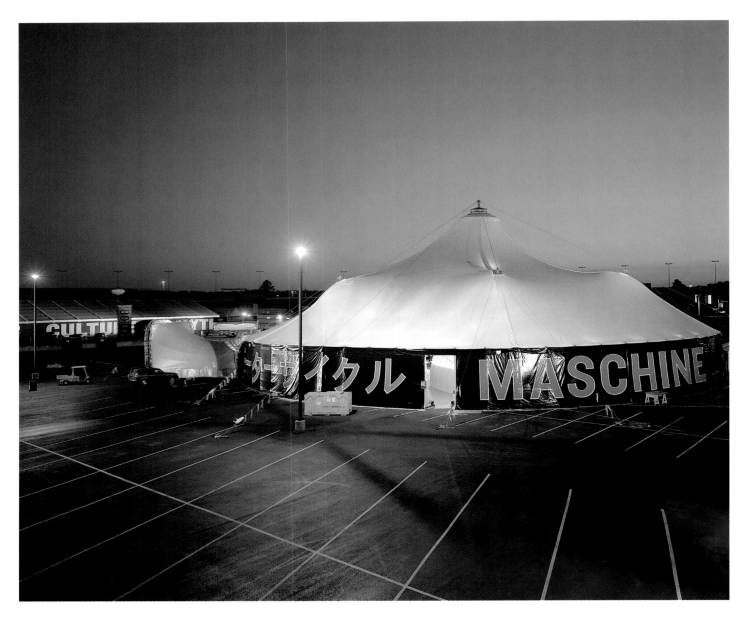

**Above** Exterior: the model is transformed into the finished design

**Top** Model of the exterior of the exhibition tent

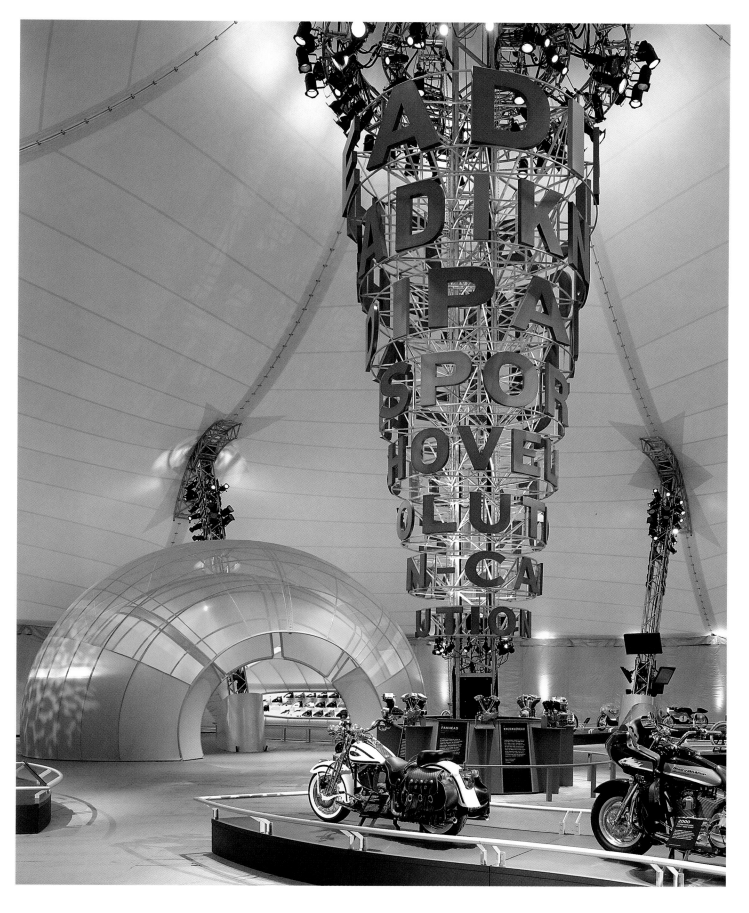

**Above** The final design brought to life

**1/26**

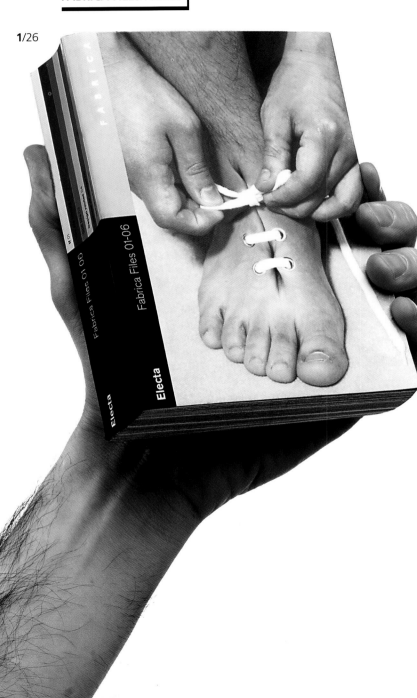

Fabrica, being Benetton's research center for creativity and communication, is home to 60 young artists of all nationalities, working in visual communication, editorial design, photography, video and film, 3D design, new media, and music. As a result, an enormous amount of work is generated across the school's multiple research environments, but this remains largely unseen. In response, it was decided to publish *Fabrica Files* as a vehicle to showcase this work.

Back in 1999, Omar Vulpinari, Fabrica's Head of Visual Design, began editing and designing a series of A5 (c. 5³⁄₄ x 8¹⁄₄in) booklets, with a view to publishing one per month. These were self-promotional, self-funded editions that collected and featured Fabrica's most important projects. When the decision to seek an external publisher for the project was made, Vulpinari presented the concept to Electa, Italy's leading art and architecture publisher. "I prepared six dummies held together by a transparent plastic slipcase to give them an idea of the project's potential growth in time." Electa loved the content and design but felt that, individually, the books were too small. Instead, they decided to combine the six booklets to create one biannual publication. *Fabrica Files 01–06* is a 384-page book compiled from six 64-page booklets containing three collective projects and three single-author projects.

Having a clear project structure and an efficient system to organize and catalog the images was vital for effective project management, and this could not have been achieved without Fabrica's immaculately structured filing system. In addition to producing books, the editorial offices of *Colors* magazine are also housed within Fabrica, so concept, design, and production resources are permanently in place. The production process was: 1. editorial concept; 2. design concept; 3. text and image editing; 4. text and image retrieval; 5. text translations; 6. thumbnail layout; 7. computer layout; 8. 2D dummy layout and 3D dummy check;

**Top** Fabrica's data retrieval software can immediately locate digital files from a CD archive

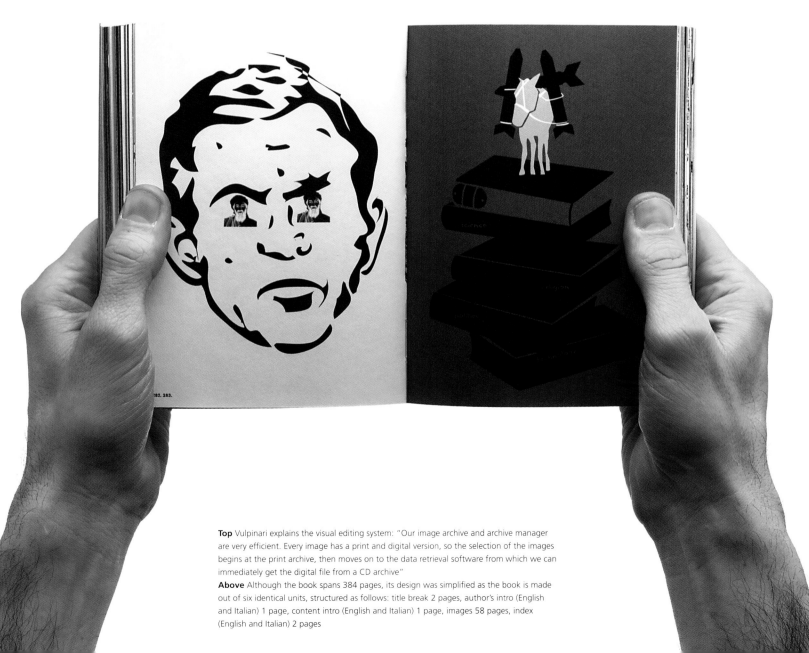

**Top** Vulpinari explains the visual editing system: "Our image archive and archive manager are very efficient. Every image has a print and digital version, so the selection of the images begins at the print archive, then moves on to the data retrieval software from which we can immediately get the digital file from a CD archive"

**Above** Although the book spans 384 pages, its design was simplified as the book is made out of six identical units, structured as follows: title break 2 pages, author's intro (English and Italian) 1 page, content intro (English and Italian) 1 page, images 58 pages, index (English and Italian) 2 pages

9. text and image correction on complete color laser prints; 10. text and image correction on complete digital color proofs; 11. blueprint check; 12. print-run quality control; 13. assembly quality control.

"Large-content projects demand order and complex simplicity," continues Vulpinari. He stresses the importance of first examining ALL the content in order to assess what function the design needs to achieve. He also draws comparisons between architecture and editorial design. "It is a long step-by-step process where purity, creativity, and precision are of equal importance. Tracing a very rough structural layout will tell you how many floors your 'building' needs. Only then can you can start examining the various sections (the floors) and finally define what the pages (the rooms) will need."

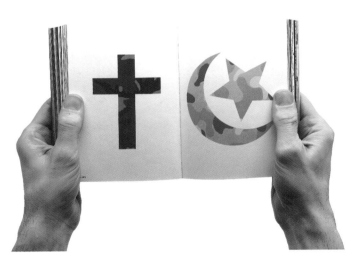

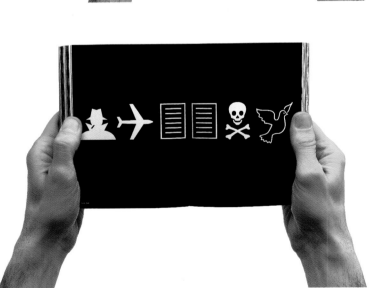

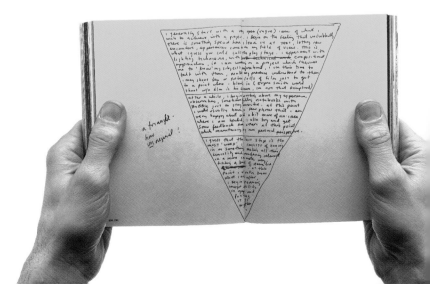

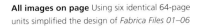

**All images on page** Using six identical 64-page units simplified the design of *Fabrica Files 01–06*

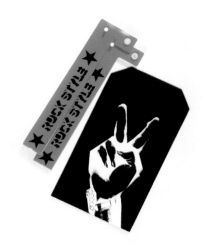

## ROCK STYLE Studio Myerscough

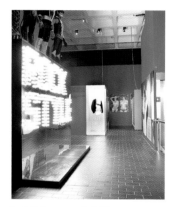

Rock Style: a name in lights

A simple typographical treatment

A rotating rail showcases original outfits

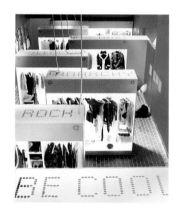

Wardrobes labelled for bird's-eye view

Held at the Barbican Gallery in London, Rock Style was the first major British exhibition to celebrate the influence of pop music over the last 50 years. The exhibition was originally organized by The Costume Institute of the Metropolitan Museum of Art, New York and the Rock and Roll Hall of Fame and Museum, Cleveland, before being brought to the Barbican for its London showing, designed by Studio Myerscough. Exhibits were divided into five main sections, with two interactive areas, and included some 100 original iconic costumes set alongside classic rock photography, concert footage, and ephemera.

In terms of managing the job as a whole, the Barbican was responsible for much of the administrative element, liaising with the US and arranging to have the content shipped to the UK. All of the US content was cataloged and a numbered Polaroid supplied for each item. Studio Myerscough used these to make their selection for the British exhibition, before going on to source a number of items themselves.

As the items were being held overseas, the Polaroids helped to structure the work-in-progress by providing a clear visual reference for the designers to both work from and build upon. They were also provided with information such as the different dimensions of the outfits and objects prior to their arrival. In order to visualize the space in 3D, a model was created, and this was revised and updated as the design evolved.

Working with a small budget required a certain amount of creative thinking too. For example, agreeing to return the motor for the rotating clothes rail once the exhibition had ended cost less than buying it outright. By allocating a set amount for each element of the design, they were able to achieve the required overall aesthetic without exceeding the funds provided.

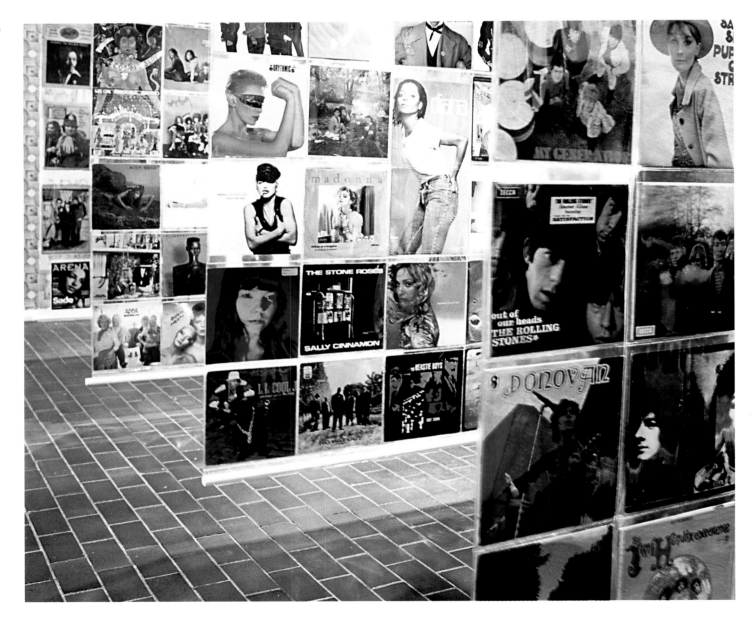

**Top** All the US exhibits were cataloged and a numbered Polaroid supplied for each

**Above** Original record covers displayed in suspended panels

**FRAKCIJA** Cavarpayer

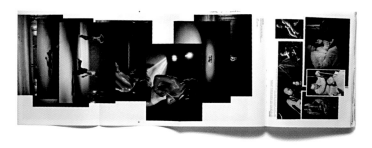
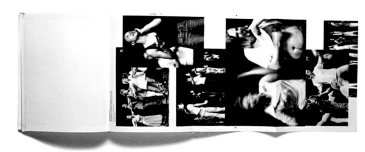

**Frakcija** Actor as/and Author issue

Designed by Croatian design studio Cavarpayer, *Frakcija* is a bilingual quarterly magazine for the performing arts. Produced by the Center for Drama Art, Zagreb, the magazine publishes texts on new theater, arts, and theoretical and philosophical discussions. Aimed at an "elitist circle of intellectuals in the spheres of philosophy, sociology, contemporary arts, and theater," each themed issue is presented in an entirely new format and produced in a limited print run of only 500 copies. "Our concept was to use the language of design to present a different journal and with every new issue to research the iconography and graphical conventions in the same way that the text covers different theaters and artists," says Art Director Lana Cavar.

This issue dealt with the postmodern performer/actor and his/her identity. After examining the classical "mask" and conventions of Greek theater, Cavar opted for a "no identity" issue. The text and photographs were published as they arrived at the studio, in the same size, typeface, and resolution. "We left all the graphic data untransformed and vacuumed, like a piece of raw meat. The paper we used was found in the printer's storage." As a result of this, each copy is printed on different stock, making it totally unique. "As there is no cover, identity may be added by keeping it in a folder."

**All images on page** *Frakcija*: The Actor as/and Author issue was printed and bound to be read in from both the "front" and the "back"

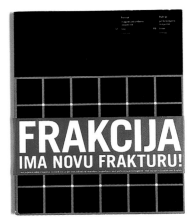

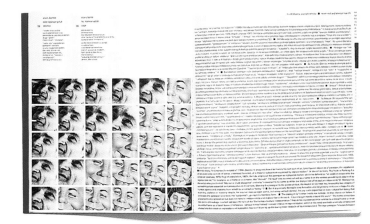

**Frakcija** The Energy issue

As the theme of this issue was "energy," Cavar decided to experiment with "energy of body text" in the design; everything else, from illustrations to titles, was secondary.

After reading through each of the texts several times and discussing their meaning with the magazine's editors, each page was then conditioned by the meaning of the text, its direction, and the principles it addressed.

1/33

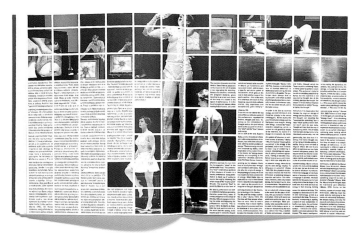

**All images** Cover and spreads from the Energy issue

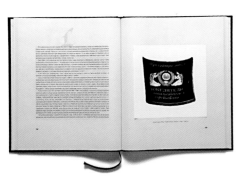

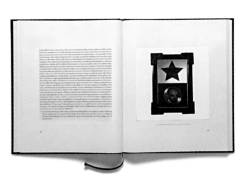

**Frakcija** Radicalisms of Eastern Europe issue

"There were tight rules for everything in Eastern Europe, not much space for open minds, and 'free ideas' were almost forbidden. So was the graphic style. We grew up in such an environment and therefore are very critical and skeptical about it. As a result we came to a graphic solution without an 'original' or 'radical' graphic style. We used Jan Tschichold's *The New Typography*, and tight rules governing the layout, because we wanted to develop an issue whose graphic appearance was totally defined by typographic ideology and dictated by rules. "At the same time, we felt that every progressive graphic solution today is trying to be typographically 'radical.' Graphically 'radical' design is not very radical any more. We believe that it is the system and approach that are supposed to be radical. We hope we reached a radical solution without using radical graphic elements." The cover and magazine format itself imitate the appearance of books at the time of socialism.

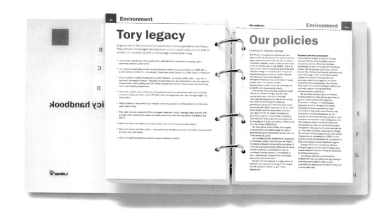

## LABOUR PARTY MANIFESTO Atelier Works

When Atelier Works were first commissioned to design the UK's 2001 Labour Party Manifesto, few could have imagined what the next few months would hold. "Normally, a client would set a deadline and copy/content can be defined by a certain date to meet that deadline," explains Ian Chilvers of Atelier Works. "The key problem we faced was that the election date was such a closely guarded secret that even we didn't really know when the deadline was until it was announced to the press." In addition, the policies were being constantly adjusted and the language continually tuned in response to opposition electioneering. "This was a stressful way of working as we normally establish clear working processes when working with clients," he continues. "They say that a week is a long time in politics, but even six hours became a long time for us— EVERYTHING changed very rapidly."

Working on such a high-profile project also brought the increased pressure of confidentiality. "We were used to holding client projects under wraps for commercial reasons, however, those sort of projects do not attract bloodhound journalists out for a spoil," recalls Chilvers. "We were warned that the slightest leak would result in our garbage being emptied or worse, so all staff were briefed on how to handle inquisitive phone calls and we were on our guard for the duration." Due to the size of the job, the project was split across two teams, although this did little to lessen the workload as both teams still had to know exactly what was going on with the other throughout the project. Eventually, as the project reached its climax, the whole manifesto design team was moved to Labour's Millbank headquarters.

Three main manifestos, two business manifestos, a summary manifesto, and a selection of pledge cards, as well as a 600-page *Policy handbook*, were all designed for the campaign. The main task, says Chilvers, was to "organize the information into visual lines of thinking."

The project began with the handbook, to be distributed to Members of Parliament (MPs), Party workers, and journalists. As well as being easy to navigate and understand, it had to be quick and easy to update as the campaign progressed. The resulting A5 (c. 5¾ x 8¼in) ring binder contained everything from facts and quotes to lines of attack and rebuttal; "everything the MPs needed as armory while out canvassing," recalls Chilvers. The handbook served as a sound prelude to the whole project.

Whereas stock photography had been used for images in previous campaigns, for this one they decided to photograph only real people in real situations. This meant that every person who was photographed had to be fully vetted before any of the images could be used. This task fell to the project managers, based at Labour's Millbank headquarters.

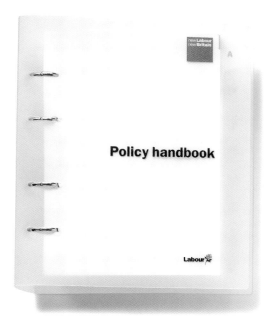

**Top/above** Designing the handbook in a loose-leaf format allowed pages to be updated and replaced relatively easily

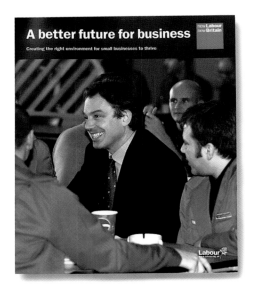

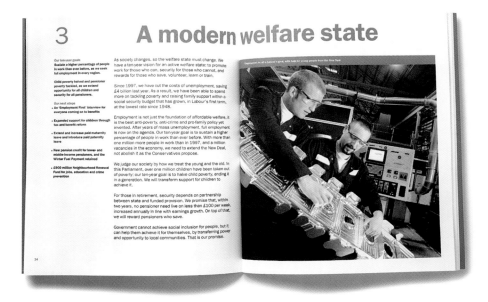

As the actual content was not finalized until the very last minute, the project was primarily managed by setting up a series of grids into which information could easily be flowed. This structure had to be in place before the copy arrived. In some cases it was possible to insert key images beforehand, but only once they had passed through a rigorous chain of checks to ensure that all permissions had been sought. A system was also set up to define a visual style that could be implemented across the range of manifestos. Developing this system saved the team from having to reinvent the visual language for each different format, as well as providing the project managers with a recognizable Labour format.

Creating a hierarchy of information was vital to the visual style of the manifesto. The copy had to be conversational, and to work on three levels for different types of people. The first level involved distilling the party's key policies into simple facts; designed for spot reading, this used large type and highlighted subtexts.

**All images** A hierarchy of information that could work on a number of levels was vital to the visual style of the manifesto

A single column that could vary in length was allocated for this.
A 300-word summary of key points followed, leading into the
detailed specifics of the manifesto. "This was carried through
the different manifestos because we wanted to keep a visual
language that was familiar," explains Chilvers. "We could see
problems looming and we had to design grids that allowed that
to happen." For the business manifesto, the format was designed
to look more like an annual report, though the overall visual
coherence was maintained across all versions.

## ANNUAL REPORTS Cahan & Associates

**1**/38 When Cahan & Associates began designing annual reports in the early '90s, its key objective was to present the client's message as clearly and strongly as possible. By the mid-'90s, thinking had progressed. "We started doing reports that were different in terms of format, because annual reports were either incredibly boring or simply arrogant in that they were talking at you rather than to you," says Bill Cahan. In 1996 and the years that followed the firm went on to revolutionize the annual report, picking up more than 2,000 design awards along the way. "Many of the things we did then are now much more common, so we are taking a completely different tack and doing work that doesn't follow the same patterns or rhythms and is, in many ways, much more interesting."

Recent disclosure issues have also impacted on the design of annual reports as clients abandon the exuberance of the late '90s in favor of as "pure" a report as possible, which cannot be misconstrued in any way. Another reason, says Cahan, to move on.

Witnessing the shifting credibility of its reports some three or four years ago, Cahan reengineered his own company to include identity along with all its accompanying material. "For us, the annual report has always been more than a financial instrument. It was also a public-relations vehicle, an advertising opportunity, and a recruitment piece. And that has enabled us to do different kinds of work," he continues. "We would do a highly strategic piece [for a company] that, in many instances, would set a precedent for the rest of their collateral and advertising— especially for companies that didn't have huge marketing budgets. The annual report was the single most important piece they produced all year, so they would take their lead from that and do other things that leveraged off it."

**Top** Silicon Valley Bank: from initial sketch to final design for introducing entrepreneurs

**Above** Silicon Valley Bank: feedback from client following initial design presentation

**Top** Silicon Valley Bank: evolution of cover design

**Above** Silicon Valley Bank: viewing the entire project can be beneficial to the designer

**1**/40

**Above** Gartner 2000: viewing a large project in its entirety can be hugely beneficial to the designer. Here, intermediate thumbnails are marked up for printing quotation purposes

**Top left/center** Gartner 2000: the designer's sketchbook provides an invaluable source of information throughout a project

**Top right** Gartner 2000: detailed print specifications and schedules leave no room for error

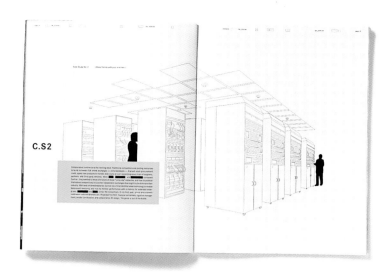

Cahan & Associates may have produced some of the most innovative and unique reports to date, but that is not to say it is an easy task. All the firm's designers must do an enormous amount of "homework" in order to understand what they are dealing with before they even begin to consider potential design concepts—a process Cahan likens to taking a crash course in a PhD or Masters program. "You work really hard just to understand it on a very basic level, and then you have to figure out how to explain it in a way that will engage people," he says. "Ninety percent of our work is research—doing all the reading, the homework—and 10 percent is design."

Working to a system is integral to the success of any large project, but when it comes to designing an annual report there really is no room for error. Presenting a client with the final piece of work at the eleventh hour only to discover that they hate it is simply not an option. Having built its reputation on pushing the boundaries of annual report design to the maximum, Cahan & Associates was quick to develop a robust system of approach back in the mid-'90s that continues to serve it well. This "internally self-adjusting" system can be scaled up or down, while still ensuring that every project is completed on time.

Prior to any design work, each client is asked to fill out a questionnaire concerning the report's communication goals, its intended audience, etc., which is then distributed to all those working on the project. This is followed by the firm's Visual Rorschach Test (VRT), which involves presenting a number of annual reports (not designed by Cahan & Associates) to the client and obtaining feedback. This not only opens the lines of communication, it also familiarizes the design team with its client's method of communication and thought process right from the start.

One of the most unusual things about the company, however, lies in its approach to work. Rather than allocate each job to one designer or design team, as the majority of design companies do, at Cahan & Associates multiple designers are allocated to every project. This not only provides the client with a choice of three to four independent design solutions, it also keeps the designers on their toes as they compete internally for every project. Each of the designers is then required to create a full-scale, fully designed model of his or her idea, including copy, which they will present to the client themselves. But not before explaining, and when necessary defending their ideas via a rigorous internal review during which their work is thoroughly critiqued, not just by Cahan but also by their colleagues and the project's account directors, whose task it will be to negotiate for both client and designer once the final concept has been decided upon. "We're not a production house," says Cahan. "We don't execute the client's idea, or my idea, just because it is an idea. The designers have to come up with their own idea and then live or die by it."

## HOURS DIARY/MINUTES DIARY Struktur Design

**1**/42  Although the basic content of a calendar (in terms of days and months) is predetermined, at Struktur Design reworking the data into different formats provides the opportunity to create something unique year on year, with each edition building on the previous year's system.

For 2002, Struktur produced a minutes diary, the second in a trilogy of diaries, which started with hours and will conclude with seconds. "I am interested in the whole process of time and time keeping," explains Roger Fawcett-Tang. "The diaries and calendars are a way of looking at the separate units in which time is measured, be it years, months, days, hours, etc."

Fawcett-Tang's approach to a large-content project involves first breaking it down into component parts. It is only then that he feels able to assess the various elements of information and begin to rationalize and form a visual structure. In the case of his calendars, this involves sitting down with an old-fashioned pen and paper, writing down the various time units, and calculating the interaction between them.

In terms of spatial organization, he is particularly interested in the negative space generated by the leading and word breaks, as this forms the organic rhythm of the typography. "There are various rules and principles that I impose upon myself in the design process, especially with the current trilogy," he continues, "such as fonts, point sizes, and hierarchy of time units as well as printing issues, such as restricting each diary to a B1 (c. 27³/₄ x 39¹/₄in) sheet size, with minimum wastage."

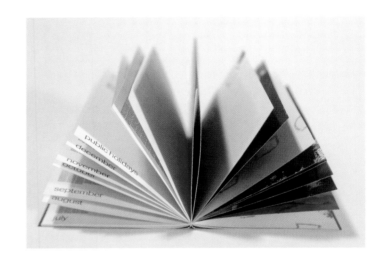

**Top** The hours diary: notes on format and packaging
**Middle** The hours diary
**Bottom** Manual calculations to work out breakdown of hours and minutes in the year

**Opposite, top left** Printout of color tests; the palette was developed with a strict logic based on clean percentages of the CMYK process
**Opposite, top right/middle/bottom** The minutes diary

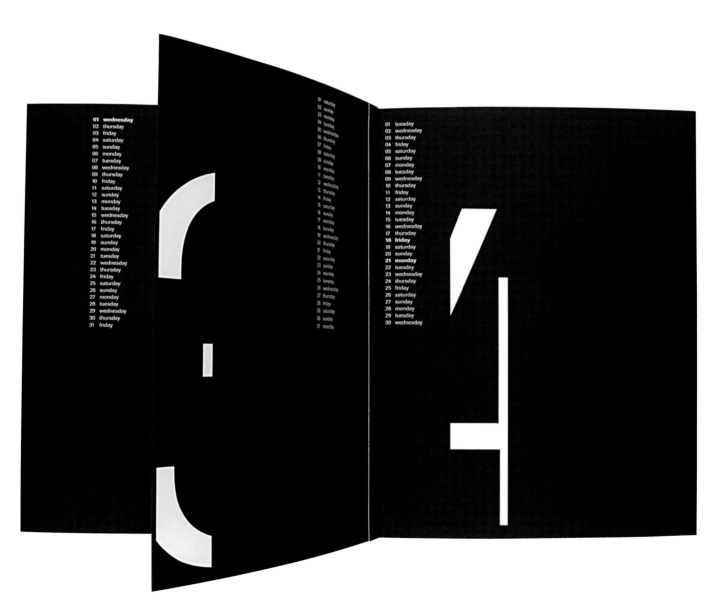

**1**/43

**ELLEN LUPTON** Curator of Contemporary Design, Cooper-Hewitt National Design Museum, New York

Working not only with a large amount of content, but often with a large team of collaborators, is an integral part of the job for any museum curator. In her role as Curator of Contemporary Design at the Cooper-Hewitt National Design Museum in New York, Ellen Lupton has been responsible for numerous major exhibitions on twentieth- and twenty-first-century design. In addition to her work as a curator, Lupton also teaches design at the Maryland Institute College of Art in Baltimore and is a highly respected graphic designer and writer.

In considering the design and management of an exhibition from a curatorial perspective there are certain systems of approach to be followed. "Every exhibition begins with an idea. Then there is a period of research, gathering masses of images and references, before the idea is narrowed down in the form of an exhibition proposal, which is used internally as well as for fundraising," she says. "This document is concise and visual. Then, we begin building back out from that document." It is also the responsibility of the curator to ensure that the design does not overwhelm the content or the objects on view. As Lupton points out, "An exhibition design must be a coherent statement

of an idea. It should make the objects look good, and make the overall space of the museum look good, too."

Using a database program (in Lupton's case, FileMaker Pro) to organize all of the information, contacts, and potential exhibits for a show, allows the curator the flexibility to arrange and rearrange objects, images, and people into categories, themes, and spaces both quickly and easily. In addition, Lupton is able to use the database to generate correspondence with all of the participants in the exhibition.

One of Lupton's most recent projects, and her favorite to date, is "SKIN: Surface Substance + Design," an exhibition examining how today's designers are reshaping the traditional notions of "skin" in fashion, product design, packaging, architecture, and art. As with all of her major exhibition projects, an accompanying book, designed by Lupton, was also produced. Due to the schedule demands of publishing, the book will always go into production first. "The book becomes a 'bible,' a scripture that the rest of the exhibition content spins out of, always in a reduced, shortened form," she says. While some designers might see the production of a companion book as

an additional workload, for Lupton the two support and complement each other. "A book is a portable commodity; it is international, it travels, it's light, it's permanent," she says. "An exhibition is an unwieldy experience, but it's the real thing. It's the stuff itself."

In her role as a curator, Lupton has worked with a number of architects over the last few years, but she is especially fond of the team who designed "SKIN"—Adam Yarinsky and Beth Huck at Architecture Research Office. From a design perspective, she is also a big fan of Ralph Appelbaum's design of the permanent exhibition at the US Holocaust Memorial Museum. "He was able to handle an enormous and oppressive body of information in a beautiful, sensitive, and accessible way."

When considering the marriage of form and content, different media provide different opportunities. "In an exhibition, content certainly takes the lead. But a good exhibition idea is highly suggestive and responsive to formal interpretation." She also cites writing as a "crucial and constant" part of any project. "Print gives you an opportunity to use language more freely. In an exhibition, you have to say a lot in very few words."

# TALKING POINT
## The Curator

While an exhibition is often referred to as a single medium, exhibitions, says Lupton, are never one-dimensional in terms of media. "An exhibition IS a multimedia product, involving print, installation, web components, educational programs, etc. All those elements spin out from the core content, whose essential form is the exhibition catalog/book."

When it comes to the organizational aspect of her role, Lupton always works with an intimate team: an exhibition assistant and editor, plus the design team—an architect, herself as curator, and others who deal with graphics, film, and web.

While the role of the exhibition assistant tends toward pursuing leads on objects, communicating with designers, maintaining the database, and sending out loan forms, the editor has the final word on all matters of published text, from the book to exhibition labels and websites.

Working in collaboration is a key part of the curator's job but some projects can be a lot more demanding than others, simply due to the large numbers of people involved. The National Design Triennial held at Cooper-Hewitt is one such example. Involving 80 designers

and three to four curators, "it's a lot of voices to deal with. I always think of an exhibition as being analogous to a film. The curator is like the director, working with many others who bring specific skills to the project," she concludes. "I enjoy having a degree of control as the 'director,' but I am also completely comfortable leaving a lot of decisions to the architect, the editor, and so on."

# HIERARCHIES

"It is not so hard to be original, what is hard is to be original with continuity" <span>Andrés Segovia, musician, b.1893</span>

**INTRODUCTION** |

Presenting a large amount of information in a visually coherent, clear way requires a level of order that can most easily be obtained by structuring the information on different levels of importance and maintaining consistency with your choice. Annual reports and other business documents containing large amounts of diverse, complex financial data may even adopt multiple hierarchies in order to present the information accurately.

Creating a visual hierarchy, whether through choice of typefaces, sizes and colors, textures, weights, or surfaces, adds to the overall aesthetic of a design, but its primary function in large-content design lies in articulating the meaning and/or structure of the text with optimum clarity. Making the correct decisions relating to hierarchical structure and its related typographical expression is crucial to the success of such design, but that does not mean that a solution is universal; far from it.

As in most areas of design, considering how the information will be consumed will dictate the type of structure to be used. For example, a gas bill or children's website requires a very different hierarchical structure from that of a novel.

Typography—the structuring and arranging of the written word—is a major consideration here, as is the choice of typeface. Designing for both use and appearance was vital to Omnific's design of the *Book of Common Worship*, where readability and elegance were required in equal measure. The use of color and a typeface with an extensive family (Gill Sans) ensured a clear differentiation between the multiple levels of information presented on each page.

The modernist approach to graphic design is also worth noting, particularly when dealing with large amounts of information. "Modernism embraced the idea of analysis; it was schematic," says Lucienne Roberts of sans+baum, whose work is heavily influenced by this school of thought. "Complex design problems demand these skills. There is a place for more obviously self-expressive use of type and image, but by far the majority of graphic design is about communicating a client's message to the public and using design tools to help this process." Apply this thinking to

hierarchies and prioritization and modernists would argue that, for example, a heading does not need to be enlarged, emboldened, and underlined; the same effect can be achieved through the use of spatial relationships, color, and weight. This "less is more" approach can be extremely effective, but it is also crucial to consider your audience. Where a visually sophisticated audience will understand and appreciate it, an inclusive audience, such as that of the Labour Manifesto, will not.

Presenting vast amounts of historical information in a way that is both fresh and memorable can be a real dilemma, but one that has been overcome at Ralph Appelbaum Associates (RAA) by developing multiple layers of information, thus creating a period of discovery before the project even starts. RAA adopted an encyclopedic approach which allowed them to break down the chronology of information into multiple viewpoints and perspectives; this was then clearly articulated for mass consumption—a process Appelbaum likens to unweaving a giant rope. "The general measure of society, especially knowledge-based and experiential societies, is how well it democratizes accessibility to information," he says. "And if you take it as a fundamental requirement that you may have people of all educational and literacy levels, all language levels, some even unable to speak your language, all standing in a room, you need to find multiple points of entry to a single story for all these people, each of whom has different experiential requirements." In designing the permanent exhibition at the US Holocaust Memorial Museum, Appelbaum used typography and materials to distinguish between quotes from survivors and victims and quotes from Hitler. "Even the selection of materials should have a relationship to the importance of information. If you have a story that is particularly noble you probably should surround it with noble materials and not plastic and Formica," he argues. "If you have words that are important and meaningful, perhaps they shouldn't be silk-screened onto a panel where they can be wiped off with thinner."

The examples selected for this chapter range from exhibitions and annual reports to books and directories, all of which rely heavily on hierarchies and prioritization to effectively communicate a content-heavy message.

## ENGENHO E OBRA Henrique Cayatte

Held in Lisbon, Portugal, Engenho e Obra was an exhibition about engineering in twentieth-century Portugal, occupying 32,290 sq ft (3,000 sq m). The exhibition, along with accompanying publications, promotional material, and a website, was designed by Henrique Cayatte. "Every exhibition is unique," says Cayatte. "I try to reconcile the different technologies available to us nowadays to ensure maximum legibility of content. I've visited major exhibitions in many different countries; in Portugal, only the Lisbon Expo of 1998 showed an appreciation of how an exhibition can be both fun and informative."

The subject of the exhibition itself provided significant clues in terms of materials, scales, and colors. From a typographical point of view, Cayatte sought to use fonts that would ensure good legibility and could be applied to the different historical periods without looking incongruent. "Rather than relying on a grid method, we sought to give the exhibition a corporate identity," he continues. "Then, we worked on developing this identity."

The exhibition, which took two years to complete, was organized by a team of six: Cayatte as designer, two historians, an engineer, a photographer, and a specialist in multimedia content. Cayatte's own team, consisting of three designers and a producer, worked from his studio for the duration of the project. "My role was to design, monitor, and coordinate the various phases," says the designer, who is keen to stress the importance of teamwork when working on big-content projects. "In this type of project there are no exclusively solo performances."

The entire exhibition was initially designed as sketches, which were then transformed into the scale drawings needed for construction. Small cardboard mock-ups were then used to visualize spatial layouts and visitor mobility. Once the content had been structured and the design of the installation completed, the three-month process of building the exhibition began.

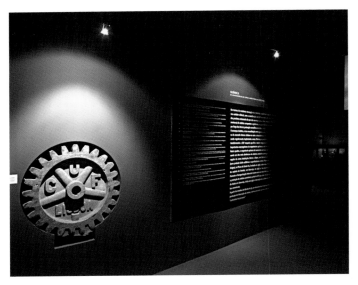

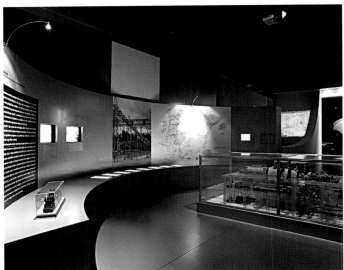

**Top** Exhibition catalog

**Middle/bottom** Occupying 32,290 sq ft (3,000 sq m), the exhibition alone was a vast project

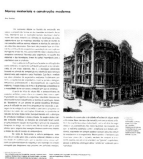

Working from Cayatte's original sketches on paper, computers were used to gradually refine the final design. For the logo, two letter Es—one for the exhibition and the other for engineering—were structured in the same way as a physical construction. The original was then prepared for reproduction in all environments: large-format enlargements, video, and publications of all types.

For Cayatte, when it comes to publication and exhibition design, the designer must aim for a formal refinement that allows the information to be conveyed effectively. "It is essential that voids, text, and image—fixed or animated—be mixed in the correct proportions. No two contents are the same, therefore no two solutions are the same."

The text for Engenho e Obra was produced jointly by researchers and external contributors, and took various forms: programs and timetables, introductory texts and wall signs, as well as spoken and dynamic (video) text. Despite budgetary constraints and "excessively tight completion deadlines," the exhibition still opened on time. "I constantly tried to keep the authors aware of the need to produce succinct texts from the materials available," he goes on to explain. "Too much information kills information!" Cayatte also worked closely with specialists from television, multimedia, and photography to ensure that each element was suited to its particular support. "To perfect content, you have to appreciate the limits of design and work in a team," he concludes, "with as much experience of other, similar projects as possible."

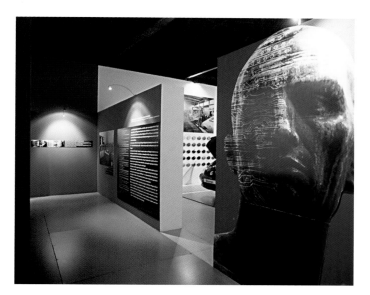

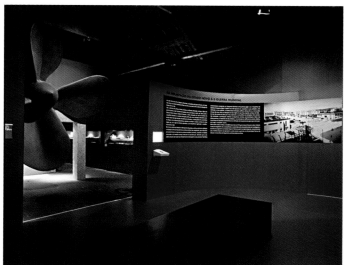

**2/52**

Designed by Derek Birdsall at Omnific, with John Morgan, Shirley and Elsa Birdsall, *Common Worship: Services and Prayers for the Church of England* is a series of worship books commissioned to replace the *Alternative Service Book*, published in 1980. From the sheer size of the task itself to the vast print run, totalling 910,000 copies, this was a huge job. From the process of selecting the designers through to final publication, every step was closely monitored, and continuous, open communication between designer and client was essential.

Having made the decision to prepare a new series of worship books, a Design Panel was set up by the Liturgical Publishing Group. The task of this panel was to select the designers and approve the design for the books. A design brief was sent out to 18 potential designers, eight of whom expressed an interest. From these, three were invited for interview and to present their ideas to the panel. They were also asked to submit a sample page design of three double-page spreads showing extracts from the Holy Communion service for the Standard Edition. Omnific was the only group to show rough work (early trial proofs and alternative layouts), providing the panel with a much-appreciated insight into how Omnific arrived at their final design. Almost four months after receiving the initial brief, Derek Birdsall and John Morgan were selected as the designers for *Common Worship* at a press conference held at the Royal College of Art, London. From the initial invitation to submit proposals to the time of the launch took just over one year.

Although the design was refined over the course of the project, the essential elements remained the same as the initial presentation. The aim of the new books was "to bring together traditional and modern elements of worship in the Church." The typeface selected for *Common Worship* was Gill Sans—an English, sans-serif type design that offered a wide range of distinctive variants within the same family. A clear distinction was required between the words spoken by the priest and the congregation, and service instructions. Trial proofs showed Gill Sans to be both the clearest typeface and the one with the clearest distinction between roman, italic, and bold. Omnific were also provided with the Liturgical House Style Guide stating, amongst other things, that "bold should always be used for congregational text."

The names of prayers and parts of the service are ranged right in bold 11pt to differentiate them from the rest of the text, while instructions are in both italic, for the color-blind, and traditional red. Red running feet and folios are used to distinguish the Holy Communion section from the rest of the book. In order to achieve common pagination between all editions of the booklets and the book, the large-format President's Edition and separate booklets used a dual pagination system. This consisted of a bolder page number beginning with page 1, accompanied by the page number from the standard edition in lighter type.

One of the most interesting aspects of the project was the nature of the production process, necessitated in part by the number of people involved. "The process of producing *Common Worship* was exhaustive and involved all parts of the church, starting with the Liturgical Commission, which produced the first drafts," recalls John Morgan. "These went to the House of Bishops, which amended the texts where necessary before sending them on to the General Synod, where representatives of the clergy and laity, with the bishops, debated the drafts. 'Revision Committees' then considered and amended the drafts. When revision was complete, the House of Bishops again considered the texts. Finally, the General Synod voted on the final form of the services, the authorization dates were set, and the process of publication began." Once the design was complete, there were also six proofreading stages. For the first time the prayer book was published by Church House Publishing, the Church of England's in-house publisher, enabling costs to be kept to a minimum.

**Opposite** The simple cover design used the title to create the image of a cross

**Top** Users were invited to comment on the new liturgy by completing the questionnaire bound into the back of a preliminary edition of *Daily Prayer*

Although the team's complex work schedules were regularly revised, this did not alter the final deadline. The design of *Common Worship* was also open to debate from those outside the industry, with readers being invited to comment.

As well as the printed editions, *Common Worship* material was published in the software program Visual Liturgy 3.0, allowing the user to create customized services. This was made available on the web, free, and as The Common Worship Text Disks.

"The openness to comment and criticism from clergy and laity was essential in achieving the widest assent possible," concludes John Morgan. "In this sense, the production of *Common Worship* could be a model of book production for the future."

**Top** *Common Worship* was produced in a number of print formats; Main Volume Standard Edition, Main Volume Desk Edition, Pastoral Services, and President's Edition

**Above** Working plans for the structure and layout of the book
**Opposite** Standard Main Edition showing the red divider pages introduced by Omnific

*The Order for the Celebration of*
# Holy Communion
*also called*
# The Eucharist
*and*
# The Lord's Supper

---

¶ *The Liturgy of the Word*

### Readings

*Either one or two readings from Scripture precede the Gospel reading.*

*At the end of each the reader may say*

This is the word of the Lord.

All **Thanks be to God.**

*The psalm or canticle follows the first reading; other hymns and songs may be used between the readings.*

### Gospel Reading

*An acclamation may herald the Gospel reading.*

*When the Gospel is announced the reader says*

Hear the Gospel of our Lord Jesus Christ according to N.

All **Glory to you, O Lord.**

*At the end*

This is the Gospel of the Lord.

All **Praise to you, O Christ.**

### Sermon

### The Creed

*On Sundays and Principal Holy Days an authorized translation of the Nicene Creed is used, or on occasion the Apostles' Creed or an authorized Affirmation of Faith may be used (see pages 138–148).*

All **We believe in one God,**
**the Father, the Almighty,**
**maker of heaven and earth,**
**of all that is,**
**seen and unseen.**

**We believe in one Lord, Jesus Christ,**
**the only Son of God,**
**eternally begotten of the Father,**
**God from God, Light from Light,**
**true God from true God,**
**begotten, not made,**
**of one Being with the Father;**
**through him all things were made.**
**For us and for our salvation he came down from heaven,**
**was incarnate from the Holy Spirit and the Virgin Mary**
**and was made man.**
**For our sake he was crucified under Pontius Pilate;**
**he suffered death and was buried.**
**On the third day he rose again**
**in accordance with the Scriptures;**
**he ascended into heaven**
**and is seated at the right hand of the Father.**
**He will come again in glory to judge the living and the dead,**
**and his kingdom will have no end.**

**We believe in the Holy Spirit,**
**the Lord, the giver of life,**
**who proceeds from the Father and the Son,**
**who with the Father and the Son is worshipped and glorified,**
**who has spoken through the prophets.**
**We believe in one holy catholic and apostolic Church.**
**We acknowledge one baptism for the forgiveness of sins.**
**We look for the resurrection of the dead,**
**and the life of the world to come.**
**Amen.**

## Top section (proof of The Liturgy of the Word)

Hear the gospel of our Lord Jesus
Christ according to N.

**All** Glory to you, O Lord.

*At the end:*

This is the gospel of the Lord.

**All** Praise to you, O Christ.

### The Sermon

### The Creed

*On Sundays and Principal Holy Days the Nicene Creed is used, or on
occasion the Apostles' Creed (see page 00) or an authorized Affirmation of
Faith may be used.*

**All** We believe in one God,
the Father, the Almighty,
maker of heaven and earth,
of all that is,
seen and unseen.

We believe in one Lord, Jesus Christ,
the only Son of God,
eternally begotten of the Father,
God from God, Light from Light,
true God from true God,
begotten, not made,
of one Being with the Father.
Through him all things were made.
For us and for our salvation
he came down from heaven,
by the power of the Holy Spirit
he became incarnate of the Virgin Mary,
and was made man.

For our sake he was crucified
under Pontius Pilate;
he suffered death and was buried.
On the third day he rose again
in accordance with the Scriptures;
he ascended into heaven
and is seated at the right hand
of the Father.
He will come again in glory
to judge the living and the dead,
and his kingdom will have no end.

We believe in the Holy Spirit,
the Lord, the giver of life,
who proceeds from the Father and the Son,
who with the Father and the Son is worshipped and glorified,
who has spoken through the prophets.
We believe in one holy catholic and apostolic Church.
We acknowledge one baptism for the forgiveness of sins.
We look for the resurrection of the dead,
and the life of the world to come. Amen.

### THE PRAYERS OF INTERCESSION

One of the forms on page 00 or other suitable words may be used.

The prayers usually include these concerns and may follow this
sequence:

The Church of Christ
Creation, human society, the Sovereign and those
in authority
The local community
Those who suffer
The communion of saints

These responses may be used:

*The Liturgy of the Word*

6 —Order 1

20

Order 1—7

20

## Lower section

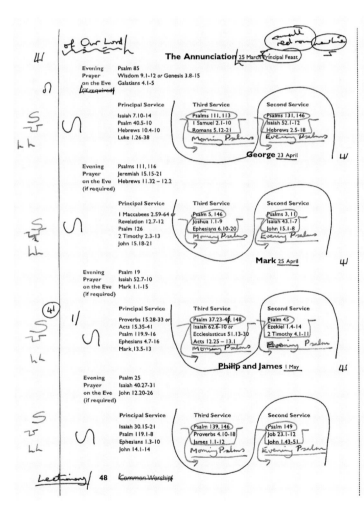

### The Annunciation 25 March Principal Feast

Evening
Prayer
on the Eve
(if required)

Psalm 85
Wisdom 9.1–12 *or* Genesis 3.8–15
Galatians 4.1–5

| Principal Service | Third Service | Second Service |
|---|---|---|
| Isaiah 7.10–14 | Psalms 111, 113 | Psalms 131, 146 |
| Psalm 40.5–10 | 1 Samuel 2.1–10 | Isaiah 52.1–12 |
| Hebrews 10.4–10 | Romans 5.12–21 | Hebrews 2.5–18 |
| Luke 1.26–38 | | |

### George 23 April

Evening
Prayer
on the Eve
(if required)

Psalms 111, 116
Jeremiah 15.15–21
Hebrews 11.32 – 12.2

| Principal Service | Third Service | Second Service |
|---|---|---|
| 1 Maccabees 2.59–64 *or* | Psalm 5, 146 | Psalms 3, 11 |
| Revelation 12.7–12 | Joshua 1.1–9 | Isaiah 43.1–7 |
| Psalm 126 | Ephesians 6.10–20 | John 15.1–8 |
| 2 Timothy 2.3–13 | | |
| John 15.18–21 | | |

### Mark 25 April

Evening
Prayer
on the Eve
(if required)

Psalm 19
Isaiah 52.7–10
Mark 1.1–15

| Principal Service | Third Service | Second Service |
|---|---|---|
| Proverbs 15.28–33 *or* | Psalm 37.23–40, 148 | Psalm 45 |
| Acts 15.35–41 | Isaiah 62.6–10 *or* | Ezekiel 1.4–14 |
| Psalm 119.9–16 | Ecclesiasticus 51.13–30 | 2 Timothy 4.1–11 |
| Ephesians 4.7–16 | Acts 12.25 – 13.1 | |
| Mark 13.5–13 | | |

### Philip and James 1 May

Evening
Prayer
on the Eve
(if required)

Psalm 25
Isaiah 40.27–31
John 12.20–26

| Principal Service | Third Service | Second Service |
|---|---|---|
| Isaiah 30.15–21 | Psalm 139, 146 | Psalm 149 |
| Psalm 119.1–8 | Proverbs 4.10–18 | Job 23.1–12 |
| Ephesians 1.3–10 | James 1.1–12 | John 1.43–51 |
| John 14.1–14 | | |

Lectionary 48  Common Worship

### Matthias 14 May

Evening
Prayer
on the Eve
(if required)

Psalm 147
Isaiah 22.15–22
Philippians 3.13b – 4.1

| Principal Service | Third Service | Second Service |
|---|---|---|
| Principal Service | Psalm 16, 147.1–12 | Psalm 80 |
| Isaiah 22.15–25 | 1 Samuel 2.27–35 | 1 Samuel 16.1–13a |
| Psalm 15 | Acts 2.37–47 | Matthew 7.15–27 |
| Acts 1.15–26 | | |
| John 15.9–17 | | |

*(or)*

Acts 1.15–26
Psalm 15
1 Corinthians 4.1–7
John 15.9–17

### The Visit of Mary to Elizabeth 31 May

Evening
Prayer
on the Eve
(if required)

Psalm 45
Song of Solomon 2.8–14
Luke 1.26–38

| Principal Service | Third Service | Second Service |
|---|---|---|
| Zephaniah 3.14–18 | Psalm 85, 150 | Psalms 122, 127, 128 |
| Psalm 113 | 1 Samuel 2.1–10 | Zechariah 2.10–13 |
| Romans 12.9–16 | Mark 3.31–35 | John 3.25–30 |
| Luke 1.39–49[50–56] | | |

### Barnabas 11 June

Evening
Prayer
on the Eve
(if required)

Psalms 1, 15
Isaiah 42.5–12
Acts 14.8–28

| Principal Service | Third Service | Second Service |
|---|---|---|
| Job 29.11–16 | Psalms 100, 101, 117 | Psalm 147 |
| Psalm 112 | Jeremiah 9.23–24 | Ecclesiastes 12.9–14 *or* |
| Acts 11.19–30 | Acts 4.32–37 | Tobit 4.5–11 |
| John 15.12–17 | | Acts 9.26–31 |

*(or)*

Acts 11.19–30
Psalm 112
Galatians 2.1–10
John 15.12–17

Lectionary 49 Festivals

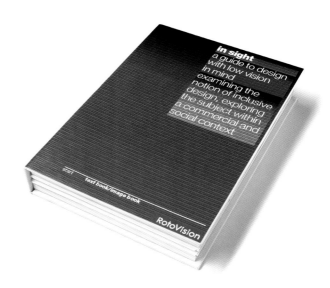

## IN SIGHT sans+baum

With population aging now a major concern worldwide, the need for inclusive design is greater than ever. Designed by Lucienne Roberts and Bob Wilkinson of sans+baum, *in sight* is a book about design that includes the needs of blind and visually impaired people.

No large project can be undertaken without research, but when designing to accommodate those with special needs, there are also official guidelines to be considered. On this occasion, the clear print guidelines produced by the Royal National Institute of the Blind (RNIB), UK, and the rules set out by Lighthouse International in the USA were both fully analyzed before the book's design proposal was developed. The design was also amended after consultation with a group of visually impaired people at the Helen Hamlyn Research Centre at the Royal College of Art in London.

"The main design objective for *in sight* was to prove that graphic design CAN be accessible and still be visually exciting," says Roberts. "We followed the RNIB's clear print guidelines, which most designers would, I think, regard as a constraint, but found that they actually cover many of the basic typographic issues that we consider anyway." These guidelines include everything from line lengths and leading to alignments, word spacing, and, of course, type size. Although the guidelines specify a minimum type size of 12pt, it was important that the page size did not become too large and difficult to handle as a result. The guidelines also point out that integration of text and images can be confusing. *in sight*, therefore, has been designed as two cross-referenced books just under A5 (c. 5³⁄₄ x 8¹⁄₄in) in size—one of text, the other of images—that are bound side by side.

Roberts describes herself as primarily a typographer, explaining that her main interest lies in language and how to make sense of it. "This means that the design should make navigation

obvious and easy," she says. "A main heading has to look more important than a subhead and so forth, but I see no point in reinventing the wheel. We have typographic devices that people understand to mean 'important.' A hierarchical structure works when the reader understands the relative relationship between all the items on the page." How these devices are used, however, is another matter and is entirely at the discretion of the designer.

Heavily influenced by modernism, Roberts prefers the minimalist approach. "A heading doesn't need to be bigger, bolder, in color, and underlined for example," she continues. "If at all possible, I set myself the challenge of using one type size and one font throughout a job and then use weight, color, and spatial relationships to make the navigation clear. I read all the jobs that we design first and mark up what I consider to be 'a' heads, 'b' heads, and so forth. Once I know how many heading levels there are, I can allot different methods to make this clear."

Working with larger type sizes, however, does limit the use of size and space to create an effective hierarchical structure. "Without space around something it has less definition," she continues. "It is harder to make the hierarchy of text clear and that can result in clumsy layouts that lack design refinement and dynamism." For designers to feel more comfortable with large type, a shift in focus is required. "Instead of seeing areas of type as textured rectangles positioned in a white space, designers need to enjoy maximizing the distinction between each letterform."

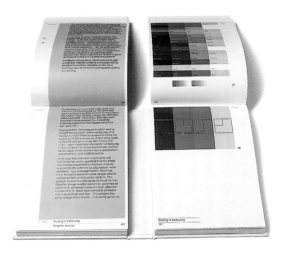
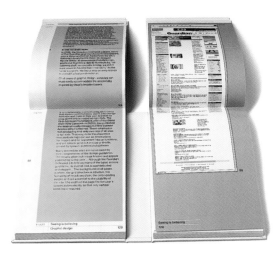
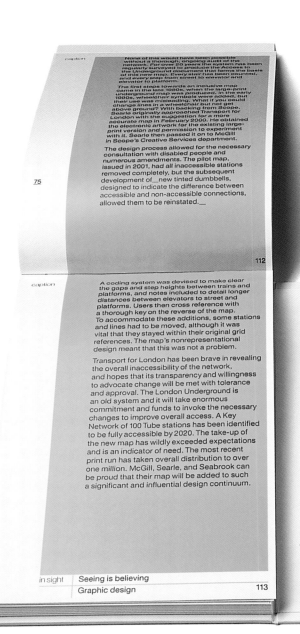
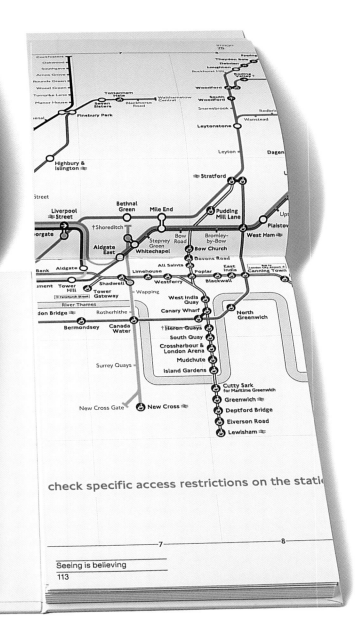

**All images** Spreads showing the separate text and image books of *in sight*, and the use of wide margins to hold image numbers

**Additional design solutions developed for in sight**

- *in sight* is set in sans-serif Neue Helvetica, selected for its large appearance, variety of weights, and familiarity

- To assist navigation, the positioning of devices such as folios and image numbers is consistent throughout, with a margin dedicated solely to image numbers

- Layout and differences in type weight, rather than size, are used to create a visually dynamic design

- Rather than separate captions (traditionally in a smaller point size), text that explains an image is highlighted and aligned with the image number in the margin

- As glossy paper is highly reflective and can make text hard to read, the corresponding text and image sections alternate in stock between matte-coated and uncoated. This also assists navigation

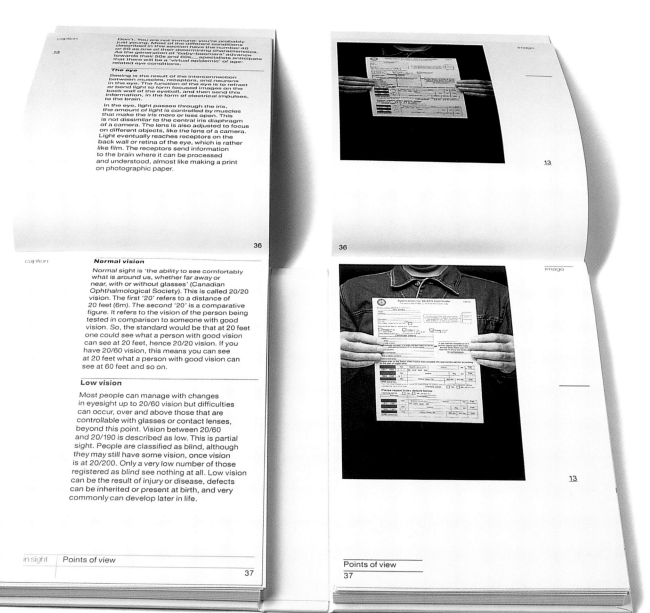

**2**/60 Organized over three floors and covering some 40,000 sq ft (3,716 sq m), the United States Holocaust Memorial Museum Permanent Exhibition was a project vast in both scale and complexity. Taking some five years to complete, the project involved the comprehensive mounting of a full research and collection program with a large team of people including 20 photo researchers, as well as numerous archivists and scholars; all organizing, cataloging, and focusing on different aspects of the story. "Typically, most historical work is done after everyone is dead so you are dealing only with historians; but when you are dealing with complex personal memories, some 30 or 40 years after an event, it is a difficult process," says Ralph Appelbaum. "The most fundamental thing was coming to terms with the nature of the story, so the first thing we did was actually experience it 'in situ' by going there." Most projects begin with what Appelbaum describes as "a 'chronological data file' that gives us an organized road map based on time for most of our structures." Out of these files they are able to weave thematic constructs that follow a more traditional narrative.

Working almost exclusively on social cultural history and natural history projects, Ralph Appelbaum Associates (RAA) require very different skills of their designers from those normally expected. "We came to realize that we needed to be highly collaborative with writers, and particularly people who understood narrative structure, as the key to understanding how to organize our content." Here, the designer only ever makes up one-third of the team, always working alongside a content coordinator, usually with an academic background, and a writer. RAA also insist that their designers are well read. "That is almost more important to us than whether they know how to draw because it's out of reading and literature that one begins to understand the narrative form." Creating "a period of discovery" before the project even begins is also vital. "We don't believe designers should dive into these large-content projects without convincing the client that

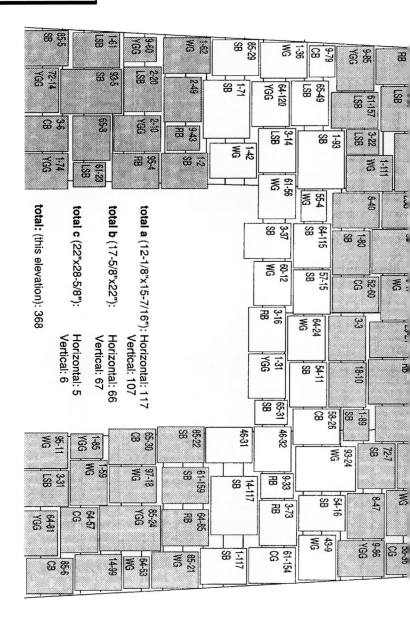

**Above** Layout plan for the wall of photographs

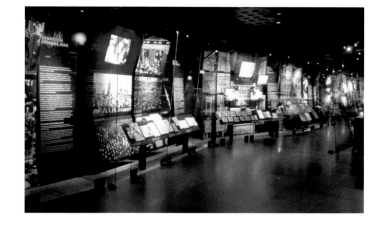

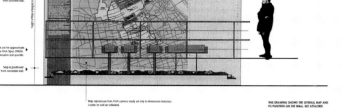

**Top left** Section of the final exhibition

**Top right** Drawing showing the overall map and its position on the wall

they have to be educated. You need to find multiple points
of entry to a single story for a variety of people who all have
different experiential requirements that need to be served.
Most design I see is busy having a dialogue with style or with the
designer's ego or personal aesthetic. What we try to do is develop
projects that only have a dialogue with information." This is
where the importance of the team's early decisions—such as not
cropping any of the photographs and neutralizing the typeface
to avoid any overt stylistic attributes—were key in helping to
contribute to the feeling of the period and place. The strategies
used to present the information were largely governed by the
treatment of photographs, films, and artifacts as 'evidence.'
Typography was used to create distinctions between the different
levels of information, important quotes from survivors and victims
are honored with raised metal type embedded in the wall, while
Hitler's words appear in two-dimensional, ordinary ink, suggesting
the ability to wipe them away.

As it often works with historical content, literature and books play
a key part in the research of most RAA projects, but it is the way
that they process that information that sets them apart. While the
information exists, much of it will not have been comprehensively
digitized before. At RAA, however, at any one point in the history
of a project they will have every component—not just the words,
but the maps, diagrams, photographs, oral histories, even the film
imagery, all digitized on one server, in one place, at one time.
A rare occurrence when working with vast amounts of historical
information, but one that certainly eases the management process,
as well as enabling the designers to work with the content from
one, centralized location. And a very different scenario from
Appelbaum's early days. "We would use multicolored cards for
the different elements and almost create our own database on a
giant working wall," he recalls. "Today we do similar things using
large portable sheets of foamcore, but we make them easy to
handle so we can meet with clients or other designers and show
them how we're thinking about the constructs."

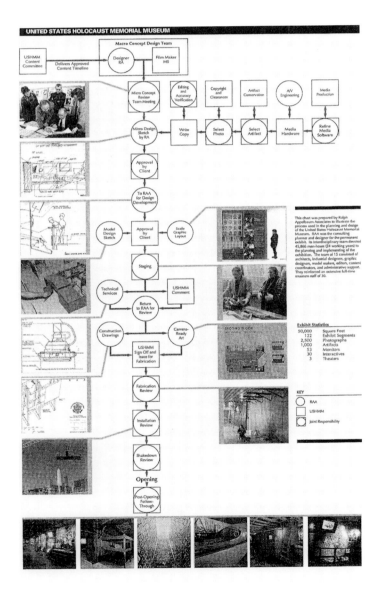

**Above** Chart prepared by RAA to illustrate the process used in the planning and design
of the United States Holocaust Memorial Museum

**Opposite** Wall of photographs: the finished exhibit

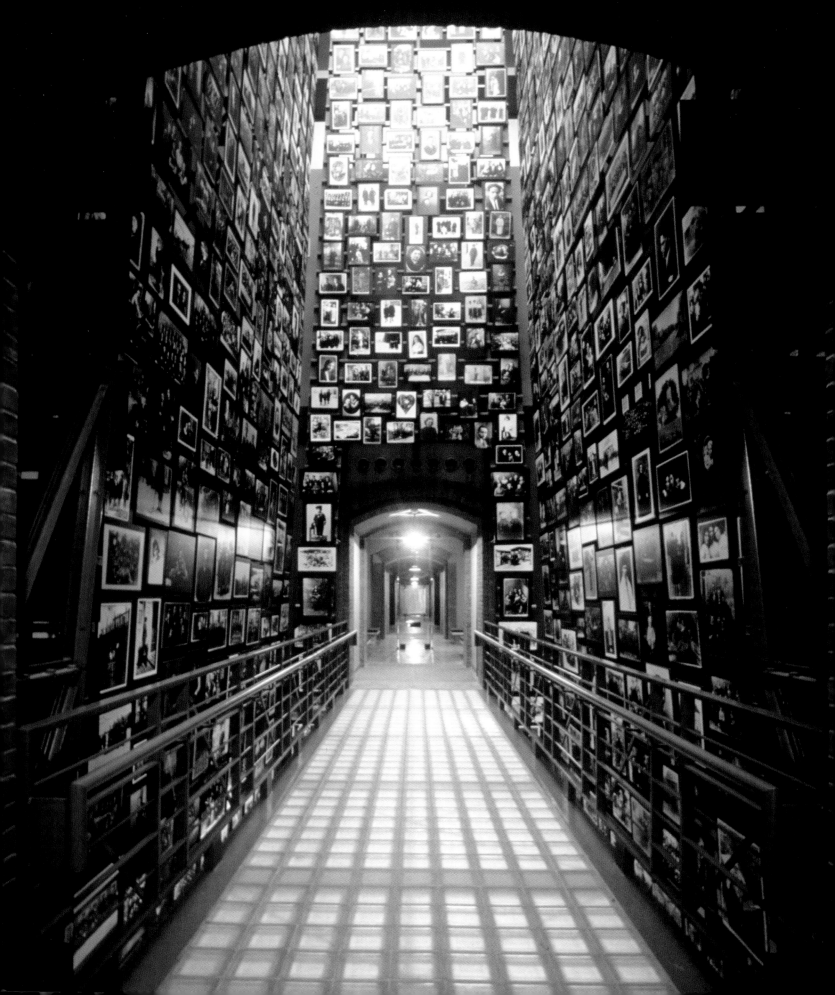

**2/64** Produced in 76 editions across the UK and Ireland and with a print run of millions, the *Yellow Pages* is almost an institution in its own right, as johnson banks discovered when they were brought in to work on the directory's redesign. The design team from johnson banks consisted of four people: Michael Johnson as creative director/designer, two account directors, and one other designer. "*Yellow Pages* are formidably complex. They have teams of people whose job is to agree category headings, other teams to discuss whether ads should be color, other teams discussing how to put postcodes into the entries; the level of detail is amazing," recalls Johnson. "First we had to meet all the teams, make friends, and gain their trust."

Working in such detail, however, meant that any amendments to the internal layout of the directory had huge consequences. "For example, our desire to create a little more space in the layout met with huge resistance because that would mean redoing all those ads (and ringing up all those plumbers!)," he continues. "Our initial work centered around two opposite poles of the spectrum; our view was that at a macro level the covers were dreadful (just a big, centered logo) and at a micro level you couldn't read them. After working on the two opposite ends we started to work on the bits in between, the grids, the internal guides, and advertising, etc. In the end our main task was the headings and getting the body copy to work. The wayfinding within the book was very poor, so we spent a lot of time trying to make the 'See also' section work better and be easier to read."

Futura Bold was retained for most of the headings, in different weights, while Yellow, the new typeface, art directed by johnson banks and designed by The Foundry, was used for the body copy. Contrary to its predecessors, the new, narrow typeface featured truncated ascenders and descenders, allowing the lines of type to be set very close together. *Yellow Pages* UK estimate that the redesigned typeface makes savings that amount to 550 short tons (500 tonnes) of paper per 75 books, or £500,000 (US$750,000). They also opted to stick with the existing three-column grid as "the consequences of change were too horrendous."

Optimum legibility was achieved by drawing the typeface specifically for use at a very small size, and to accommodate the low print quality synonymous with directories. "It means that large, the letters look strange, with huge gouges in them, but small, they stay sharp," explains Johnson. Johnson banks also introduced various graphic symbols and internal cross-category ads (fillers), making the directory easier and lighter to look at.

What did they learn? "That daunting and potentially swamping projects can actually be interesting and useful. That potentially boring projects can actually be the most rewarding; people are always impressed if you can change something as traditional as the *Yellow Pages*. It is also still one of our most 'public facing' projects, so if I'm stuck describing what graphic designers do, I say we redesigned the *Yellow Pages*."

**FARMERS 531 F**

| | | | |
|---|---|---|---|
| Banbridge | 62492 | McErlean C,42 Carnaman Rd,Knockcloghrim......Bellaghy | 386262 |
| Rd....Stoneyford | 648243 | McErlean Edw.J,49 Largy Rd......Portglenone | 821039 |
| ...Maghera | 44105 | McErlean Patrick,20 Downings Rd......Portglenone | 821744 |
| ...Dervock | 41689 | McErlean T,118 Mullaghboy Rd......Bellaghy | 386269 |
| ...Bready | 841374 | McErlean T,79 Tamlaght Rd......Rasharkin | 71364 |
| ...Stewartstown | 738614 | McEvoy J,51 Knocknagore Rd,Gilford......Banbridge | 62021 |
| ...Stewartstown | 738211 | McEvoy J,111 Kilkinamurray Rd......Katesbridge | 71403 |
| ...Dunamanagh | 398258 | McEvoy P,11 Carnalroe Rd......Ballyward | 50265 |
| ...Stewartstown | 738244 | McEvoy P.T,34 Magherahamlet Rd......Ballynahinch | 562621 |
| ...Ballyward | 50419 | McEvoy T,65 Glenloughan Rd......Kilkeel | 62031 |
| Dromore (DN) | 692334 | McFadden J,10 Drum Rd......Kells | 891412 |
| ...Ballyward | 50222 | McFadden Thomas,46 Bells Hill......Castledawson | 468655 |
| nch........Crossgar | 830582 | McFall D,25 Ballydevitt Rd......Aghadowey | 868456 |
| ...Castlederg | 71814 | McFall Maynard,6a Ballyclogh Rd,Bushmills......Dervock | 41608 |
| ...Castlederg | 71488 | McFarland A.C,35 Aghnamoyle Rd......Omagh | 242645 |
| ...Crossmaglen | 861394 | McFarland C.G,165 DOnaghanie Rd......Beragh | 58289 |
| ...Beragh | 58611 | McFarland D.J,33 Main St,Killen......Castlederg | 71351 |
| ...Aghalee | 651274 | McFarland E,71 Deerpark Rd......Newtownstewart | 61537 |
| ...Hillsborough | 682204 | McFarland Fleming,102 Castletown Rd......Newtownstewart | 61441 |
| ...Lurgan | 323020 | McFarland J,Corrick Lodge Corrickbeg Rd......Newtownstewart | 61292 |
| ...Strabane | 382274 | McFarland J.C,21 Killymore Rd......Newtownstewart | 61432 |
| ...Drumquin | 831352 | McFarland J.D,73 Tirbracken Rd,Drumahoe......Cross | 301212 |
| Newtownstewart | 61541 | McFarland Jim,Drumnastrade Dunseark Rd......Dungannon | 724200 |
| ...Ballinaskeagh | 51205 | McFarland John H,22 Annagh Rd......Clogher | 48277 |
| s........Carrickmore | 61326 | McFarland L,102 Beltany Rd,Castletown,Mountjoy......Omagh | 243238 |
| ...Ballymena | 652887 | McFarland T.A,48 Tattynure Rd......Newtownstewart | 61298 |
| ...Drumbo | 826307 | McFarland W,39 Mullantoomog Rd,Drumquin......Omagh | 245307 |
| ...Cookstown | 62680 | McFarland W.F,Benchran,69 Deroar Rd......Beragh | 58315 |
| ...Gortin | 48538 | McFarland W.R, | |
| ...Brookeborough | 31227 | Drumhorrick House,73 Drumaspil Rd......Dungannon | 723178 |
| ...Draperstown | 28088 | McFarland W.T,62 Drumduff Rd,Beragh Sixmilecross......Beragh | 58316 |
| ...Feeny | 81310 | McFarlane A.J,22 Gortnagross Rd......Dungiven | 41536 |
| ...Gortin | 48385 | McFarlane F,60 Ballygrainey Rd......Holywood | 428443 |
| ...Swatragh | 401264 | McFarlane G,88 Davagh Rd,Mountfield......Tulnacross | 51559 |
| iore........Millisle | 861208 | McFarlane I,58 Ballygrainey Rd......Holywood | 423759 |
| ...Moneymore | 48002 | McFarlane W.L,45 Ardmore Rd......Crumlin | 422321 |
| ...Newtownards | 812051 | McFaul D.L,141 Drumcroone Rd,Blackhill......Aghadowey | 868295 |
| ...Ballyclare | 352033 | McFerran A.G,29 Inishargy Rd......Kircubbin | 38369 |
| ...Crumlin | 422332 | McFerran J.C,48 Aghill Rd......Rasharkin | 71235 |
| ...Glarryford | 685567 | McFerran Roy,90 Bowtown Rd......Newtownards | 812271 |
| ...Glarryford | 685278 | McFetridge J,106 Drumcrow Rd......Glenarm | 841552 |
| ...Greyabbey | 88295 | McFetridge L,52 Garvaghy Rd......Portglenone | 821024 |
| ...Glenarm | 841273 | McFetridge W.H,140 Carrowreagh Rd,Garvagh......Kilrea | 40548 |
| ...Dromara | 532662 | McGaffin John H,15 Lairds Rd,Ballyward......Katesbridge | 71277 |
| ...Glarryford | 685295 | McGahie J,77 Ballymaguire Rd,Stewartstown......Coagh | 37362 |
| ...Gortin | 48528 | McGarel J.J,70 Drumnagreagh Rd......Ballygally | 583532 |
| ...Maze | 621414 | McGarrigle H.K,Site Off Laurel Drive......Strabane | 382344 |
| ...Broughshane | 861643 | McGarry D.G,61 Tober Rd,Ballymoney......Loughgiel | 41338 |
| ...Broughshane | 861327 | McGarry J,94 Moyan Rd,Dunloy......Loughgiel | 41361 |
| in..Aghadowey | 868344 | McGarry John,29 Foy Lane......Portadown | 353116 |

Saving space: the old compared with the new typeface

Internal, cross-category ads introduced by johnson banks
to make the directory easier and lighter to look at

Yellow Regular

# ABCDEFGHIJKLMNOPQRSTUVWXYZ
## abcdefghijklmnopqrstuvwxyz
## 0123456789!?,"£$&%@*

Yellow Bold

# ABCDEFGHIJKLMNOPQRSTUVWXYZ
## abcdefghijklmnopqrstuvwxyz
## 0123456789!?,"£$&%@*

The brief: design a new typeface for the Yellow Pages
Directory which allows more characters per line,
is cleaner and more readable at very small sizes and
can be used with negative leading.

Ascenders
75% of
normal height

Bottom of counter
amended to allow
for ink fill

Condensed basic form

# abcdefg

Junctions chiselled
away to allow for
fill in at very small
type sizes

Bottom stroke
thinned to allow
for ink spread

Descenders
75% of
normal height

**Above** *Yellow Pages* font design: the typeface was developed to be set at a narrow width and with negative leading

**2**/66

The creative team at *The Wall Street Journal* partnered with international information design firm Garcia Media to create a new look for the publication, which was launched in April 2002. The Garcia Media team was headed by Mario Garcia, and *The Wall Street Journal* team was headed by Joanne Lipman, Managing Editor, and Joe Dizney, Design Director.

The main design goals were to make the paper easier to navigate and faster to read, while securely preserving the past so that an avid reader would still recognize the newspaper. Key changes to the journal, which was last redesigned in 1962, included the introduction of color to the front page of each section, more color pages throughout the paper, increased graphics, and the introduction of various new columns and features. A new section, "Personal Journal," was also introduced. "The process actually began when I was invited, in 1999, to redesign the international editions of *The Wall Street Journal* in Europe and Asia," states Mario Garcia, President and Senior Designer of Garcia Media. "That work was completed successfully in 2000, when the newspaper introduced color and photography to those editions."

The new edition of the US *Wall Street Journal* features better navigation with developed story structures to facilitate hierarchy through the pages, designed to help the reader move from story to story. Page architecture also changed slightly, and an elegant color palette was integrated into the design.

The redesign also saw the introduction of the HTF Retina typeface, created specially for the journal. Designed by Tobias Frere-Jones, a specialist in newspaper typography, Retina is a family of newspaper types specifically engineered to succeed in small sizes—much needed when dealing with the financial and stock listings in the "Money & Investing" section. "They're the most complex and specialized part of a newspaper, with their own specific restrictions," says Frere-Jones of the stock listings.

"Entire lines have to be set in boldface for emphasis, though the page grid never allows for extra space." Retina accommodates this practice by keeping all 10 of its weights on a common set of widths, one of many techniques employed by Frere-Jones to address the journal's specific requirements.

"With the new design, you can see a marriage of the decades, the preservation of that which is genuinely and uniquely *Wall Street Journal*, with new elements that no doubt will become part of its identity for future readers," says Mario Garcia.

**Top** Use of the HTF Retina typeface ensured financial listings were clear and easy to read

## MANAGING YOUR CAREER
### By JoAnn S. Lublin

### Employees Abandon Struggling Professions For More Fertile Fields

A FREE-LANCE PHOTOGRAPHER no longer makes a good living telling stories through pictures. A podiatrist wishes he were a high-school biology teacher, enjoying regular hours and guaranteed benefits. A stock research analyst worries that a conflict-of-interest scandal engulfing his profession could hurt his employability elsewhere.

Professionals from many walks of life find themselves in turmoil these days, buffeted by diminished pay, increased regulation, lessened prestige—or all three.

Feeling you no longer can do what you've long done is a classic midlife crisis, says Dory Hollander, president of WiseWorkplaces, an executive-coaching firm in Arlington, Va. "But it can be accelerated by the field taking a turn for the worse."

At what point should you abandon your vocation? How can you find the resources to learn something new?

"It's much harder to reinvent myself and enter a completely different profession at this point in my life," says Paula Lerner, the struggling photographer. "And I'd still have to start at the bottom."

From 1985 to 2000, the 43-year-old Boston resident largely took pictures for magazines. She devoted 30% of her time to commercial assignments, such as executive portraits.

SINCE THEN, PURSUING her passion for her brand of photographic storytelling "has become all but unworkable," Ms. Lerner laments. Adjusted for inflation, magazines typically pay free-lance photographers roughly 35% less than 18 years ago.

Ms. Lerner earns half of what she did three years ago, despite aggressive efforts to supplement her scarce magazine assignments with additional commercial projects. She craves more work "that will feed my soul," she says.

Career specialists urge besieged professionals to undergo a scrupulous self-assessment, pinpointing their favorite and most transferable talents. "Don't think of yourself as an accountant. Think of yourself as someone with strong financial-management skills who, say, understands the hospitality industry," advises Barbara Moses, president of BBM Human Resource Consultants in Toronto and author of several career self-management books.

This identity-dissection process helps some individuals plot an escape. Gynecologist David Holt treated patients holistically, but "wasn't being reimbursed for my time," he says. "I could not afford to practice anymore."

Aided by a career coach, Dr. Holt sold his practice in June 2002 and began exploring alternatives. A self-assessment confirmed he was "very good at human relations," says the Anderson, S.C., physician, who is 70. "I figured I should go into a business where I hit on [people's] problems."

Dr. Holt aims to become a personal coach—once he amasses the needed money for training and certification. Switching professions "is not an easy transition," he admits. He doesn't see his age as a big issue, except that it encourages him to speed up the transition.

The most difficult aspect of such a change is the typical drop in income. A veteran Midwest stockbroker despaired when the protracted market downturn destroyed his close ties with clients. "No matter what you did to do a good job, it was beyond your control. It was very frustrating because it was your life's work," he remembers. Yet he feared making even less by changing careers.

His coach, Dr. Hollander, suggested he was selling the wrong product. And he realized he hated being in an office all day.

The stockbroker talked to more than 400 people about sales positions in various industries. The upshot? He has lined up a job as a division president of a local construction firm that intends to build athletic surfaces. He will take only a small pay cut.

A LESS-DRAMATIC career shift makes sense for many midcareer professionals. Dr. Moses says she often sees people embrace a related "shadow" profession where "they don't need to learn a new trick; they already own the trick."

An Atlanta chiropractor initially took that route. He abandoned his practice several years ago because insurers often ignored his expertise and his field lacked social acceptance.

Today, he mainly teaches neurology continuing-education courses to chiropractors. But the amateur electric-guitar player is mulling over a more radical move: turning his pastime into a livelihood, perhaps as a bar owner who performs, too.

The hobby-to-job strategy paid off for Douglas E. Lee. The systems-analyst programmer from Clemmons, N.C., discovered demand for his profession had virtually evaporated after he got laid off in October 2001. However, he had always been handy with his hands. As a teenager, he finished off his parents' basement to have a nice place for his parties. He later built a deck and remodeled his own home.

Mr. Lee, 53 years old, now runs a business that renovates log cabins, vacation homes and decks. As a sideline, he offers Internet marketing services. If you're a professional in turmoil, he recommends, "find out what you're good at—and get someone to pay you to do it."

*E-mail comments to me at joann.lublin@wsj.com. To see other recent Managing Your Career columns, please go to CareerJournal.com.*

---

# Tracking West Nile Virus

**Blood samples** *drawn by Alexandra Porshnikoff will be tested for mosquito-borne diseases that could affect humans.*

### Two Technologies Vie to Win New Market After Government Orders Blood Supply Screened

#### By Marilyn Chase And David P. Hamilton

THE THREAT from mosquitoes carrying West Nile virus is spurring competition over a new blood-screening market valued at up to $70 million a year.

This summer, U.S. and Canadian blood banks and screening labs have begun testing two competing technologies that check donated blood for West Nile's genetic signature. Developed in record time, the new tests—from Swiss pharmaceutical company Roche Holding AG and a partnership of two California biotech companies, Chiron Corp. and Gen-Probe Inc.—were rushed into action on an experimental basis after U.S. health officials mandated that the nation's blood supply should start being screened for the virus by July 1.

Fueling the rush was the discovery that West Nile—which killed 284 people in the U.S. last year—can be transmitted by organ transplants and blood donations. Only about 20% of the people infected with West Nile get symptoms, usually a mild flu-like illness with a headache, fever and muscle aches. And only one in 150 infected people develops the most dangerous form of West Nile disease, a potentially fatal inflammation of the brain or its casing. But in 2002, at least 23 people in the U.S. are known to have contracted West Nile from tainted blood, and four others got it from organ transplants. So far, with 69 human cases of West Nile virus and three deaths tied to the virus this year, this season is strikingly parallel to last year's. But the widening circle of affected states means that the 2003 season could be worse than 2002's, say experts at the Centers for Disease Control and Prevention. Neither of the West Nile tests has been approved by the Food and Drug Administration, since both are still in clinical trials. But the tests have probably spared scores of people from tainted infusions, blood-bank officials say. And the battle for market share is happening now, as the testing competitors urgently woo blood centers to participate in their trials. The theory is that once a company's test is installed at a blood center for the trial, the center is likely to keep using it.

The stakes are especially high for Roche: The Swiss pharmaceutical company is using the clinical trial to introduce a new generation of testing equipment that is potentially valued at $200 million world-wide. "This is a huge global opportunity," says Richard Thayer, Roche's vice president for blood screening. "This is the beginning of our next-generation rollout."

For now, Roche is the underdog. Although the Swiss company is a powerhouse in diagnostic testing world-wide, Chiron dominates the U.S. market for gene-based blood screening and claims to handle 80% of all blood units screened for HIV and hepatitis C. Both companies use versions of "nucleic-acid" viral testing, which amplifies genetic signs of the virus so that it can be detected and identified.

Eager to spotlight its test's success, Roche issued an unusual press release in early July to tout its first "hit," or confirmed detection of the West
*Please Turn to Page B4, Column 4*

### Taking a Toll
The West Nile virus season is just getting started, but CDC experts say it could be worse than last year.

| YEAR | CASES | DEATHS |
|------|-------|--------|
| 1999 | 62 | 7 |
| 2000 | 21 | 2 |
| 2001 | 66 | 9 |
| 2002 | 4,156 | 284 |
| 2003* | 69 | 3 |

*As of August 1*   Sources: Centers for Disease Control

---

### Chicken Flocks Set to Signal Virus's Arrival

#### By Marilyn Chase

*San Bruno, Calif.*
BRAVING A BURST of clucks and beating wings, a woman in a white Tyvek jumpsuit grabs a red-brown hen by the feet and holds it upside down until the flapping stops. Then she flips the bird over, tucks it between her knees, and pricks the hen's comb with a tiny lancet, dabbing drops of blood onto a strip of filter paper to be tested for West Nile virus.

So begins the workday of Alexandra "Sasha" Porshnikoff, a disease ecologist with the San Mateo County mosquito abatement district. Her task is "sentinel chicken surveillance" for West Nile virus. Fulfilling a role similar to that of canaries in coal mines, the chickens, crosses between Rhode Island Reds and white Leghorn fowl, live in open coops, where they can be bitten by mosquitoes, and, potentially, develop antibodies to the virus, which would signal West Nile's arrival here.

Except for a time, mysterious human case near the Los Angeles airport—probably the result of a stowaway mosquito aboard a plane—California so far has been West Nile-free. But the disease already has spread across 38 states from the East Coast, where it was identified four years ago, and California's escape from it isn't likely to last much longer.

"Sentinel chickens are a natural way to monitor what's going on in nature," says Lyle Petersen, acting director of vectorborne infectious diseases for the U.S. Centers for Disease Control and Prevention. Such flocks are on
*Please Turn to Page B4, Column 4*

---

*Please Turn to Page B4, Column 4*

## Grads Seeking Public Service Find Few Jobs

### By Juliet Chung

SHAN PATEL graduated with high honors from Harvard University in June. But that wasn't enough to get him a position with Teach for America or the New York City Urban Fellows Program, two public-service programs.

"I made the mistake of thinking that because I want to do something that's public service-oriented, which ... I thought was somewhat noble, it wouldn't be so competitive," says Mr. Patel, a Bedford, Mass., native who taught English to Somali refugees as a high-school volunteer outside Boston. "I thought I could pick and choose, but it didn't really pan out that way."

Neither prior experience nor an Ivy League pedigree, it turns out, is any guarantee of success in the heated-up competition for slots in the public-service sector. Applications for such positions are soaring, while budgetary problems at AmeriCorps, the federal umbrella organization that runs and finances national and community service, are taking their toll on the number of positions available.

Not long ago, politicians and university presidents were bemoaning the lack of interest in public-service work by college graduates, many of whom were being lured by high-paying jobs in the private sector or had too much college debt to take up a low-paying career dedicated to the common good. But all that has changed drastically, partly attributed to altruism engendered by the 2001 terrorism attacks but, even more significantly, to one of the worst jobs markets for college graduates in years. Over the past two or three years, the number of employers participating in campus job fairs has dropped by 30% to 40%, with fewer positions being offered by those who still come.

At Teach for America, a much-lauded program
*Please Turn to Page B6, Column 1*

*Please Turn to Page B6, Column 1*

**CAREER JOURNAL**

### Slim Chances
Employment in public-service sector jobs from the 2003 application cycle:

| Applicants | Slots |
|---|---|

**City Year***   2,468
490

**Jesuit Volunteer Corps**   790
433

**Alliance for Catholic Education**   421
435

*Stopped accepting applications early because of funding cuts  Source: the programs

---

## End of Warning Isn't Spurring Big Olestra Push

### By Sarah Ellison

For the purveyors of olestra, is it too little too late?

After Friday's decision by the U.S. Food and Drug Administration to remove the warning label from olestra-laden snacks, the much-maligned "fake fat" should be poised to make a comeback. But executives at Procter & Gamble Co. and PepsiCo Inc.'s Frito-Lay division say that even though they are delighted that seven years of stigma have been stripped off their products, the ruling doesn't necessarily guarantee a new lease on life.

This ought to be the perfect time to peddle a nonfat fat substitute. Health concerns about obesity are rising, and food companies are increasingly looking for new ingredients to help them make low-fat or fat-free foods that taste good. According to the U.S. Surgeon General, more than 60% of American adults are obese or overweight, and a growing incidence of Type 2 diabetes in children has been linked to obesity.

But P&G has been burned before, and it's careful to play down olestra's growth potential.

The ingredient was filled with promise when it was first introduced after $500 million and 25 years in development. Then, after its approval in 1996, it began to be associated with digestive problems. More than 20,000 people have complained to the FDA about diarrhea and cramping since olestra started appearing in products like P&G's fat-free Pringles chips, Frito-Lay's WOW! snacks and Utz Quality Foods Inc.'s Yes! chips.

After the much-ballyhooed launch of the product, which P&G branded "Olean" and which was
*Please Turn to Page B8, Column 5*

*Please Turn to Page B8, Column 5*

### INSIDE

**Career Journal**

### Ditch the Stuffed Buffalo And the Sandals
The grim hiring market hasn't stopped silly missteps by job candidates. B6

**Advertising**

### Adidas Signs Garnett
The basketball star agreed to a $45 million "lifetime" contract. B4

Classifieds ...................................B4,6,7

---

# NBC Casts Vegas Casino in a Starring Role

### By Christina Binkley And Emily Nelson

*Las Vegas*
GET READY to meet NBC's newest television star: the Mandalay Bay casino.

When NBC airs its fall television lineup, Monday-night viewers will quickly become familiar with the casino's shimmering gold towers and sumptuous high-roller suites. On Sept. 29, they will see Mandalay Bay playing itself in the "Fear Factor" gross-out reality show. Later that night, and each week thereafter, Mandalay will take on the fictional role of the Montecito Resort & Casino in "Las Vegas"—one of NBC's top drama prospects this fall—alongside the show's other star, James Caan.

All this attention is the fruit of an unusually close partnership between NBC, owned by General Electric Co., and Mandalay Resort Group, which owns Mandalay Bay as well as the Luxor pyramid casino, the Excalibur and others. The relationship is so close that Mandalay Resort Group President Glenn Schaeffer gets a cameo in "Las Vegas." He plays the casino's fictional owner, artfully named ... Glenn Schaeffer. "I show up in foreboding moments and look pretty grim," he says.

In a deal that has spawned plenty of favor-trading but no cash payments, NBC gets to film free of charge the Mandalay's gambling halls and other rooms, in a city that makes ratings soar. "Fear Factor," known for its gross-out stunts, is particularly popular with young male viewers, as is Vegas. "Vegas has a sexiness that appeals to our demographic," says Matt Kunitz, the show's executive producer. The "Fear Factor" crew and contestants received more than 820 room nights at Mandalay, Luxor and the Monte Carlo resorts, and 2,100 free meals, which Mr. Kunitz valued at about $400,000. "We couldn't travel the show without that support," Mr. Kunitz says, referring to the on-location shooting. The budget for a typical episode, filmed in Southern California, is about $1 million.

In turn, Mandalay gets a giant product placement built into the shows that can't be zapped by viewers' remotes or by recording devices such as TiVo, which is a hot issue in advertising these days. "It's a great infomercial," says Mr. Schaeffer. The casino's Las Vegas-based ad agency, R&R Partners, estimates the one-hour "Fear Factor" is worth more than $10 million in paid advertising.

It all started because NBC Entertainment President Jeff Zucker noticed in his previous job as producer of the "Today" show that ratings jumped whenever "Today" covered Vegas. So NBC approached Gary Scott Thompson, who wrote the stylized movie "The Fast and The Furious," to create a series based in that city.

The result is "Las Vegas," which follows the security team in the fictional Montecito. Mr. Caan is the security chief, and the show is narrated by a character named Danny, who works for him. They track gambling cheats, chase high rollers and flirt with prostitutes at the bar. The pilot cost about $3.3 million and each additional episode is expected to run about $2 million per episode, pricey for a first-year drama.

Mandalay doesn't have script-approval rights, so it can't control the plot. But one of the reasons the producers chose a fictional casino name was to avoid any spillover for the real casino from plots that might cast a negative image.

In typical Hollywood fashion, the deals came about because certain people knew certain people. When the producers of "Fear Factor" sought to shoot in a casino last year, nearly every casino in town turned them down, including Mandalay Bay. "I thought, 'Eating bugs, hanging from the chan-
*Please Turn to Page B4, Column 5*

*Marsha Thomason, Josh Duhamel and Nikki Cox in NBC's drama 'Las Vegas,' coming this fall.*

*Please Turn to Page B4, Column 5*

# MONEY & INVESTING

## THE WALL STREET JOURNAL.

TUESDAY, AUGUST 12, 2003 C1

## Ahead Of the Tape

*—Today's Market Forecast—*

By Jesse Eisinger

**Misunderstood**

■ Thirty-one "sell side" analysts at brokerage firms will scramble to their keyboards when earnings today. Yet Thomson First Call lists only 11 analysts who track General Electric, which, as the biggest company by market cap, has a value roughly 100 times that of Abercrombie.

When it comes to the biggest, most complex companies in America, Wall Street's attentions are focused elsewhere. Tech, telecom, retail and biotech dominate the ranks of the overcovered. Goldman Sachs Group picked up coverage of Abercrombie last week. Talk about adding value.

The reason is obvious: That's where the Wall Street money is—the trading, the volatility, the stock-offerings. But companies that touch the most lives and move the economy often go begging. Knock sell-side research all you want; it deserves it. Is the remedy less coverage?

Of the top 25 companies in market cap, five rank among the top 25 most covered by analysts, according to Reuters Research. Of the 25 most covered, 21 are in tech, telecom or cable, an obvious vestige of the bubble.

Analysts on the most covered companies are more likely to estimate revenue. Thirty-three of 34 analysts covering the $4 billion market cap Check Point Software Technologies (18th most covered) come up with revenue estimates. Meanwhile, American International Group, with a market cap of $142 billion (seventh largest), has one lonely analyst of 24 who publicly estimates revenue. How do analysts put out earnings-per-share estimates without revenue estimates? Your friendly neighborhood investor-relations department.

Part of the problem rests with investors, particularly hedge funds. As companies get bigger and more stable, investors lose interest and they lose coverage. Investors tend to be attracted to fast-growing companies or those with frequent trading opportunities, such as monthly retail-sales figures. Hedge funds often shy away from the biggest companies because of the perception the stocks move with the market and are impossible to understand financially.

Ideologues contend that markets settle on the right price for a stock. But it's not a coincidence that some of the biggest blowups, like Enron and Tyco International, have been hard to cover. If knowing the right price for a stock requires actually following it, then start worrying.

*Are the biggest companies well understood? Send comments to tape@wsj.com and check Mondays for some letters at WSJ.com/Tape*

### —Inside—

■ **World Stock Markets:** The Bombay market has been soaring, but now an insider-trading case could deter foreign buyers.
(Article on page C14.)

■ **Mutual Funds:** Massachusetts filed its complaint in the case alleging Morgan Stanley pushed its in-house products.
(Fund Track, page D7.)

## How 'Worst' Bond Fund Did It

By Karen Damato

WHILE MANY INVESTORS got hit by the bond market's recent selloff, a small bond-focused mutual fund that uses complex derivatives strategies took a particularly rough beating.

FBR Total Return Bond Fund returned a negative 19.08% in the month of July, the worst performance among more than 3,900 bond funds tracked by Lipper Inc. The fund bounced back to a peer-beating 8.40% gain in the first week of August, but its negative 15.55% return so far this year, through Friday, still ranks as the worst bond-fund performance of 2003. Yesterday, the fund was down a further 2.42%.

Investment professionals have speculated that other bond portfolios, possibly including some hedge funds, may have been bloodied in the bond-market tumble, but so far no significant examples have emerged. As interest rates surged and bond prices fell, the month of July saw taxable-bond mutual funds post their worst monthly loss in 16 years, since April 1987, Lipper said. However, the negative 2.50% monthly return on the average taxable-bond fund pales in comparison with the FBR fund's results. The average taxable bond fund is up 3.46% so far this year, through Friday.

Patrice Milton-Blue, co-manager of the $29 mil-

### Bond Blues

An investment of $10,000 in FBR Total Return Bond Fund at the end of last year would have lost far more than one in the average fund holding long-term government bonds.

Note: Data are through Friday, Aug. 8.
Source: Morningstar

lion FBR fund, says the fund's recent decline wasn't a complete surprise given the portfolio's investment strategy, which combines holdings of U.S. government bonds with transactions in fixed-income options and futures. In time periods when the bond market is particularly volatile, which it has been in spades these past several weeks, the portfolio "is going to be significantly more volatile than the market itself," Ms. Milton-Blue says.

Still, some investors in the FBR fund might have been caught unawares by the fund's recent beating. The fund's prospectus says the manager uses options and futures in an effort to boost return or "to protect the fund from adverse interest-rate movements." That also was the way the use of those derivatives instruments was pitched to fund investors in late 2001, when the fund's adviser sought and obtained shareholder approval to modify the fund's strategy to include use of options and futures.

FBR Total Return is overseen by a unit of Friedman, Billings, Ramsey Group Inc., a securities firm based in Arlington, Va. But FBR, which took over management of the fund two years ago, doesn't actually select securities for the portfolio. Rather, effective January 2002, FBR hired the Los Angeles asset-management firm of Bradford & Marzec Inc., Ms. Milton-Blue's employer, to serve as the day-to-day portfolio manager.

At FBR, Webb C. Hayes Sr., president of the firm's Money Management Advisors unit, said in a statement that "there are risks in the fund's use of futures and options, that are fully disclosed to investors in the prospectus." Asked whether FBR has concerns about the performance of the subadvisory firm, Mr. Hayes says, "short-term and long-term performance of the subadviser is under continual review."

*Please Turn to Page C13, Column 1*

## Some Homebuilders Face Shaky Foundations

*Companies Are Spending Cash On Their Own Inflated Shares, As Housing Sector Begins to Cool*

By Queena Sook Kim

### HEARD ON THE STREET

HOMEBUILDERS KB Home and Ryland Group Inc. are squandering their cash on their own pricey stocks, rather than snapping up attractive land deals or saving it for a rainy day, some investors and analysts say.

Builders' stocks as a group are up 35%, so far this year. Meanwhile, the torrid pace of new-home sales is threatened by rising mortgage-interest rates, and escalating land prices, a lagging indicator of the new-home market, could squeeze profit margins in some markets. Bearish investors see all this adding up to tougher times ahead.

"Cash is king when times get bad," says Barbara Allen, an analyst at Natexis Bleichroeder, a brokerage and trading company for institutional clients, in New York. "I've seen so many companies in cyclical industries buy stocks when prices were high only to regret it a year later."

### Plus

*When your home mortgage's 'rate look' doesn't hold. Article on page D1*

She says builders should reduce debt and conserve money now that interest rates are rising and new-home sales could fall from record highs. She has been advising clients to lighten up their holdings of home-building stocks on the belief their valuations are set to contract sharply in coming months.

"I'm very skeptical when people rationalize buying these stocks at peak historic multiples in the face of substantial increases in the interest rate," adds Marco Battaglia, a portfolio manager at Thales Fund Management LLC. The New York investment firm, which both owns shares and sells them "short"—betting on price declines—has

*Please Turn to Page C3, Column 1*

### Stock Add-ons for Home Builders

Building-company stocks have risen as mortgage rates have fallen, but harder times could lie ahead as interest rates begin to rise. Below, daily closing share price for three large building companies.

KB Home — June 24: Interest rates hit a low
Ryland Group
Lennar A shares

Source: Thomson Datastream

## Merrill Faces Troubles Linked To Ex-Trader

*Canada Investigates if Employee Of Firm's Former Energy Unit Embezzled About $43 Million*

By Randall Smith

MERRILL LYNCH & CO., whose energy transactions ensnared the big securities firm in the Enron Corp. scandal, now faces a potential new black eye from its former energy trading unit.

Prosecutors in the U.S. and Canada are investigating whether a former Merrill Lynch energy trader embezzled about $43 million in 2000, according to court documents and a Canadian government official. The criminal investigation is examining whether the former trader, Daniel Gordon, and two other entities committed theft, fraud and money laundering, according to a spokesman for the Attorney General's office in Alberta.

Merrill sold the energy unit in 2001 to Allegheny Energy Inc. for $490 million plus a 2% stake, then valued at $115 million, in Allegheny's unregulated trading and marketing subsidiary. In a legal battle that broke out last year in a New York federal court after Merrill tried to collect the $115 million, Allegheny claimed Merrill inflated the value of the unit through a series of "wash trades"—or quick purchases and sales of securities—with Enron.

A lawyer for Mr. Gordon didn't return calls for comment. A spokesman for Merrill said in a statement, "If the allegations are true, then Merrill Lynch was victimized by this individual. We are working with law enforcement authorities who are investigating this former employee's activities. We've taken steps to strengthen our controls as a result of our review of this matter." The court case between Allegheny and Merrill is pending.

Merrill agreed earlier this year to pay $80 million to settle charges by the Securities and Exchange Commission that Merrill helped Enron pad its profits artificially with two fraudulent transactions at the end of 1999. Merrill agreed to the pact without admitting or denying the allegations. The SEC also brought related charges against four former senior Merrill executives, who are contesting them.

The current probe relates to what appeared to be an insurance contract Mr. Gordon purchased in 2000 for Merrill's Falcon Energy Holdings SA for $45 million, according to a memo prepared last November by an assistant to Manhattan U.S. Attorney James Comey. The memo noted that while Mr. Gordon portrayed the contract as being with a unit of French energy concern Elf Aquitaine, which became part of Total SA, "there is evidence (that it was) an offshore shell corporation" he used to pocket some proceeds of the contract.

The case is being pursued by Canadian authorities including the Royal Canadian Mounted Police because Mr. Gordon may have used Newport Pacific Financial Group SA, an Edmonton company, to establish offshore entities including Falcon which got the $45 million, according to an Allegheny court filing. The spokesman for the Alberta Attorney General, Jason Chance, said that the Royal Canadian Mounted Police is investigating Mr. Gordon, Newport and its chief executive, Michael Ritter, for possible money laundering.

A lawyer for Newport and Mr. Ritter said they "did nothing wrong at all." When Newport and Mr. Ritter became suspicious, they contacted Allegheny, according to the lawyer, Hersh Wolch of Calgary. As far as Newport was concerned, it was

*Please Turn to Page C11, Column 1*

## Stocks Rise, Bond Prices Fall Ahead of Fed Rate Meeting

By E.S. Browning

STOCKS SCORED mild gains ahead of today's Federal Reserve interest-rate meeting, but bond prices again fell sharply amid fears that, even if the Fed does nothing now, interest rates have nowhere to go but up.

New York Stock Exchange trading was the lightest of any full trading day this year, barely exceeding one billion shares.

After gyrating during the day, the Dow Jones Industrial Average finished up 26.26 points, or 0.29%, at 9217.35. The index has risen 11% since the year began.

"We expect the Fed to raise rates sooner and faster than current market expectations, responding to stronger growth and to the waning of deflation concerns," said Bob Doll, president of Merrill Lynch Investment Managers, a Merrill money-management arm, in a report to clients. That trend of recovering economic growth, he said, would be good for stocks and bad for Treasury-bond prices.

Almost no one expects the Fed to change its rate targets soon, but the fear that it will raise rates once the economy strengthens helped knock bonds down. The benchmark 10-year Treasury note fell 19/32, or $5.9375 for each $1,000 invested. The yield, which moves inversely to price, rose to 4.367%.

Just two months ago, the 10-year note's yield had fallen almost to 3% amid fears of recession and deflation. Signs of economic recovery, albeit mild, stifled those fears and sent bond prices plummeting—and yields soaring—as investors pulled back from bonds, cashing in profits.

When the Fed announces its interest-rate decision this afternoon in Washington, investors will be watching mainly to see what Chairman Alan Greenspan and fellow Fed policy makers have to say about the economic outlook.

Stock investors want to hear that the economy is improving, but bond investors want to hear that interest rates will remain low. It is hard to achieve both at once, because interest rates tend to rise when the economy rebounds. That helps explain why bond investors, for whom interest rates are the central concern, are more worried about the Fed meeting than are stock investors.

At the same time, investors remain unsure whether corporate profits will meet hopes for a second-half rebound. Because of those doubts, together with the normal August doldrums, volume on the NYSE reached only 1.02 billion shares, lighter than any day this year except July 3,

*Please Turn to Page C13, Column 5*

### The Fed on Tap

The Dow Jones Industrial Average, and the Fed's rate announcements so far this year.

Jan. 28–29: Rates unchanged
March 18: Rates unchanged
May 6: Rates unchanged
June 26: Cut rates by ¼ point

Source: WSJ Market Data Group

## Markets Diary / Trading for Monday, August 11, 2003

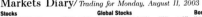

### Stocks
Dow Jones Industrial Average 9217.35 ▲ +26.26

| INDEX | CLOSE | NET CHG | 12-MONTH % CHG | YTD % CHG |
|---|---|---|---|---|
| DJIA | 9217.35 | +26.26 | +9.7% | +10.50 |
| Nasdaq Comp. | 1661.51 | +7.24 | +37.14 | +24.41 |
| S&P 500 | 980.59 | +1.00 | +9.31 | +11.45 |
| Russell 2000 | 459.27 | +5.33 | +1.17 | +10.38 |

### Global Stocks
DJ World Stock Index (excluding U.S.) 117.86 ▲ +1.39

| INDEX | CLOSE | NET CHG | 12-MONTH % CHG | YTD % CHG |
|---|---|---|---|---|
| DJ World (ex. U.S.) | 117.86 | +1.39 | +7.60 | +12.75 |
| Nikkei 225 | 9407.80 | +160.27 | +1.72 | +17.41 |
| DJ Euro STOXX 50 | 2476.06 | +18.92 | +0.77 | +7.18 |
| MSCI EAFE | 1048.55 | +7.15 | +0.68 | +9.06 |

### Bonds & Interest
10-Year Treasury Note Yield (4 p.m. ET) ▼ −19/32 4.367%

| | MON YIELD | MON PRICE CHG | YTD YLD CHG |
|---|---|---|---|
| *10-Year Treasury note* | 4.367 | 99.06 | −0.62 |
| 3-month Treasury bill | 0.93 | 0.93 | −0.01 |
| DJ Corporate Bond Index | 167.28 | 5.04 | −0.77 |
| Lehman Brothers MBS | 1052.29 | 5.24 | 1067.01 |

### U.S. Dollar
Percentage change since August 12, 2002

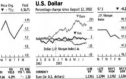

| CURRENCY | LATE NY MON | LATE NY FRI | DAYS % CHG |
|---|---|---|---|
| Euro (in U.S. dollars) | 1.1361 | 1.1304 | +0.50 |
| Japanese yen (per U.S. dollar) | 118.67 | 119.05 | −0.32 |
| British pound (in U.S. dollars) | 1.6094 | 1.6028 | +0.41 |
| Canadian dollar (per U.S. dollar) | 1.3905 | 1.3914 | −0.06 |

### Commodities
DJ-AIG Commodity Futures (1991=100) 118.671 ▲ +0.050

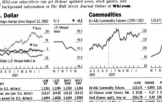

| | CLOSE | CHANGE | FRI | WK AGO |
|---|---|---|---|---|
| DJ-AIG Commodity Futures | 118.671 | +0.050 | 118.621 | 90.920 |
| Oil (Nymex crude future), bbl. | $32.01 | − 0.17 | $32.18 | $27.86 |
| Gold (Comex spot), troy oz. | $361.70 | + 5.40 | $356.30 | $314.10 |
| Wheat (CBT #2 hard RC), bu. | $3.6600 | −0.0650 | $3.5950 | $4.2750 |

# THE WALL STREET JOURNAL.

DOWJONES

TUESDAY, AUGUST 12, 2003 · VOL. CCXLII NO. 30 · ★★★★ $1.00

WSJ.com

---

## Coming Home

### Seeking Benefits, Disabled Soldier Faced New Battle

As Mr. Stiffler Awaited Help, His Case Was Snagged In Veterans' Bureaucracy

What Is a Pair of Legs Worth?

By Robert Tomsho
And Rachel Zimmerman

BLUFFTON, Ind. —Jason Stiffler, a high-school dropout, hoped the U.S. Army could help him make something of himself. But two years after enlisting, the 20-year-old veteran of the Afghanistan war struggles just to care for the tiny garden outside his rented trailer home.

On a recent afternoon, Mr. Stiffler eased himself from his crutches to weed the flowers, dragging himself on his bottom. Half an hour is usually all he can take. "I still can't feel parts of my legs," says Mr. Stiffler, a gaunt man with dark, buzz-cut hair.

*Jason Stiffler*

Mr. Stiffler was injured while managing an Army Kandahar near Kandahar in April 2002: He plunged to the ground, leaving him in a coma for days and without memory of the incident. The Army says it was an accident, although it has never provided the veteran with details.

He continues to suffer from partial paralysis, memory loss and episodes of post-traumatic stress disorder. He and his wife have struggled to make ends meet. After missing payments on their car, they lost it in January. Trying to save on heat, they dragged mattresses into the living room of their trailer and slept around a space heater.

Since his discharge last October, Mr. Stiffler has relied on payments from the Department of Veterans Affairs, or VA, to provide for his wife and toddler son. When he argued that he deserved more than the $731 a month he was receiving—because his disabilities were more serious than doctors originally thought—he ran up against a vast medical bureaucracy. The wait for final disposition of his disability claim and appeal took seven months, a timetable that the VA concedes would have been even longer if it wasn't prompted to act by inquiries from The Wall Street Journal for this article.

Mr. Stiffler's story shows the human toll when critical benefits judgments are delayed, and the confusion veterans and their families often feel when they're forced to confront bureaucracy. It also illustrates some of the flaws in the $60.4 billion veterans agency, and how those problems could prove overwhelming as veterans of the conflicts in Afghanistan and Iraq start to enter the VA's rolls.

The roughly 175,000 military personnel who have served in the war against terror have not begun to apply for VA services in big numbers. But about 50,000 of them will file disability claims in coming years, if the 30% rate of VA utilization after the Gulf War is any guide.

That will place added burdens on a system that has been swamped for years. The average wait to get a medical appointment with the VA is seven months, according to a recent survey by the American Legion. There's a backlog of 280,000 veterans awaiting a disability rating, which determines how much they should receive in benefits; 105,000 veterans are waiting to hear back on appeals of rating decisions.

One reason for the backlog: a 1996 Congressional decision that expanded benefit eligibility to all veterans. Previously, the VA had been open only to low-income veterans and those wounded or injured during service. Since the change, the number of veterans seeking VA medical services has doubled to 6.5 million, while VA spending has risen 56%.

VA Secretary Anthony Principi says he "decided something was terribly wrong" last summer. He ordered the agency to stop enrolling higher-income veterans without disabilities, and to place its priority on

Please Turn to Page A2, Column 1

---

### INDEX

---

## What's News—

### Business and Finance

**D**ELTA SAID it will stop funding a special bankruptcy-proof pension program for executives and will cut some management bonuses, seeking to end a "divisive debate" over executive compensation at the financially struggling airline. Employees have been critical of the program.
*(Article in Column 5)*

■ **U.S. and Canadian prosecutors** are probing whether an ex-Merrill Lynch energy trader embezzled about $43 million, according to an official and court documents.
*(Article on Page C1)*

■ **MCI was forced** to lower its earnings estimates. Federal investigators are probing a defunct firm in connection with MCI.
*(Article on Page A3)*

■ **The global economy** is showing signs of perking up, just as evidence mounts that the U.S. economy is gaining momentum. Japan's GDP rose a faster-than-expected 0.4% from the prior quarter and at a 2.3% annualized pace.
*(Articles in Columns 5 and on Page A10)*

■ **A U.S. jury** ordered Microsoft to pay $521 million to a start-up firm and the University of California for patent infringement. A lawyer who has made a career of battling Microsoft is forcing the company to defend "bundling" before European regulators.
*(Articles on Pages A3 and B1)*

■ **The Dow Jones Industrials** rose 0.29% to 9217.35, while the Nasdaq advanced 1.06% to 1661.51. Meanwhile, bond prices declined. Fed policy makers meet today, and face the question of how to convince markets they aren't going to raise rates anytime soon.
*(Articles on Pages A2 and C1)*

■ **AOL Time Warner** is moving toward dropping AOL from its name due to an initiative by the chief of its America Online arm.
*(Article on Page B1)*

■ **Hewlett-Packard unveiled** 158 consumer-electronics products and launched a big ad campaign.
*(Article on Page D2)*

■ **GM and DaimlerChrysler** will drop their suit against California's zero-emission-vehicle program.
*(Article on Page D3)*

■ **Hyundai Motor's** net rose 86%, but it likely will pay back some gains this quarter after a strike.
*(Article on Page B2)*

■ **Airbus and Honeywell** have devised an automated system to take control of jetliners to keep them from flying into obstacles.
*(Article on Page D3)*

■ **Martha Stewart Living's** net fell 86%, hurt by its founder's legal woes, and amid a gloomy forecast.
*(Article on Page B3)*

■ **Deutsche Bank is suing** insurers Allianz and AXA over the fate of its New York tower, damaged in the 2001 terror attacks.
*(Article on Page C13)*

■ **The EEOC alleged** that the law firm founded by David Boies discriminated against women.
*(Article on Page B1)*

■ **MetLife reduced** its second-quarter earnings by $31 million. The head of its New England financial unit left the company.
*(Article on Page C13)*

■ **The SEC barred** an ex-Pricewaterhouse Coopers partner from auditing listed firms due to past audit work for MicroStrategy.

---

### World-Wide

■ **LIBERIA'S TORMENT MAY EASE** as leader Charles Taylor decamped.
The Boston-educated warlord, who fought to power 14 years ago in a vicious struggle that also left neighboring Sierra Leone in ruins, headed to exile in Nigeria vowing to return. Unaddressed for now is the question of whether he will be handed over to a U.N. tribunal for a war-crimes trial. While his absence should calm rebels pressing into the capital and allow aid to reach refugees, reconstruction efforts after previous conflicts proven scattershot and fleeting. (Page A10)
*The head of a Marine assault unit on ships visible from Monrovia beaches meets with the Nigerian peacekeeping commander today to determine whether U.S. deployment is needed.*

■ **U.S. troops detained** 70 Iraqis in a village near the Iran border in the hunt for Saddam Hussein's inner circle. An ambush wounded three soldiers and one was killed Sunday outside Baghdad. The British struggled to restore reliable power to Basra after 120-degree temperatures brought weekend rioting, but the port and a nearby refinery don't have electricity.

■ **Israel warned** Syria it will be held accountable for any surge in Hezbollah attacks from Lebanon. The U.S. urged all sides to show restraint. Israeli police detained a Jewish settler for making threats on Sharon's life.

■ **NATO assumed command** of the 5,000-strong international peacekeeping force in Afghanistan, its first foray outside of Europe. The alliance is under pressure to provide security in areas outside of Kabul. (Page A10)

■ **Pakistan accused** U.S. forces of killing two of its soldiers in a battle along the Afghanistan border, lodging a strong protest with Washington.

■ **Bush named** Utah Gov. Mike Leavitt to head the EPA. He is an advocate of shifting the regulation of the environment to the states. (Page A4)

■ **An Indonesian imam said** he welcomed the death penalty prosecutors seek as he went on trial for allegedly masterminding the bombings in Bali.

■ **The U.S. held** a Virginia man in secret for a month before indicting him on immigration charges in a probe of a Saudi charity. (Page A2)

■ **A Saudi police arrested** 10 suspected Muslim militants after a gunfight that erupted when police tried to stop their cars outside Riyadh on Sunday.

■ **China warned** serious gaps remain between U.S. and North Korean positions as preparations continued for six-party talks on the nuclear crisis.

■ **Philippine President Arroyo lifted** the state of rebellion imposed after the July 27 failed coup. Under it, police made arrests without warrants.

■ **An Indian helicopter crashed** while taking oil workers from an offshore rig in the Arabian Sea, and only three of 29 aboard were rescued.

■ **California coped** with nearly 200 recall candidates by picking alphabet letters from a lottery hat, then putting the ballot list in that order.

■ **Arizona police killed** a man after he evaded a checkpoint near an area Bush was visiting. It was later found he posed no threat to the president.

■ **The board of the ABA** voted to loosen ethics rules to let lawyers ignore privilege and tell authorities of clients engaging in corporate fraud.

■ **Medicare's future** is as much a bone of contention in Congress as a drug benefit. Some see the government-run program in peril. (Page A6)

■ **Agent Orange still contaminates** the food chain heavily in Vietnam, a study in the Journal of Occupational and Environmental Medicine reports.

■ **Europe's heat wave** is taking a heavy toll on the elderly. The head of France's emergency physicians association claimed 50 deaths in Paris.

■ **Died:** Herb Brooks, 66, who coached the U.S. hockey team to a Cold War victory in 1980 Olympics, in a car wreck outside Minneapolis.

---

### —Markets—

**Stocks:** NYSE vol. 1,020,243,720 shares, Nasdaq vol. 1,149,867,484. DJ industrials 9217.35, ▲ -26.26; Nasdaq composite 1661.51, ▲ +17.48; S&P 500 index 980.59, ▲ +3.00.
**Bonds** (4 p.m.): 10-yr Treasury ▼ -19/32, yld 4.367%; 30-yr Treasury ▼ -23/32, yld 5.294%.
**Dollar:** 118.47 yen, +0.38; euro $1.1343, +0.57 cent against the dollar.
**Commodities:** Oil futures $32.01 a barrel, ▼ -$0.17; Dow Jones-AIG futures 118.671, ▲ +0.059; DJ-AIG spot 149.919, ▲ +0.184.

---

### —Online Today—

**The Small Screen:** Bravo hopes "West Wing" reruns will help build its reputation as a hip cable network. But the gamble might not pay off, Joe Flint says.

**Gene Machines:** Some biotech firms reinvent themselves to survive, with new research and names. Yet makeovers may not be good for investors.

**Economic Swings:** Find out about the Fed's view of the economy in the late edition of The Afternoon Report.

---

## Rough Justice:

## Maj. Bereik's Day In an Iraqi Court

Army Lawyer Tries to Make A Balky System Work; Guns and 'Leg Breakers'

By Michael M. Phillips

KARBALA, Iraq—Fadhil Abd Al-Khadir's alibi evaporated the instant the prosecution's star witness, a U.S. Marine sniper, took the stand. The Marine held up surveillance photos showing that the round, yellow-orange objects Mr. Khadir was selling outside a local mosque were not, as he claimed, tomatoes. They were hand grenades.

Mr. Khadir, cocky when the arraignment began, shook his head in dismay as the Iraqi investigating magistrate sent him back to his cell to await trial.

For Maj. Bernard Bercik, a U.S. Army Reserve lawyer, Mr. Khadir's indictment was a welcome win. Maj. Bercik and the military governor of the area surrounding Karbala, Marine Lt. Col. Matthew Lopez, have almost complete powers over

*Bernard Bercik*

Karbala's legal system. The 46-year-old Maj. Bercik could simply order prisoners jailed or released. But he prefers to adhere to Iraq's 1969 criminal code in the hopes of setting an example for the local judiciary to follow.

As U.S. forces prepare to turn over control of this southern city to a small contingent of Bulgarian peacekeepers, Maj. Bercik is racing to leave hundreds of people languishing in Karbala's fetid city jail are either indicted or released.

"I'm going to clean house before I leave," says Maj. Bercik, of the Army's 304th Civil Affairs Brigade. "But I'd prefer they do it themselves."

It's a delicate balance between ensuring justice, and ensuring that the justice system works on its own. Criminal justice is often slow here, and confusing to all involved. Dangerous suspects are sometimes released on bond and harmless ones—such as the 17-year-old arrested for holding hands with her husband at the mosque—are held for weeks. Before he leaves next month, Maj. Bercik is trying to right what wrongs he can.

Twice a week Maj. Bercik walks into the bowels of the municipal building, to a central chamber surrounded by padlocked cells. The largest cell houses perhaps 100 men, sprawled on every bit of available floor. The odor of human waste and sweat, simmering in temperatures that can top 120 degrees. One Marine likens it to a kennel. Guards place large blocks of ice in the center room in the vain hope of cooling things off, and the U.S. has its stalled fans. During visiting hours, family members press against the welded steel rods that crisscross the cell doors.

A recent hearing day went like this: Maj. Bercik began by politely berating the head prosecutor, Najm Abdullah Hassan, for not clearing more of the cases away, or even keeping a complete ledger of prisoners and their alleged offenses.

An American military policeman handed the major a torn slip of paper, with a handwritten note. Its Iraqi author pleaded for the release of a relative arrested by the religious police and held for 26 days for allegedly drinking alcohol during the major's dressing-down and held for 26 days for allegedly drinking alcohol. The major waved the paper at Mr. Hassan.

"We have 200 people in the jail," Maj. Bercik pressed, "Why are these people in jail?"

Mr. Hassan consulted his file and told the major that the prisoner wasn't arrested for being drunk—he was proportioning women at the mosque. Still, he promised to seek the man's release. The major said he was pleased that at least Mr. Hassan was able to find some record of the case.

Soon the arraignments themselves began. One of the first defendants was Nasar Arudyah, arrested by a Marine patrol after two men on a motorcycle opened fire on several houses with an AK-47 assault rifle. The Marines pulled Mr. Arudyah over because he and his passenger matched the general descrip-

Please Turn to Page A8, Column 4

---

## Follow the Leader

## As U.S. Shows Signs of Strength, Global Economies Look Up, Too

In Germany, China and Japan, Wallets Begin to Open; Rising Profits and Stocks

Job Losses Cast a Shadow

Just as evidence mounts that the U.S. economy is gathering momentum after months of disappointing growth, some signs are emerging that the beleaguered global economy is beginning to perk up as well.

In Germany, business confidence has risen for three consecutive months, an indication that the worst may be over for Europe's largest economy. Executives are also feeling more optimistic in France, Belgium and the Netherlands. China has quickly emerged from the SARS health crisis and consumers are aggressively buying cars and homes. In Japan, the longest-standing underperformer of the advanced economies, gross domestic product expanded at a stronger-than-expected 2.3%, annualized rate during the second quarter, the government reported yesterday. Meanwhile, some of the world's largest multinationals—including some hard-hit technology companies—are seeing rising global sales.

Of course, nearly two years of recovery pronouncements have proved too optimistic for all but executives and some economists with deep skepticism about the outlook. But unlike previous false dawns, when falling global stock markets acted as a headwind on the economy, this time stock prices are working in favor of recovery.

Germany's Xetra DAX index is up 15% so far this year and Japan's Nikkei Stock Average is up 17%. Share prices also are rising in Latin America, though they have slipped recently after big run-ups. Argentina's Merval index is up 50% so far this year. Brazil's Bovespa index is up 20%.

By Jon E. Hilsenrath in New York, Christopher Rhoads in Berlin, Robert Buckman in Hong Kong and David Lebhar in Mexico City

"The second half of this year will begin a period of more rapid global economic growth," says Michael Mussa, an economist with the Institute for International Economics and the former chief economist of the International Monetary Fund. "This move in global growth has been pretty well synchronized around the world," he said. One reason is policy makers across continents have tried to pump up their economies in different ways. The U.S. has cut short-term interest rates to 45-year lows and lowered income tax rates, Germany is also reducing taxes and European interest rates have been lowered. State-controlled Chinese banks are handing big government projects and showering consumers with auto and home

Please Turn to Page A8, Column 1

### World Markets Gain

Rising stock prices add weight to global recovery expectations

| | LOCAL CURRENCY | IN U.S.-DOLLAR TERMS | IN U.S.-DOLLAR TERMS | LOCAL CURRENCY |
|---|---|---|---|---|
| | ■ 18 weeks before the March market bottom* | ■■ Since the March market bottom | | |
| **Germany's Xetra DAX** | -6.9 | -47.2% | +56.8% | +51.6% |
| **Thailand's Bangkok SET** | -8.9 | -5.6 | +48.8 | +45.6 |
| **Argentina's Merval** | 37.6 | +4.0 | +37.7 | +28.9 |
| **Mexico's IPC** | 15.9 | -32.8 | +29.6 | +26.6 |
| **Britain's FTSE 100** | -37.7 | -28.9 | +26.3 | +27.1 |
| **Japan's Nikkei Stock Average** | -30.4 | -23.1 | +18.2 | +19.4 |

*March 12*

Source: Thomson Datastream

---

## Pressured by Union, Delta Cancels Payment to Special Pension Plan

By Evan Perez

Seeking to end a "divisive debate" regarding executive compensation at the financially struggling carrier, Delta Air Lines said it will stop funding a special bankruptcy-proof pension program for executives and will cut back some management bonuses.

The nation's No. 3 airline, behind AMR Corp.'s American Airlines and UAL Corp.'s United Airlines, had established pension trusts for 35 employees that the company said it needed to retain to navigate through the airline industry's worst financial crisis.

Delta, which is trying to wring wage concessions from its pilots, has made payments to the trusts totaling about $45 million so far. This includes money to cover the tax liability Delta's employees will incur when they withdraw the funds. But the company said it won't make the final payment of about $20 million, which was to have been made by early next year.

Still, Delta isn't rescinding the special program. The employees benefiting will be allowed to receive their share of the trust funds whenever they leave the company, regardless of age. It isn't clear whether the changes will help restart talks with the pilots union, which has criticized the program. No new talks are scheduled. The pilots group, the only major union at Delta, said it was reviewing the changes announced by the company.

Employees have been critical of the special payments because regular employee pensions are underfunded by as much as $4.9 billion and, unlike the executive program, aren't as protected in the event of a bankruptcy-court filing. In addition, the company has switched its contribution to employees' pensions to a "cash balance" plan, which saves the company money, and can boost profits, since it reduces the pensions of older, longer-serving employees.

The Wall Street Journal reported in a page-one article last week that three employees who were granted the special trusts have left the airline, taking their pension trusts with them. And while top management said it wasn't aware of the bulk of the trust payments, internal Delta documents detailed trust payments made to less-senior employees, including several attorneys and the head of Delta's employee credit union.

Delta isn't alone in protecting the pensions of its key people. Many large companies have been setting up special pensions for top executives, even as they cut pensions for the rest of their workers. Donald Carty, AMR's chief executive, lost his job in an uproar last spring over retention bonuses and supplemental pension benefits, which weren't disclosed until after employees had agreed to large pay cuts.

Mr. Mullin, in a letter to employees yesterday, acknowledged that Delta's effort to cut costs has been affected by the pension controversy. "The intention has been clear: Make further tangible sacrifices in executive compensation; eliminate, as much as possible, any sense of 'we versus they' on compensation philosophy, such that everyone appreciates we are all in this together."

In his letter, Mr. Mullin said, "The

Please Turn to Page A6, Column 6

---

### INSIDE TODAY'S JOURNAL

**Chic Swedish Retailer Finds New World a Challenge**
H&M's well-hyped U.S. debut, followed by a smorgasbord of errors, shows how hard it can be for specialty apparel retailers to cross the Atlantic. Page B1

**Why China's Banks Do Well**
Treasury-bond trading has offset losses for banks burdened by increasing worries about bad loans. Can the sector make money in traditional banking? A10

**Don't Shoot the Tuba**
Tighter baggage and security rules make life harder for musicians. Rules vary by airline, type of plane and individual security screener. Even buying a cello its own seat doesn't always work. D5

**Real-Estate Narcissists?**
KB and Ryland, which have been buying up their own stocks at dizzying rates, should be picking up cheap land or saving cash for tougher times, some pros say. Heard on the Street, C1

### PERSONAL JOURNAL.

**Personal Health**
Fake Fat and Other Additives: Does FDA Digest All Data?
Getting a Virtual Second Opinion
Also: Hidden Rate Increases—How Shippers Play Address Game

---

**Above** The redesign of *The Wall Street Journal* saw the introduction of color to the front page

**CLARE JACOBSEN** Editorial Director, Princeton Architectural Press, New York

As Editorial Director at Princeton Architectural Press (PAPress), Clare Jacobsen's role is multifarious. From acquiring a new title to reviewing final proofs, Jacobsen works on all aspects of a title including reviewing proposals, negotiating contracts, setting schedules and budgets, editing text, supervising design and production, and gathering sales and publicity materials. But the most important aspect of her job, she says, lies in achieving a vision for a book. "So many proposals come in with not one but ten good ideas. It's my job to sort through all those ideas —and text, and art, and everything else—and bring out THE idea," she says. "It's the same editing books as editing anything—music, film, etc. All editors like to shape something from a big mass of whatever material they're using to a refined sculpture."

PAPress involves its authors in every stage of the book production, so Jacobsen collaborates first and foremost with the book's author. "As a design press, this is necessary: it makes a better book." Additional collaborators include graphic designers, editorial support (from in-house assistants to outside copy editors, proofreaders, and indexers), and a production manager. "I like working with graphic designers," she says.

"I'm always surprised when I hand them some material and they hand me back something I could never have imagined. It's kind of like working with an architect—you have some idea of what you need and what you like, and they surprise you with something much, much more." Jacobsen is particularly fond of PAPress's current design director, Deb Wood, and in-house designer Jan Haux. "A lot of designers are very creative, and a lot are really good with schedules," she comments. "Deb and Jan are both, which is rare. Sometimes, you have to give up one for the other."

Working in a more intimate environment also allows for a strong editor–designer relationship. "Our design director is present at meetings when we review proposals, so she has a say in how projects look from their initiation." At PAPress, editors work with in-house designers to establish the format and other specifications for a book before its text is edited, after which the designers prepare a design proposal for the author and sales staff to review. Once this has been approved and the text and art are finalized, the designers then lay out the book, working back and forth with the editors through rounds of reviews and corrections. Both designers and editors

also review and correct the proofs of the book that come back from the printer. While many publishers prefer to stamp an identity on their books, this is not something to which PAPress aspires. "We pride ourselves in designing each book according to its content. We think it is much more important for a design press to design each book than to design an overall look for itself."

When a book is not designed in-house, the designer can be introduced to the project at varying stages. "Sometimes, they are part of the book's definition and arrive when the proposal comes in," says Jacobsen. "Other times they are hired after the book's specifications have been determined, so follow preset guidelines that the editor and in-house design staff have already determined."

Although Jacobsen describes part of her role as "supervising design," she does not dictate it. "Rather, I consider myself to be the central person on the project—the person who connects the author to the designer to the printer— and so the person who needs to make sure the design meets the book's requirements: achieving a look to match the content, meeting the budget and schedule, and, most importantly, bringing something unique to it."

# TALKING POINT
## The Editor

Working on large-content projects requires a structured approach from the outset. At PAPress, the author, editor, designer, and sales staff reach a mutual understanding of the basic structure of the book at the onset of the project. "These specifications—how many pages of text, how many and what type of pieces of art, the type of binding and other materials—are even written into the author's contract. It is then the author's job to meet this structure, and the editor's to make sure it's met." The company also insists on receiving all texts as electronic files, which are then formatted by editorial assistants who run each text through a 26-point list of instructions, ensuring that the editor always starts out with a clean manuscript.

For Jacobsen, collected, illustrated essays are the most difficult projects. "Obviously, it's hard to give one voice and one look to materials coming from many sources," she says, "but the bigger problem in such projects is corresponding with so many people, which is always hard to orchestrate." Systems of approach are vital to the organization of big content. From her own experience, Jacobsen believes that the following three points are vital in avoiding confusion and making larger projects easier to manage.

1 "Insist that the author or editor does the initial organization of the book for you. They know their material best, and it will take them a quarter of the time it will take you. We send each author an information packet explaining how work should be prepared for us—what type of text files we can read, what formats of art we will accept, how art needs to be ordered and labeled, and assigned to the text, etc.

2 "Always work with the project as a whole. You might think that you'll save time by sending all but one chapter of text to a copy editor, or all but a handful of images to the designer, but those missing pieces usually create big headaches—they get delayed, misplaced, or forgotten.

3 "Don't count on the designer to organize the work. This might sound ridiculous, but I've heard from several designers that too often they receive text in one pile and art in another, with no indication of how things go together. It's impossible to get a good book out of that."

# SYMBOLISM

"Except for the immediate satisfaction of biological needs, man lives in a world not of things but of symbols"

Ludwig Von Berrenfly, details not known

Graphic icons and symbols are not only one of the most important forms of visual communication, they are also one of the most complex. Although we may not realize it, this is one area of graphic design that we all rely on almost every day of our lives. In hospitals, museums, airports, when using maps, guidebooks, and TV guides, having the ability to independently navigate foreign territories, whether physically or on paper, is vital. Whatever the individual format, representing systems of information visually requires the designer to distill large amounts of information to the bare minimum in order to effectively communicate them to the user. And while the results often appear very simple, the thinking behind them is anything but.

Symbols have been used as a form of communication for as long as history records, and while some have truly stood the test of time, others have developed over the years in response to our ever-changing world. Just as daily life continues to increase in pace, so advances in technology mean we now communicate faster and more efficiently than ever before. In response, a whole new graphic language has evolved. From the general operational symbols imposed on us by mobile phone manufacturers to the graphic language we have developed independently through the increased use of text messaging and email, readability is increasingly being achieved through the use of graphic symbols. On bills and bank statements, where readability, again, is paramount, we find ourselves interpreting a myriad of signs and symbols almost without thinking.

Symbols also bridge the gap between different cultures and countries. Just as the 1972 *Pioneer 10* mission to Jupiter used graphic symbols to send messages to unknown cultures, today pictorial guides such as *point it* offer a universal language, allowing us to communicate simply and effectively without worrying about the language barriers that once would have made this an impossibility. Although we often respond to symbols without thinking twice, their meaning is not intrinsic to the design: it has to be learnt. What meanings we attach to these symbols form part of our identity and are reliant on a number of factors including race, religion, and age.

Symbols can be incredibly useful when working with big content, whether you are looking to map a large amount of information, as for Harry Beck's London Underground map, or to provide the visual glue for a large exhibition, such as the Rewind symbol created by johnson banks, symbols function as

shortcuts to information. Systems of symbols should have a coherent look and be treated consistently in terms of size, placement, and rendering. In this way, they may be used to excellent effect in signage.

Signage plays a key role in our physical world—from the road signs we respond to automatically and encounter daily, to the navigational signage we actively look for to guide us through unfamiliar surroundings. Working on a large signage system requires an intense amount of research and preparation and, ironically, the best signage systems are those we hardly notice at all. Whether directing a worried relative in a hospital or a museum visitor engrossed in an exhibition, the split second it takes for the user to receive information, almost subconsciously, and act upon it, can mean the difference between the success and failure of the designer. Projects of this kind often take the longest amount of time to complete due to the detailed planning process, the amount of money invested in them, and the need for total accuracy. Moreover, the results are likely to be around for many years, leaving no room for error.

Creating signage for a large project is a logistically complex task, often involving many different people. For example, the needs of the client, architect, construction manager, and quantity surveyor, as well as local planning authorities, fire and safety officers, must all be addressed and assessed by the designer throughout the project. The designer will not only be involved in reviewing tender submissions, they should also play an active role in the preparation of prototypes, further enforcing the need to maintain a strong relationship with the manufacturer from the start. A comprehensive sign schedule, such as those that incorporate sign type, size, fixing, and position, provides the designer and any potential contractors with all the necessary information to complete the job correctly and without error.

As a society we are becoming ever more graphically literate. Never has the need to understand and interpret information presented in this way been more relevant than it is today. Cheaper transport, the worldwide web, and the globalization of commerce all demand, increasingly, that information be universally understood. The visual language created by systems of symbols can fulfill these needs. Such was the case when Alexander Gelman was commissioned to create a universal language of symbols for Seiko Epson, to be used on the control panels and remote controls of its LCD (liquid crystal display) projectors (see chapter 5). However, including this element in the design process is, perhaps, an area that has yet to be fully considered. Traditionally, this occurs at the point where content (usually words) meets form; but the use of symbols and the very nature of their development as a successful graphic language requires that the designer be brought in at a much earlier stage in order to develop the most effective design possible.

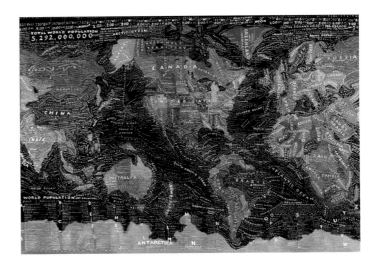

## HAND-PAINTED MAPS Paula Scher

In contrast to the planning, order, and accuracy required to create and execute a successful wayfinding system are Paula Scher's hand-painted maps, each of which takes between four and six months to complete. "My maps express the opposite of wayfinding: they are information gone berserk, and I have total control," she says. "I find joy in their being wrong. They don't have any pretence of being accurate." So much so that "if it doesn't fit, it's not on there." This approach to map design is the complete antithesis to that of her father, a cartographer for whom maps were all about accurate, geographical data.

The notion that maps are packed with factual information is also an attraction. "Maps tell you where you are, and what is there. They serve you in this factual way, with authority—and you trust and believe them," she explains. "But there is this disconnect between reality and a two-dimensional rendering. You'll look at a map and point out your location on this big piece of paper: 'I'm here.' No, you're not."

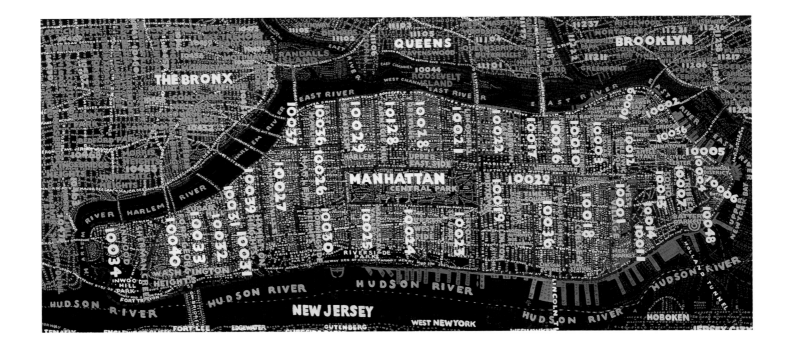

**Top** *The World*, 1998, 8 x 5in (200 x 127mm)    **Above** *Manhattan*, 2002, 11 x 5in (279 x 127mm)    **Opposite** *New York State and Long Island*, 1999, 5 x 8½in (127 x 216mm)

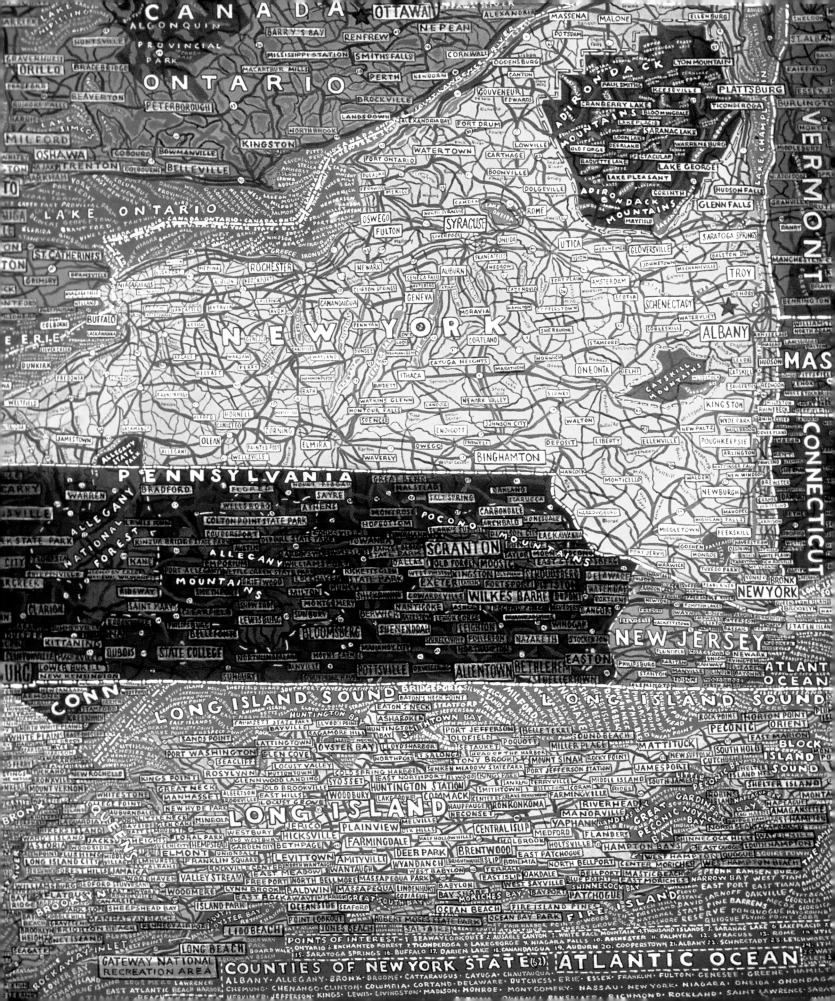

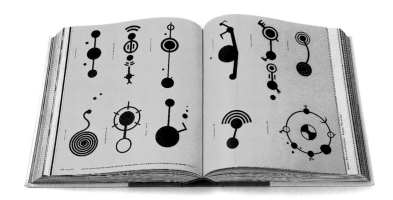

## THE ART OF LOOKING SIDEWAYS Alan Fletcher

**3**/78 As a founding partner of the international design group Pentagram, Alan Fletcher has certainly seen his fair share of large projects, but when it came to designing his own book, *The Art of Looking Sideways*, there were a number of obstacles to overcome. "This was probably the most complicated job for me, mainly because there was no client and there were no rules," he says, "and also because I wrote most of it. I had never written anything before so I had to learn to write too." Although having total ownership of a project carries with it a certain level of satisfaction, it is also, says Fletcher, one of the most difficult things to do because you are responsible for everything, from the research to the writing to the design.

*The Art of Looking Sideways* brings together Fletcher's vast personal collection of anecdotes and quotations, images and facts, all concerned with the interplay between the verbal and the visual, and loosely arranged into 72 sections spanning in excess of 1,000 pages. His artful and quirky use of symbols adds to the book's unique character. Describing the book as "organized chaos" united by "intelligence," Fletcher began by listing the areas that would eventually become the book's 72 section headings. Deciding these were just "too boring" as standalone titles, he then set about finding a related but "oblique" thought or comment to accompany each one. "I decided I needed to assert some control over it so that I wouldn't end up writing a narrative," he continues. "I knew that would make it very confusing so I wanted to keep it as tight as possible." Part of this tactic involved confining each subject to one spread, and it is from this that the system of numbering each spread, as opposed to each page, developed.

At first glance there appears to be no structure whatsoever; even the discipline of the page numbers is interrupted by their ever-changing format and position. That said, as is often the case, the best design is that which is invisible. "The book has over 200

different typefaces in it, so I tried to design each spread differently. There is a grid but I made the grid so complicated that it meant I could do whatever I liked. It's not really discernible, or at least I don't think it is." The design and layout was an ongoing process that took place over a period of five years, running alongside Fletcher's other projects.

Each section begins with a black page. This features a section heading and comment accompanied by an illustration on the opposite page. "I've tried to make the illustrations equally oblique so one is a verbal obliqueness and the other is a pictorial one." Symbols also feature heavily in the design, as in the seemingly random replacements of page numbers and section headings with hand signals. The book is also full of "secrets," giving it an added personal touch—the word ABRACADABRA is spelt out over the 11 pages that make up the section entitled Illusion. "It's more of a designer thing really; if people get the references that's fine but if they don't, it doesn't matter."

There are also a number of common threads running through the book, such as a series of diary excerpts scattered throughout, always framed in a blue patch and always relating to whichever section they are in. Although the overall content is largely unrelated, simple graphic devices such as this instill a sense of familiarity. As the reader encounters them time and time again they can be equally—if not more—effective than a navigation system bound by rules and regulations.

**Top** Spanning more than 1,000 pages, the book is littered with unusual signs and symbols

**Opposite** The book's distinctive cover uses only text and color to convey its message

Words and pictures on how to make twinkles in the eye and colours agree in the dark. Thoughts on mindscaping, moonlighting and daydreams. Have you seen a purple cow? When less can be more than enough. The art of looking sideways. To gaze is to think. Are you left-eyed? Living out loud. Buy junk, sell antiques. The Golden Mean. Standing ideas on their heads. To look is to listen. Insights on the mind's eye. Every status has its symbol. 'Do androids dream of electric sheep?' Why feel blue? Triumphs of imagination such as the person you love is 72.8% water. Do not adjust your mind, there's a fault in reality. Teach

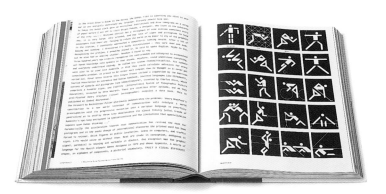

**Middle left** A series of randomly placed yellow "scraps" pages bring a sense of order to "the bits that wouldn't fit anywhere else"
**Bottom** Spread taken from the section on symbols

**Top left** In the Numbers section, page numbers are shown as hand signals
**Top right** A series of pages "secretly" spell out the word ABRACADABRA
**Middle right** With over 200 typefaces, Fletcher tried to design each spread differently

## AMERICAN IMMIGRANT WALL OF HONOR Ralph Appelbaum Associates

For the opening of Ellis Island in 1990, a wall to honor America's immigrants was planned. Americans were invited to submit the names of their ancestors or relatives who entered the country at Ellis Island and other gateways. Ralph Appelbaum Associates (RAA) was subsequently selected to redesign this highly symbolic Wall of Honor to accommodate additional names.

The wall itself is a double-sided, freestanding, 652½ft (200m) long, semicircular structure with stainless-steel panels. Standing 4ft 10in (147cm) tall, the information is easily accessible to most visitors. The long exterior structure borders the docking area where immigrants first set foot on American soil. The engraved names of those who peopled and built America over the last four centuries are a monument to freedom, hope, and opportunity, and range from the Founding Fathers to the most recent immigrants of today. All the names are acid-etched into stainless steel and then in-filled.

On the original wall, the names were etched on copper and connected to the sea wall that surrounded the island. "We decided to make it a vertical wall so people couldn't sit on the names and we worked with ornithologists to make sure birds couldn't perch on the edges. Then we had to figure how to navigate the names," says Ralph Appelbaum. Using a large circular form made it very easy to organize the information alphabetically but, initially, posed the problem of how to keep expanding the different alphabetical zones. Rather than compromise the circular design, this was solved with a lateral yearly addition of names.

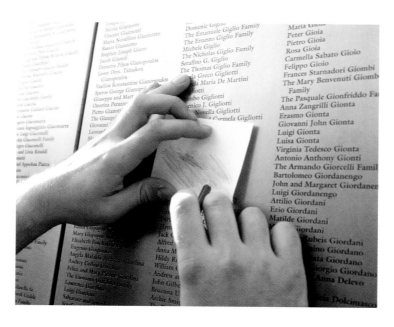

**Top** American Immigrant Wall of Honor, Ellis Island (© Scott Frances/Esto)
**Above** Names are etched deep enough for visitors to take a rubbing (© Scott Frances/Esto)

# ABCDEFGHIJKLMNOP
# QRSTUVWXYZ

## LONDON UNDERGROUND MAP Harry Beck

Designed by Harry Beck back in 1932, the London Underground or Tube map has long been heralded as an iconic piece of information design. Originally conceived as nothing more than a simple navigational tool for London's "Tube" travelers, the Diagram, as it was then known, has since become an essential part of London life, for visitors and residents alike.

An electrical draftsman by trade, Beck based the map on the circuit diagrams he drew for his day job, stripping the sprawling Tube network down to its bare minimum. The result was an instantly clear and comprehensible guide to London—and a template for transport maps the world over.

Beck's original sketch showed the simplification of the main route lines to verticals, horizontals, and diagonals, eliminating all surface detail apart from the line of the River Thames. "Looking at the old map of the Underground railways, it occurred to me that it might be possible to tidy it up by straightening the lines, experimenting with diagonals, and evening out the distance between stations," said Beck when asked to describe his thinking. "Selecting the central London Railway as my horizontal base line, I made a rough sketch. I tried to imagine that I was using a convex lens or mirror, so as to present the central area on a larger scale. This, I thought, would give a needed clarity to exchange information."

This purposeful distortion of the central area was, and still is, vital to the success of the map. Beginning with a simple pencil sketch made across two facing pages of a note book, Beck went on to develop the Diagram using dots to denote the stations and color coding to differentiate between the various lines. Initially the design was dismissed by the Publicity Department and it wasn't until a year later, when Beck submitted his drawing for the second time, that it was accepted on a trial basis.

Although the lettering on the first proof was hand-drawn, Edward Johnston's specially commissioned "Underground Railways Sans" typeface was used on all versions of the Beck Diagram from the first Quad Royal poster of March 1933.

While the basic structure for the Diagram had been developed by 1933, as the system continued to grow and develop, Beck was regularly called upon to update the map.

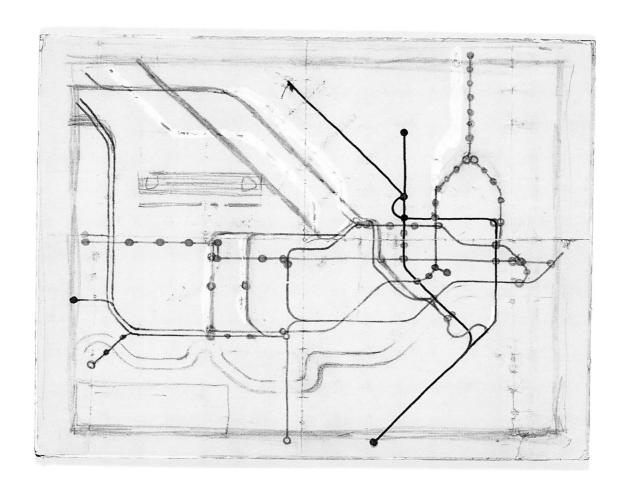

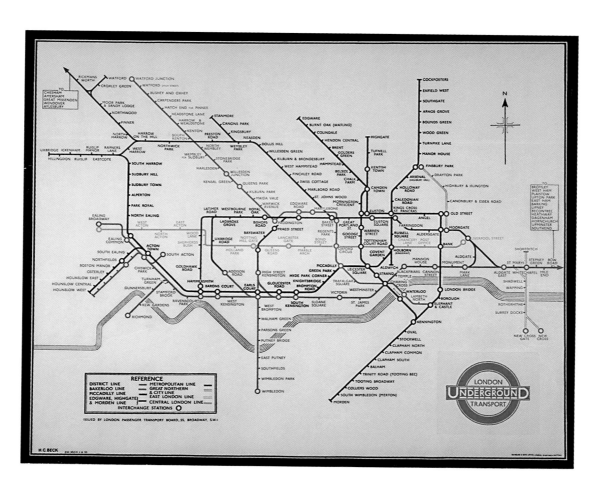

On 26th January 1952 the Publicity Officer approved the general layout of Drawing No.7 with the following alterations:

(a) Thicken lines to take names of lines as on current ...
(b) Bold grid lines and substitute plainer bullseye
(c) Re-arrange section of Piccadilly Line to reduce congestion on District Line (Ville area)
(d) Reduce congestion on Aylesbury section
(e) Reduce congestion on Northern Line (southern section)
(f) Walham Green: change to Fulham Broadway
(g) River Thames to be named
(h) Draw out suggestions for indicating interchange with Main Line.
(i) Mine the name ...

Drawing No.7 is returned herewith.
As many as possible of the above alterations have been shown on Drawing No.9.
Drawing Nos 10 and 11 show alternative ways of indicating Main Line interchange
Drawings Nos 12, 13 and 14 show ways of opening out congested areas.

Notes on alterations
(a) This has been done: Drg.9 (Hounslow section) shows ... treatment.
(b) and (c) carried out on Drg 9.
(d) The Aylesbury congestion has been slightly reduced, but Drg.14 shows a more effective treatment for that area
(e) The design had in the past been reduced without alteration to folder size, and this has fixed the limits of proportions. PTO

proportions as regards the main body of the diagram, as the design has in the past been reduced to folder size, and this fixes the limit of proportion. Drg 12 shows the southern end of the Northern Line opened out. At the same time opportunity has been made to treat similarly the northern part section of the Bakerloo Line. Drg 13 shows that even if the body of the diagram is moved right up the saving of congestion is not great. Drg 12 also indicates the portion for the words "River Thames"

(h) Main Line ... indicated on Drg 9 by the diamond symbol - solid for termini, open for the rest - and on Drgs. 10 and 11 ... ML ... are in bold and italic respectively ... Italic does not stand out too well. Bold is better on this count, but might be too heavy for small-size printings.
(i) This alteration has been made ... on Drg 9 as the re-arrangement of the lines ... in the Bank area

Drawing No.12 contains experimental redesign made possible by the extra vertical depth. They are in the ... Rayners Lane, Camden Town and Finsbury Park. ...

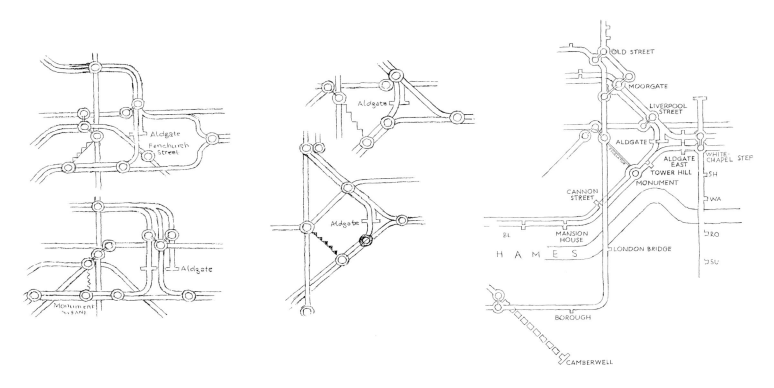

**Top** Briefing notes recorded by Beck on January 26 1952 following a meeting about a forthcoming issue of the Diagram

**Above** Beck's pencil sketches of the eastern end of the Circle Line: the two left-hand drawings show Beck's attempt to incorporate the proposed Fleet Line (later renamed the Jubilee Line)

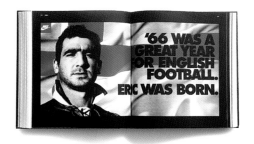
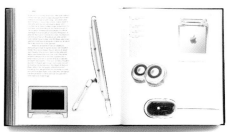
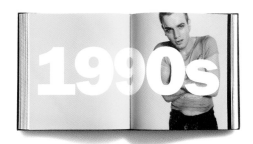

## REWIND johnson banks

In 2002, British Design and Art Direction (D&AD) celebrated its 40th anniversary with Rewind, a major retrospective held in London, in the Victoria and Albert Museum's Contemporary Space. Designed by DIN Associates and with graphics by johnson banks, the exhibition was accompanied by a 512-page book also designed by johnson banks.

The key graphic device used throughout the book, exhibition, and supporting material was the Rewind button. "We decided it would be inappropriate to lead with the D&AD symbol, but wanted something that linked back to the pencils," explains Michael Johnson. In response, a rewind button made up of two pencil tips was designed and introduced midway through the

project, providing "some good visual glue other than just the reversed logotype and D&AD yellow." Although "the pencil" is synonymous with D&AD, the location of the exhibition created a need for a strong graphic device that would appeal to both the general public and those in the creative industry.

Work selected for inclusion in the book was predominantly based on the winners from each year. This selection was then further edited to establish the exhibition content. For Johnson, designing the book prior to the exhibition eased the design process, as did working with DIN Associates. "They devised a simple format that let us get on with laying out the panels as though they were just big pages."

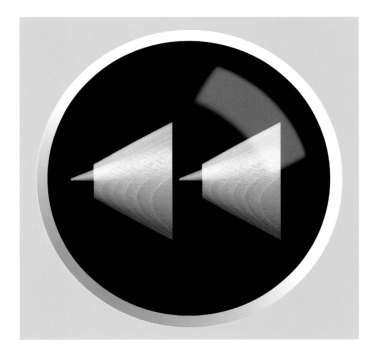
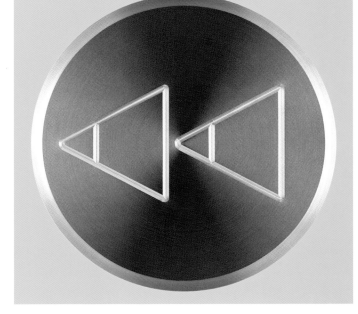

**Top** A series of spreads taken from the book
**Above** A rewind button was used as the main graphic symbol throughout. The early symbol (left) was refined to disguise the pencil tips in the final design (right)

**Following page top** Double-sided graphic panels could be designed as though they were large pages
**Following page bottom** Poster advertisement wall

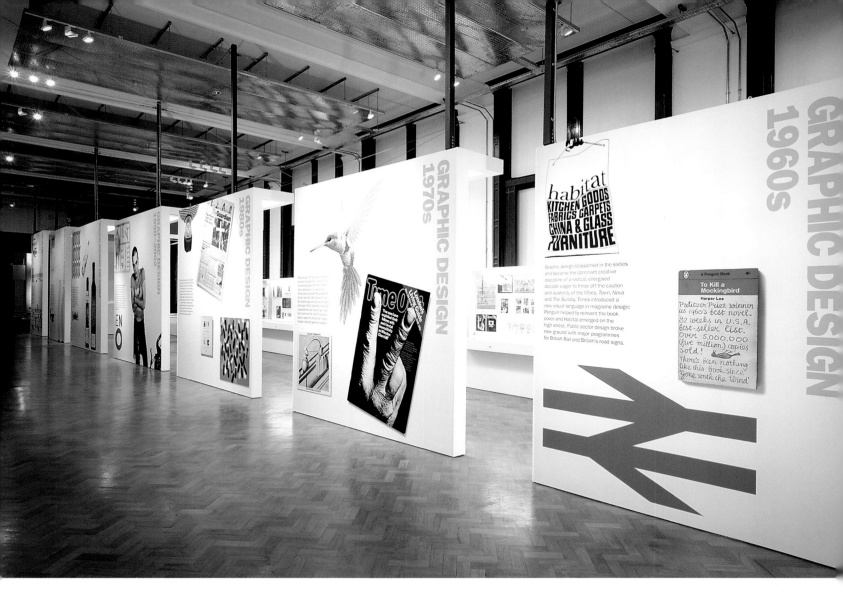

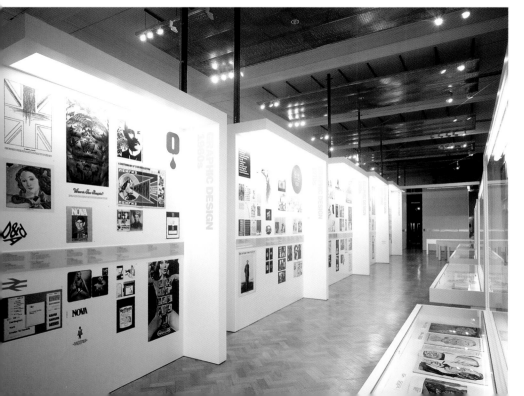

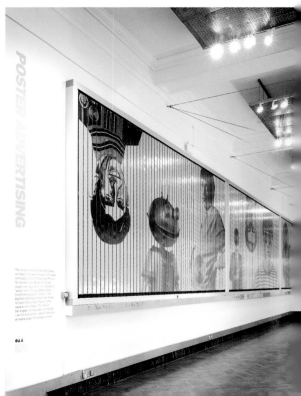

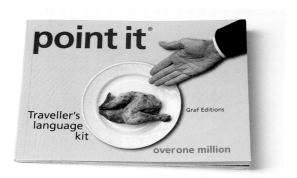

## POINT IT Graf Editions

Published by Graf Editions, the *point it* picture dictionary uses the universal language of imagery to allow users to communicate simply and effectively when in a foreign territory by simply pointing at one of the 1,200 items found inside. The dictionary has already achieved cult status among students of postmodern semiotics, but it is its primary use as a communication aid that has helped this passport-size picture dictionary sell 1,400,000 copies since it was introduced in 1992.

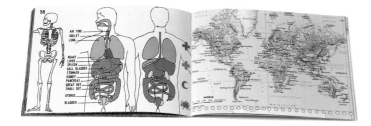

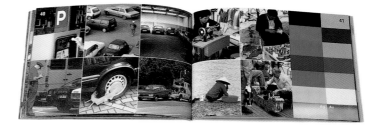

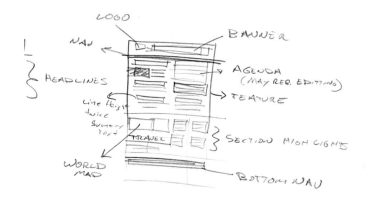

# INTERNATIONAL HERALD TRIBUNE WEBSITE John Weir

**3**/88 Designing the website for the International Herald Tribune (IHT), an international newspaper published in 26 countries around the world, is a complex task, but as designer John Weir explains, there are a number of benefits to using a graphic language when dealing with a large amount of content. "Icons are excellent for repetition and saving space. Once the user learns the meaning of an icon it reduces the amount of text required to explain the associated action. Color can work the same way. You don't necessarily even need to be given instructions on these meanings: the user can learn such a feature through their own curiosity."

The IHT had not given a brief for the project, but Zoned, who would become Weir's partner on the project, had been working with the IHT on revamping its servers and software; the redesign of the website seemed a natural progression. "The IHT did not know how to approach the problem and they were not completely convinced about the web and its utility. They also did not have a very large budget," says Weir, who suggested creating a semi-functional HTML/JavaScript-based prototype for the site. "This would allow me to explore the site and its potential and would act as a tool that could be shown internally at the IHT to inspire the staff. No commitment was required after the creation of the prototype. If the IHT felt it was successful, then I would bid on the actual site design." The project lasted one year, although work to refine the site continued for a further six months postlaunch.

The project consisted of designer, John Weir, Conley Rollins from the IHT, and Zoned as programmer, architect, and interface coder. What is interesting and somewhat unusual is that there was no project manager. "Everyone was self-managed," explains Weir.

"To some extent Conley acted as a project manager, but this was as much a software development project as a design project, so deadlines were regularly pushed back to deal with the realities of code." Weir began by defining the information architecture—a fairly straightforward process as the site structure and categories were based on the newspaper. "I mimicked the paper, with some adjustments," he explains, "and from there created paper layouts to get an idea of on-screen information and volume. Then I began creating Photoshop layouts."

Keeping the screen as clean and uncluttered as possible was integral to the site's navigation system. "I like using drop menus for some tasks, especially a site like this where the user will return and use it daily. If they don't understand something right away, it is okay; they will learn," says Weir. The IHT site may be graphically light but this "less is more" approach makes it a pleasure to use. The use of symbols is thoroughly considered and, where implemented, very effective. The rest of the site is navigable via Headline links or dropdown menus.

Working for a big client can pose problems, but is not impossible, says Weir, who cautions against "design by committee" at all costs. "That said, you have to listen to your client and explain yourself well. The IHT did not like the design at first and there were many tough battles in pushing it through." On this occasion Zoned was able to act as the "middle-man" between designer and client. This not only forced Weir to articulate his thinking to the IHT, but also forced the client to listen to and consider what he was trying to accomplish. "Communication between client and designer can be very constructive when you have such an excellent mediator."

---

**Top/opposite top** Early sketches drawn by Weir during his first meeting with the IHT. Note: the world map and the concept of columnized text were already conceived at this stage of the project

**Opposite bottom** The design schedule helped explain the work involved: creating visual comps for screen design, working with Zoned on programming the template engine, coding the JavaScript interfaces, and developing the templates

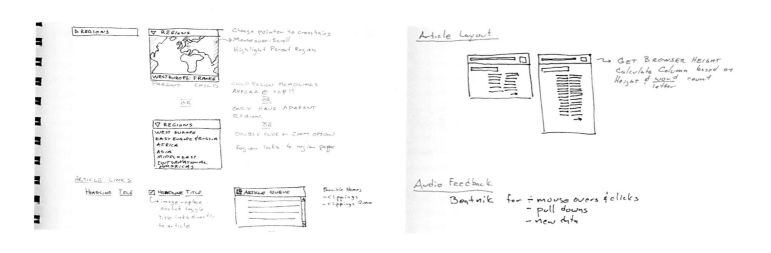

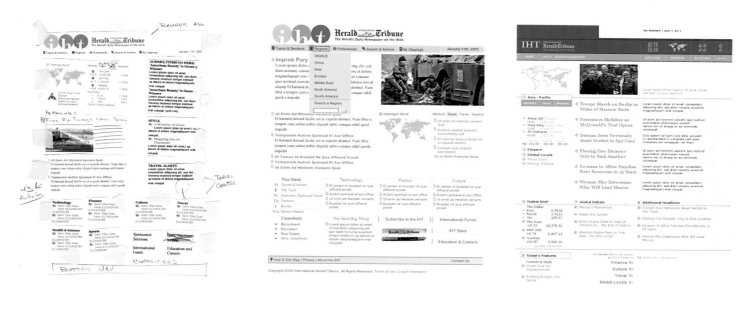

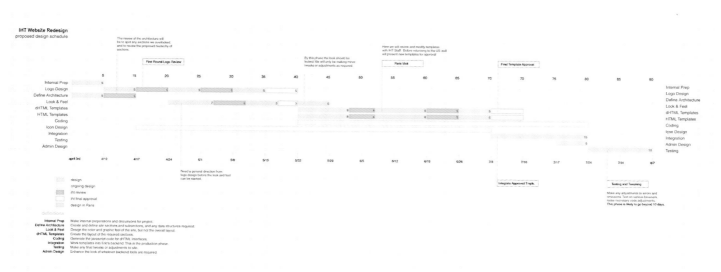

**Middle left** Paper cutouts, tape, and glue were used to lay out the pages. Early on, it is often faster to move the paper by hand than to do so digitally

**Middle center** Prototype of the Homepage: the major elements—world map, clippings, and dropdown menus—were incorporated in the prototype

**Middle right** Weir's preferred design: "The IHT did not like it at all. Eventually I was able to push it through, although I had to alter the colors and make it less flat"

As Print Studio Manager at the Architectural Association, an average day for Nicola Bailey can involve anything from production to graphic design to web direction.

Although run as an independent publishing house, the studio is also part of the Architectural Association and provides a backup service for the Architectural Association School of Architecture, designing prospectuses, brochures, and leaflets, as well as running the website and serving the advertising and marketing departments. "We have a strange twin life, which can mean that at times the two things are fighting for attention over one another," says Bailey. "And we have an unusual balance of work through the year." Currently, the studio is working on three books, a magazine, and a website, while at the same time producing mini-documents for inside the school, weekly event listings and notices, and weekly event posters.

The print studio is currently run with a team of ten staff, including marketing and distribution staff and four editors. Although the editors have autonomy within their own areas, the task of overseeing the running of the studio falls to Bailey. "I'm the only one who gets nervous if I don't have a flatplan,"

she says laughing. "I have a flatplan for everything. I find they're absolutely invaluable. That way, if the printer rings up with a problem on, say, page 35, I know exactly which section it's in and where to find it."

The Studio has been in existence for years, but the current team has only worked together for the last two, so every new book is "another learning curve about what we can do better and how," says Bailey, pointing out that increased productivity means they can no longer afford to be as casual as in the past. "We've realized that we have to be far more rigid about how files are worked on and where they're put. The same with pictures because it only takes one person to be away and the whole thing falls apart.

"Some years we produce just two books, but this year it's going to be more like eight—and that doesn't include things like the end of year review for the school—which last year ended up being a 320-page book that we produced in three weeks!" Although this is undoubtedly the busiest time of year for the team, careful planning ensures the workload doesn't get out of hand. "The best way is often to work backward," she continues. "We know Projects Review

is in June and the prospectus comes up in September, so we try to plan our production schedule around these."

Once informed about a new book project, Bailey's first task is to calculate a timeframe and consider how the material will be supplied. "Some will be completely supplied—they will have scanned their images or supplied them digitally so it's a very straightforward process," she recalls, "whereas others will bring piles and piles of folders and original material, which takes a lot longer to sort out."

The organization and cataloging of imagery also requires a great deal of attention. "For example, with the Projects Review, if you have ten different units giving you images marked one to ten and then search Quark for image one, before you know it you have multiple files and no idea which is correct." To avoid confusion, each time a file is worked on by a member of the team, it is renamed. "We try to keep the three stages of drawings," explains Bailey, "so we will have a folder for each project featured, which will then contain three sub-divisions: the original, reoriginated, and final." Copy is cataloged in a similar way using a simple initial system whereby each time the text is picked up

# TALKING POINT

## The Print Studio Manager

by an editor or designer the file takes their initials, before being passed on.

Working with highly specialized subject matter also brings its own set of design considerations. The team always tries to make sense of what the material is, rather than just make it look good but, as a designer, it can be difficult to instantly have a knowledge of such subjects. "We have a book coming up that is very math-based, so the thinking is to go and work with the author right at the beginning, rather than make it a pretty picture book. The material is very pretty to look at, but if you don't understand it, then, in a way, it just becomes another pointless book." There are also times when specialist imagery, such as engineering drawings, need to be translated into a usable format.

For Bailey, the most complex aspect of her job is the day-to-day running of the studio—answering the phone, organization, making sure files are coming in, and that everyone knows what is happening. The most important, however, has to be printers' deadlines. "One is often soothing printers along with authors and everybody else," says Bailey, who places a lot of emphasis on establishing a strong relationship with her printers.

"They give us a good price because we do a lot of work with them, but you need to build up that relationship and be able to ask them questions without feeling silly. A lot of it is how well you get along on a personal level, and how quickly they get a message to somebody when you call." Then there is the time spent "playing off printers against each other," the same with paper merchants. The studio currently uses international printers.

Although the majority of the books are designed in-house, there are times when the design is commissioned out. "At that point, designer and editor work closely, but then I will be brought in as soon as files start to be originated outside the studio. It's important to know how they are managing the material too, so that when the files come back into the studio, they are what we expect. Also, if we think there's a better way of doing it, it's best to tell them at the beginning than halfway through a project."

# NAVIGATION

"Once a journey is designed, equipped, and put in process, a new factor enters and takes over…it has personality, temperament, individuality, uniqueness. A journey is a person in itself, no two are alike" <span style="font-size:small">John Steinbeck, author, b.1902</span>

Put simply, navigation is plotting and following a logical course to get from one point to another. Place this in the context of graphic design and little changes. But while this may be the most straightforward area of design to explain verbally, that does not make it the easiest to execute. From the design of a complex venue map to that of a complicated website, from large museums to city signage, a successful navigation system can mean the difference between success and failure for a designer.

A successful navigation system can make a huge difference to the user's experience and must be designed to cater to many different types of people, as what works for one may not work for another. For example, a teenager surfing the web and logging onto the MTV website has very different expectations from a picture researcher using the Getty Images site, and a professional working under extreme pressure and to a tight deadline has neither the time nor the need for fancy graphics and sound clips. They want a site that is fast and functional and that allows them the freedom to explore while still retaining their bearings. Multiple-user navigation systems, however, must incorporate the needs of many different users within a singular framework. "You need to find multiple points of entry to a single story and for a variety of people who all have different experiential requirements that need to be served," says Ralph Appelbaum, whose strong design team and commitment to social learning at Ralph Appelbaum Associates have seen him create more than 100 public spaces in more than 50 cities over the last 20 years, most notably the US Holocaust Memorial Museum in Washington, DC.

In order to achieve the correct balance between creative expression and functionality for a range of users, the designer must adopt a problem-solving approach to their work. As with any discipline, designers are constantly looking for new means of creative expression when creating signage and wayfinding systems, from specially commissioned public art, as in the Bristol Legible City project, to creating new and improved means of accommodating those with special needs, like the Ocean Club's Braille signage.

Successful navigation can be divided into two main parts: the overview and the system of signs. The overview of a navigation system can be presented in a number of different formats. A site map on the web, a venue map at the entrance to a building or museum, or a table of contents in a book or magazine all serve the same purpose: to provide a snapshot overview of content. The creation of an Overview Document

is vital in enabling the designer to develop a logical structure to the organization of large content. Consistent hierarchies may be created at this stage to aid the navigation. Often the designer will visualize ideas on paper before committing them to screen and, particularly in web design, referring back to these paper plans can save a lot of time later on when every inch of your screen is in use.

Having a complete understanding of the user's requirements is key to creating an effective hierarchy of information and, in turn, a strong system of signs. It is important to discuss this with the client. Who are the main users? In what order will they require the information and on what level? Mapping all routes and possible destinations as part of the planning process will highlight key information and decision-making points, from which it is possible to ascertain the different levels of information required. For navigation designed to explain physical space, constantly referring back to the environment in which the information will be used is key, as what looks great on-screen may be barely legible *in situ*. In terms of "viewing ergonomics," preparing preliminary mock-ups is essential for any designer in order to assess legibility, lighting, reading heights, and distances as early in the process as possible. It is now possible to use digital software to render designs in virtual space, but many designers find there is no substitute for printing out mock-ups to scale and testing them in position.

Particularly when working in exhibition design, creating a comprehensive graphics spec sheet to accompany every piece of artwork is an excellent means of detailing and tracking every component of your artwork. Large projects invariably involve the services of a number of different contractors and attaching a copy of your spec sheet to each piece of artwork is a simple way of ensuring the job is completed without error.

Formulating an overall design concept is just one part of the job, however; the processes, and people, required for its execution are another. Planning these projects can be a lengthy process, often involving large teams of external specialists and collaborators. For example, a large purpose-built exhibition may require the skills of both subject specialists and specialist designers. There may be a multimedia element—audio guides or touch screens, which must be incorporated into the overall graphic concept. Designing a large book may mean commissioning photographers, illustrators, and picture researchers, all of whom must be considered and, most importantly, budgeted for at the outset.

Navigation is intrinsic to any large-content project; one cannot exist without the other. Creating the optimal user experience is key and can be achieved in a number of ways, but what is common to all these examples is a well-considered basic system of approach that forms their foundation, irrespective of individual format.

**OCEAN CLUB** The Kitchen

**4**/96 Housed in a converted Methodist church in East London, Ocean is one of London's largest music venues, comprising three separate performance areas spread over four levels. The venue prides itself on being user-friendly to disabled and partially sighted visitors, despite the low-level of lighting and crowds typical to that type of space. Graphic design consultancy The Kitchen was brought on board right at the start of the project to design the club's identity. Then, some 18 months later, and just three months prior to the opening of the venue, they were called in again to design the signage system. "When we were first briefed at the beginning of that three-month period, we were given a complete retour of the building—a good two or three times," says The Kitchen's Rob Petrie. Working with both client and architect, they then went on to decide where the signage should be placed and what level of information was required. The relevant information on each sign was blind-embossed in Braille at the bottom of the sign (i.e. "Toilets upstairs" or "Cloakrooms"). This information is then repeated at the top of the sign in English. The three separate performance areas and four levels of the venue were then color-coded for navigation with each level being assigned a color. "The main navigational system uses quite large signage, almost like a meeting point, in the most obvious placement."

In keeping with the venue's musical ties, the design team also suggested building song titles into the signage. These titles were chosen in accordance with the information on the sign, and printed (as opposed to embossed) in a larger Braille font. "Stairway to Heaven" points to the toilets upstairs, while "Return of the Mac" directs users to the Cloakroom. These were added purely for their aesthetic value as opposed to function, of course.

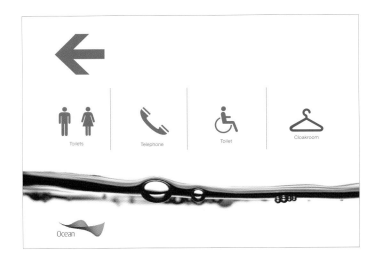

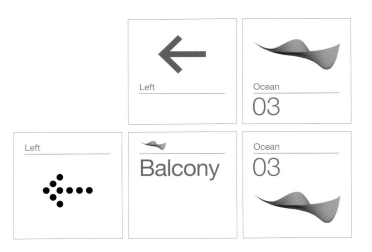

**All images on page** Early sketches/ideas for what would eventually become the final signage for the Ocean Club

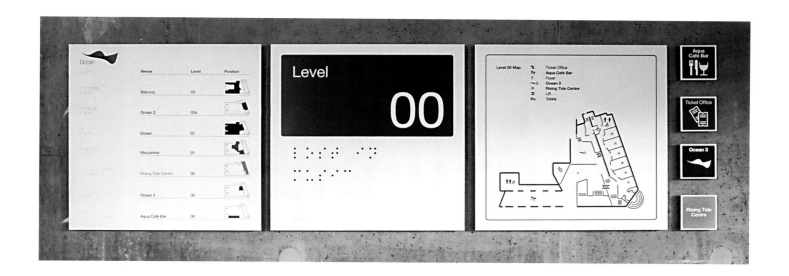

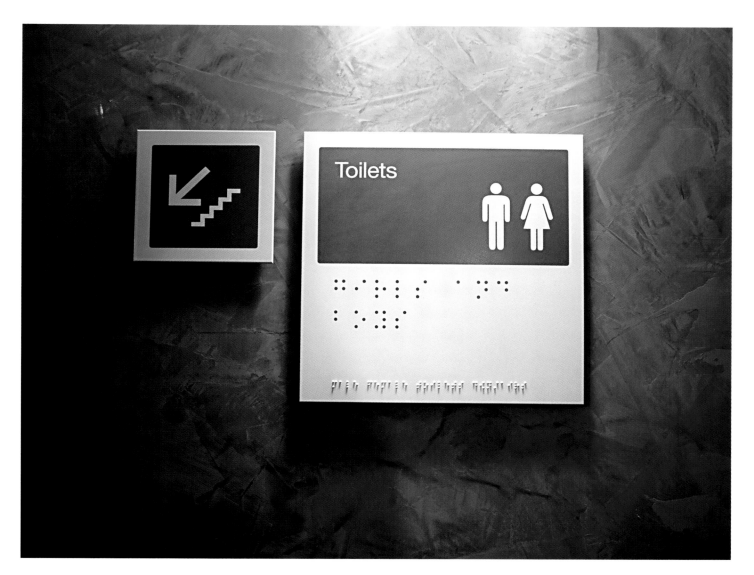

**Top** Located at the entrance to the venue, the Level 00 map details the layout of the whole building

**Above** The combination of symbols, a directional arrow, text, and Braille ensures that all users are catered for

## GETTY IMAGES WEBSITE Getty Images

**4**/98    Creating the optimal user-experience should be the ultimate goal of every web designer. The most successful projects are those that employ simple navigational techniques, allowing the user the freedom to explore while retaining their bearings. An excellent example of this is the Getty Images website. As one of the largest picture libraries in the world, the primary function of the Getty Images website is to provide all those involved in a project with fast and easy access to their vast selection of stills imagery, motion footage, and related services. It is imperative for multiple people to be able to step into the workflow on the site at any given point.

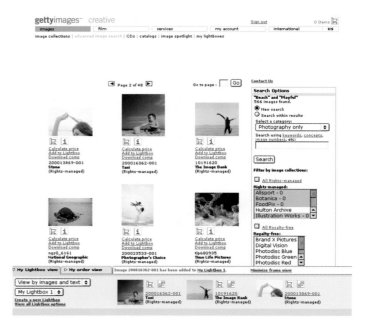

**Top** A simple, easy-to-navigate opener with instant access to all Getty Images collections. Users can go directly to the Creative site for still images, to News and Sport for editorial images, to Motion for stock footage, or view the tools and services available (including research and media storage)

**Above** The site's search facility offers three options—Quick, Search Options, and Advanced. Users can provide highly specific search criteria, such as the reference number for a particular image, or simply enter keywords for a more general search. There is also the option to select orientation and color preference

**Top left** The starting point for most stills image users: the Quick Image Search recognizes the needs of the busy, regular user. Users can refine their initial search by using the Photo/Illustration drop-down and the Rights-managed and Royalty-free checkboxes, or access other areas of the site quickly and easily using the global navigation

**Above left** A price calculator, which can be accessed from the Purchase and Download screens, allows you to price images in your local currency

**Top right** The main navigation bar spans the top of the home page, providing access to the various menu categories and subcategories, either by rolling over with a mouse or using the direct on-screen links. The Site map is accessible using the bottom navigation. Presented on one page, the main global navigation provides quick access to any page on the site

**Above right** Options to view details of images, download comps, or purchase an image can also be accessed from the Purchase and Download screens

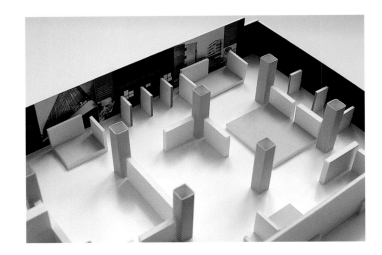

## THE BAUHAUS DESSAU John and Orna Designs

The Bauhaus Dessau was a major retrospective of the Bauhaus design school held at the Design Museum. The exhibition included many original works by leading figures of art, architecture, and design, drawn mostly from the Bauhaus archives of Berlin and Dessau. "Increasingly the designer has the responsibility of telling a story so that exhibitions are visually and aesthetically accessible to the public, of all ages and social backgrounds," says Orna Frommer-Dawson, who spent a significant amount of time researching the work of the Bauhaus designers, their products, and philosophies. "I could not have completed my design for this exhibition without having an intimate knowledge of the period—and of how three-dimensional design could be complemented by two-dimensional design panels and type to offer accessible, coherent information. A thorough understanding of the content and nature of an exhibition and the main visual theme you are attempting to demonstrate are similar to those that I encounter in book and information design."

When John and Orna Designs started the project, all items under consideration were initially checked for size. A scale model of the exhibition space was then produced. "Production of a model and scaling down of the exhibits was vital because we needed to know at an early stage how many areas for furniture, product design, and wall space would have to be constructed to display the collection successfully," says curator James Peto. "You have to know how much you have to accommodate before you can even begin to think of a design solution."

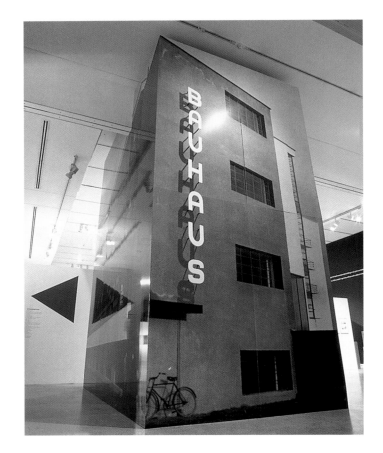

**Top** The Bauhaus' flexible approach to teaching was reflected through the use of freestanding internal walls arranged to a rigid grid defined by the series of pillars that run the length of the exhibition space. The production of the exhibition structure was developed in partnership with Richard Greenwood. This grid was further reinforced by painting each of the pillars in primary yellow and using them as signposts for information panels, cut from vinyl and applied directly to their surface. Visual indicators were designed to steer the visitor and to indicate changes of theme or period. This was achieved through large colored areas on the exterior walls contrasting with very large photographic enlargements and by the introduction of constructed walls—rather than by explicit signage
**Above** The exhibition entrance

**Bottom** The Bauhaus designed and produced "products" which varied in size from small pieces of jewelry to large housing schemes, but shared a common design approach. It was important to illustrate this range of scale and philosophy by placing different exhibits in relation to each other. "For this reason we decided to design 'room sets'; semi-abstract forms based on the dimensions of Bauhaus rooms, into which furniture and products could be placed to provide a familiar but neutral setting for the visitor." Photographs of Bauhaus architecture were printed and placed onto the full height of the gallery walls behind each of the room sets, allowing the visitor to experience the relationship between the various scales of Bauhaus design

**Left** In keeping with the Bauhaus' use of lower-case characters and sans-serif font, Futura, without capitals, was selected for the information panels and captioning of the exhibits—also cut from vinyl and mounted directly onto the walls and plinths

| MAP | PUBLIC LAYER | OLYMPIC FAMILY LAYER | STAFF LAYER | MEDIA LAYER |
|---|---|---|---|---|
| Venue Maps | ATM Machines | Accreditation Office | Access Control Points | Accreditation |
| | Concessions | Communication Control Rooms | ACOG Offices | AOB Information Office |
| | Drop off/Pick up Areas | Compound Area | ADA Info | Drop Off & Pick Up Points |
| | Elevators | Doping Control | Eating Areas | Interview Rooms |
| | Emergency Exits | Field of Play | Elevators/Escalators | Media Entrances/Exits |
| | Entrances/Exits | Info '96 Kiosks | Fire Alarms, Extinguishers | Media Parking |
| | Field of Play | Jury Rooms | Help Desk | Mixed Zone |
| | Fire Extinguishers | MARTA | Hostess Lounge | Press Conference Room |
| | General Info Booth | Mixed Zones | Hostess Waiting Room | Press Sub-Center |
| | Language Service Centers | OLF Elevators | Information Booth | Press Tribune |
| | Locker rooms | OLF Entrances & Exits | Load Zones | TV Compounds |
| | Lost & Found | OLF First Aid | Logistics Facilities | |
| | MARTA | OLF Lounge | Lost & Found | |
| | Medical Facilities | OLF Parking | Medical facilities | |
| | Merchandise Sales Areas | OLF Pickup and Drop Off Areas | Merchandise Warehouse | |
| | Olympic Transportation System | OLF Restrooms | Motorpool Drivers' Lounges | |
| | Parking | OLF Seating | Restrooms | |
| | Prohibited Items | OLF Smoking Areas | Security Posts | |
| | Restricted Areas | Protocol Office | Staff Entrances/Exits | |
| | Restrooms | Restrooms | Staff Lounges | |
| | Seating | Security Sites | Telephones | |
| | Security Stations | Sports Info Desk | Transportation Lounge | |
| | Smoking/Non-smoking Areas | Warm-up Areas | Transportation Malls | |
| | Suites | | Venue Mgmt. Compound | |
| | Taxi Stands | | Water Fountains | |
| | Telephones | | | |
| | Ticket Windows | | | |
| | Water fountains | | | |

## ATLANTA OLYMPIC VENUE MAPS International Mapping Associates

**4**/102 International Mapping Associates (IMA) was asked to design a series of venue maps for the 1996 Atlanta Centennial Olympic Games. Each map was produced in four versions (public, Olympic family, staff, and press) to cater for different audiences. Although IMA initially lost the bid to design the maps, it was asked to take over the project just six months prior to deadline.

Part of IMA's task was to simplify the amount of information the client wanted into what could realistically be shown. "Data is so prolific right now, especially in the mapping area, and part of my task was to make sense of that data but also to edit it, to be judicious about what we place on the final product and then to place it in a way that worked for both the client and their audience," says Bruce Daniel, Director of Design & Multimedia Production for IMA. For Daniel, the basic organizational structure of the Olympics was one of the most problematic areas. "It was mind-boggling," he says. "It's like taking a huge corporation and starting it from scratch, so no one knows each other and no one really knows what they're doing because they've never done it before." This also meant that finding and determining the best source material was not easy. "It is a matter of understanding client and audience well enough to be able to filter through what is the best material for the job—and it's not always about accuracy, it's about communication." Specific guidelines stating when certain materials had to be produced meant that black-and-white, diagrammatic operations plans of each site had already been produced a year earlier. According to Daniel, it was these drawings—given to IMA when it was brought in to take over the project, along with a set of rather too detailed architectural drawings for each site—that proved most useful because they had already been pared down. "I think part of the problem was simply gathering and editing the information from all these different sources," he continues. "It wasn't so much an issue of large content, as organized content—and of course things would change as we went along."

IMA was also issued with a graphics manual that included, among other things, all the symbols to be used on the maps. The maps themselves were primarily designed using Adobe Illustrator. "In map design one of the things you want to do is create multi-layers of information and separate them visually," explains Daniel. "We used different textures to help focus the main areas as well as gradients and bright colors. Software has already become much more sophisticated with things like transparency and drop shadows, which you would use to simplify the content today, but essentially it is about visual layering that allows you to look through a map, not just at it." Because of the international and wide range of the audience, the designers decided to stick to a limited color palette, using basic colors for the structural surroundings and roadways and bright, specific colors for the seating and the public areas.

IMA designed 44 maps in total in both English and French. This meant that all copy had to be sent to the Olympic translation committee, signed off, and returned before any of the designs could be finalized—a long and arduous process given that the Internet was still very much in development and files could not be transmitted electronically because of security issues.

**Top** In terms of the brief, the client's notion of what it wanted would have been impossible, no matter how small the venue was

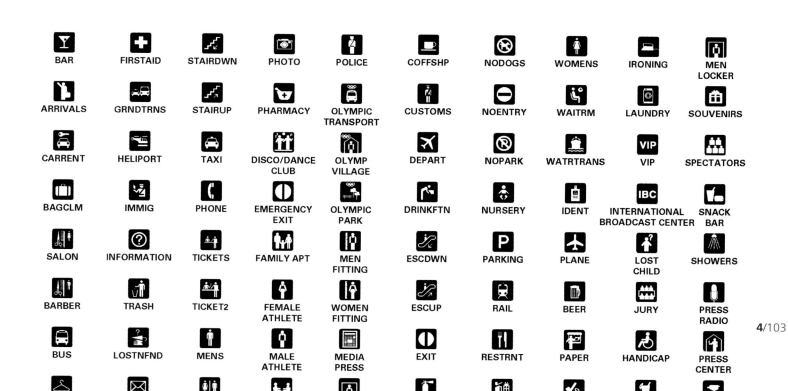

| | | | | | | | | | |
|---|---|---|---|---|---|---|---|---|---|
| BAR | FIRSTAID | STAIRDWN | PHOTO | POLICE | COFFSHP | NODOGS | WOMENS | IRONING | MEN LOCKER |
| ARRIVALS | GRNDTRNS | STAIRUP | PHARMACY | OLYMPIC TRANSPORT | CUSTOMS | NOENTRY | WAITRM | LAUNDRY | SOUVENIRS |
| CARRENT | HELIPORT | TAXI | DISCO/DANCE CLUB | OLYMP VILLAGE | DEPART | NOPARK | WATRTRANS | VIP | SPECTATORS |
| BAGCLM | IMMIG | PHONE | EMERGENCY EXIT | OLYMPIC PARK | DRINKFTN | NURSERY | IDENT | INTERNATIONAL BROADCAST CENTER | SNACK BAR |
| SALON | INFORMATION | TICKETS | FAMILY APT | MEN FITTING | ESCDWN | PARKING | PLANE | LOST CHILD | SHOWERS |
| BARBER | TRASH | TICKET2 | FEMALE ATHLETE | WOMEN FITTING | ESCUP | RAIL | BEER | JURY | PRESS RADIO |
| BUS | LOSTNFND | MENS | MALE ATHLETE | MEDIA PRESS | EXIT | RESTRNT | PAPER | HANDICAP | PRESS CENTER |
| COATCHK | MAIL | RESTRMS | INTERVIEW | WOMEN LOCKER | FIREXTIN | SHOPS | TOBACCO | DRINKS | PRESS TV |

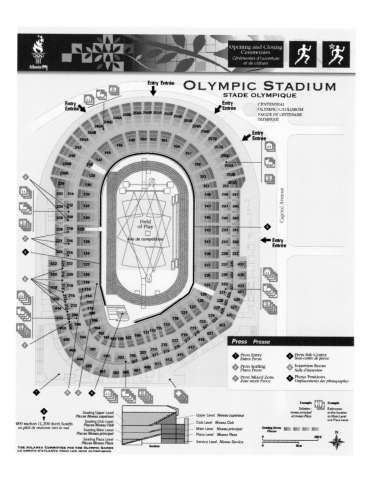

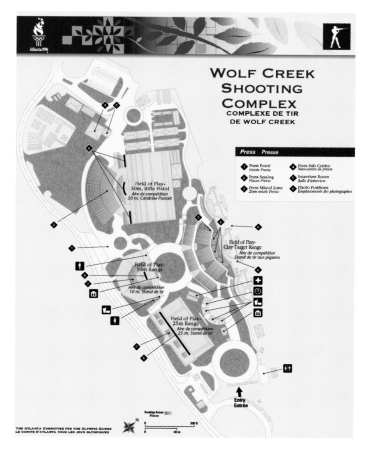

**Top** A graphics manual containing this set of symbols was issued to IMA at the start of the project. These symbols were to be used on all the Olympic maps

**Above left/right** Venue maps created for the main Olympic Stadium and the Wolf Creek Shooting Complex

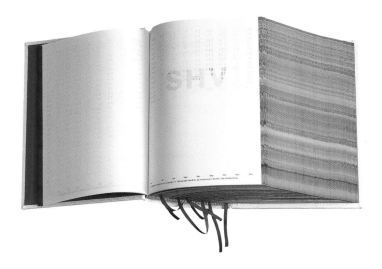

## SHV BOOK Irma Boom

Designed by Irma Boom, this 2,136-page book, weighing 7½lb (3.5kg), was created in 1996 to commemorate the centenary of Dutch multinational, Steenkolen Handels Vereniging (SHV Holdings), and took five years to complete. Given only a verbal brief to "make something unusual," Boom was essentially given carte blanche. As there was no text written specifically for the book, it was also left to Boom and Johan Pijnappel, the art historian with whom she collaborated on the project, to research the company's archival material and select the content. "I think the time schedule was exceptional," she says, "and the trust given. The fact that every door, every safe was open for us to get information was a necessity and was fantastic."

Within the five-year schedule, regular three-monthly meetings with SHV's board of directors ensured the project was kept on track, while the content itself was structured by creating what Boom describes as a "structure of study." This was used as a guide to the book's actual content. The only "specialists" working on the book were the translators whose task it was to translate the text from Dutch to English and from English to Chinese. "We had to provide them with the text and instruct them as to what kind of translations we wanted," recalls Boom. "As the book is about 100 years of SHV, ways of writing and speaking changed during that time. The translations had to take account of this, so it was quite a job to find translators to do this for us."

The overall design was driven by two factors: time, which, despite the five-year schedule was still not long enough, and the need for simplicity. As the book's structure and narrative were already complex, a simple design was important. "Grid-wise, the setup of the book is very simple. It is impossible to design 2,136 pages, so for every type of text there was a typeface, grid, color, etc." The size of the project was overcome through the use of a 24-page template. This was sent to the printer to input images, then returned to Boom to insert text and finalize the design.

According to Boom, the book should be a journey. "There is a nonlinear structure in the book," she says. "It is almost like browsing the Internet." This feeling is compounded by her decision not to include page numbers, thus encouraging the reader to explore the book's contents more freely. "We wanted a book that is going to be used; that works as a tool, a handbook," she concludes. "The ingredients we have chosen are of a specific kind which makes the book extremely interesting."

**All images** Spanning 2,136 pages, the SHV centenary book took five years to complete

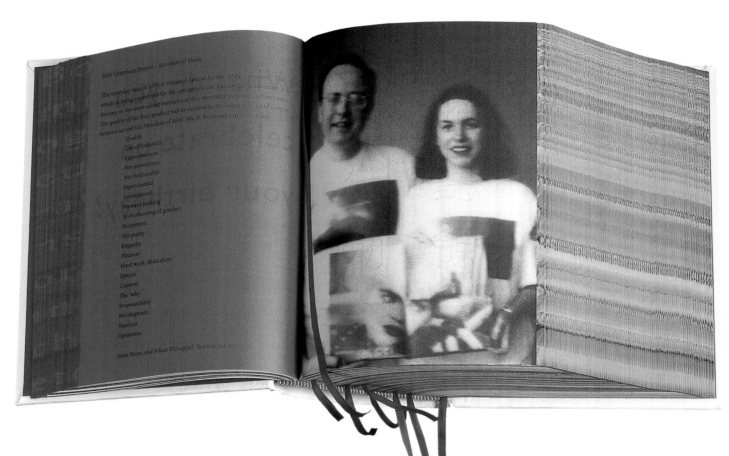

SHV Centenary Project – Structure of Study

The everyday face of SHV is rendered special by the 'SHV mentality'. This study, which is being carried out for the company's one hundredth anniversary in 1996, focuses on the most salient examples of this mentality over the past 200 years. The quality of the final product will be created by the mutual spirit of co-operation between us and the President of SHV, Mr. P. Fentener van Vlissingen.

  Quality
  Use of materials
  Expressiveness
  Not pretentious
  Not fashionable
  Experimental
  International
  Forward-looking
  No harbouring of grudges
  Enjoyment
  Not pushy
  Empathy
  Pleasure
  Hard work, dedication
  Special
  Content
  The 'why'
  Responsibility
  Not dogmatic
  Stamina
  Optimism

Irma Boom and Johan Pijnappel, September 1991

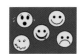

Many of the icons were based on sketches made by the children on the design team. The "feelings" icon evolved through three stages: Feelings 1 depicts the feelings as happy faces to create a more universal appeal, Feelings 2 shows what the icon looked like after the children's input, and Feelings 3, the final design

## INTERNATIONAL CHILDREN'S DIGITAL LIBRARY University of Maryland

The International Children's Digital Library (ICDL) is part of an ongoing research agenda at the University of Maryland looking at new interfaces for digital libraries for children. "Our interest is in understanding the way children search and use information," says Principal Investigator Allison Druin, who manages the project at the University of Maryland. "But our research is not only about developing the technologies, it is also reporting the processes we go through in bringing together adults and kids to make these new technologies."

Since 1999, the research program has been funded by the National Science Foundation, which has recently set up a substantial five-year grant. Additional funding is provided by the Institute of Museum and Library Services, which reports to the White House. "Their interest is in understanding the impact this kind of digital media may have on children thinking about books, libraries, and other cultures."

Aimed at children aged between 3 and 13 years, there are currently 200 books and 20 different languages featured on the ICDL, with an eventual goal of 10,000 representing 100 languages by the end of the current five-year grant program.

The site was developed through a combination of children teamed with adults. This process involved a variety of methods— from using art supplies to sketch ideas, to making low-tech prototypes, to using Post-it notes for frequency analysis.

The navigation system was designed, again by working with children, to develop a metadata scheme that allows the children to search for books via a range of criteria. "You can combine categories in a Boolean visual way and that's another combination of functionality and visual sense that is unique to our research," says Druin. "It's really about focusing on how we can think of new paradigms and more appropriate paradigms for kids."

While the majority of on-line libraries focus on keyword searches or lists of books, the ICDL offers children a much more visual experience. This type of visual search—using book covers rather than text—means the library is also accessible to new readers and children who are preliterate. The site uses Java Web Start, allowing users to zoom in and out without losing the context of where they are with a book. Another unique feature is the three book readers—Standard, Comic Strip, and Spiral—that allow children to visualize and experience the books in a variety of ways. "This comes directly out of our research of working with kids and understanding that, depending on the type of book, the child's goal in the reading experience, even their mood, can affect which book reader they use."

Search results are shown visually along the body of the caterpillar

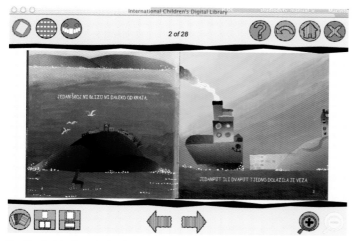

The Standard book reader, for those who want to read a book from beginning to end. Books can be viewed as single or double pages, horizontal or vertical

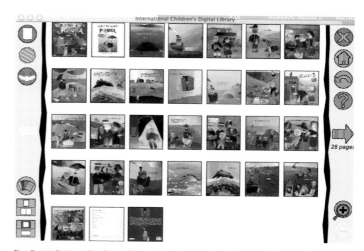

The Comic Strip reader shows the entire book as a series of thumbnails from which children can choose a page, and then zoom in

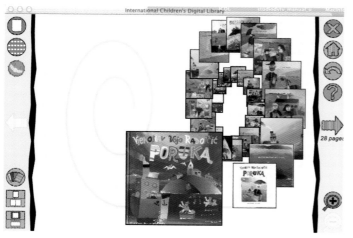

The Spiral book reader gives the option of flipping through the book to see all the pictures

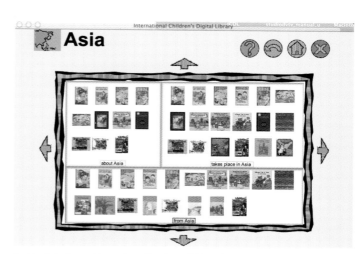

Find books in the world: overview of books available in the Asian category

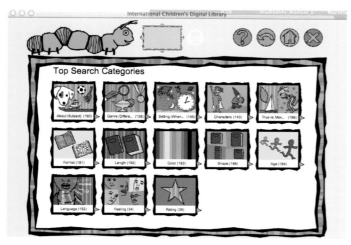

Children can search for books via a number of different categories

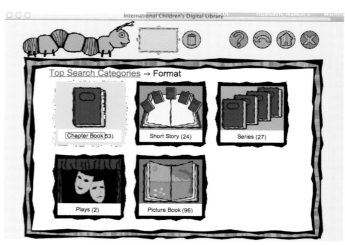

The ICDL format search

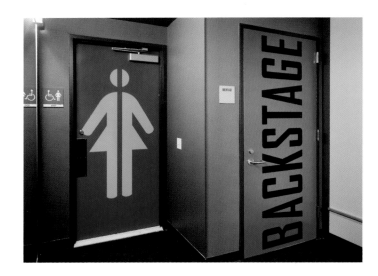

## NEW 42ND STREET STUDIOS Pentagram New York

**4**/108 Located between Broadway and 8th Avenue in New York, the New 42nd Street Studios houses ten floors of rehearsal space for performing arts groups, as well as the 199-seat Duke Theater. The building's environmental graphics and wayfinding signage were created by Paula Scher, as lead designer, and three of her team at Pentagram. "On a job like this, I usually work with two segments of my team: the graphic designers will work on the identity and its applications, and the signage designers will find ways to integrate and implement this within the architecture. The senior signage designer oversees the fabrication and installation alongside the project architects." The building itself was designed by Charles Platt of Platt Byard Dovell White. "We had a great relationship and I love Charles's work," says Scher, who has since designed the Platt Byard Dovell White identity and website. "On this project he was very open to having the building graphics collaborate with the architecture."

Scher's approach to any large-content project is to simplify and to find an overarching idea that can be understood and applied to a variety of situations. "The point is," she says, "if the idea is broad enough, it can be iterated in any form: two-dimensionally, three-dimensionally, motion graphics, etc. I look for one idea that is infinitely adaptable.

"Sometimes it comes from the architecture; sometimes it comes from the institutional identity or the use of the building, but visually everything has to serve this one larger principle. And I tackle it as I would a piece of graphic design."

Scher describes the key phases of the project as: 1 the big idea; 2 demonstration of the big idea in a variety of situations; 3 shop drawings; and 4 installation. On this occasion, the finished installation was almost a direct translation of the team's initial idea and drawings.

In creating the signage for the New 42nd Street Studios, Scher was able to take her inspiration from the space itself. "I wanted the graphics to match the level of activity in the place," she says. "The building is for entertainers, and the graphics entertain. The tools of navigation put on their own performance throughout the building." Influenced by De Stijl and Dutch modernist typefaces, the graphics also serve as a visual counterpoint to the minimalist studios, while the floor-based wayfinding was inspired by performers' stage marks and by New Yorkers' habit of looking down as they walk.

With navigation as its central focus, a successful wayfinding system uses typography, icons, colors, or materials to guide people where they want to go. Such systems should be functional, accurate, and easy to use, but, as Scher points out, this is not always the case. "I think many times wayfinding ends up accommodating the architecture instead of the user," she argues. "One consideration was the floor plan: it is treated like a decorative afterthought, just a bunch of type placed on a wall." For Scher, a successful wayfinding system is one that integrates the graphics and architecture to make something new. "It actively participates in creating one's experience of the building. It uses the facts of navigating to surprise, delight, and entertain."

**Top/opposite** Environmental graphics for the New 42nd Street Studios/Duke Theater

NEW 42ND ST. INC.

9

MARIAN HEISKELL
STUDIO 9A

6

JOAN AND JOE CULLMAN
STUDIO 9B

2M

STUDIO 9C

STUDIO 6A

LuEsther Mertz
BOARD RM

DRESSING ROOMS

STUDIO 6B

PRODUCTION

1

JERRY ZAKS
STUDIO 6C

8

DRESSING ROOMS

WILLIAMSTOWN THEATRE FESTIVAL

ROUNDABOUT THEATRE COMPANY

4

MARIAN'S LOBBY

PARSONS DANCE FOUNDATION

ADDITIONAL TENANT

STUDIO 4A

2

THE DUKE ON 42ND STREET

3

STUDIO 3A

STUDIO 4B

BOX OFFICE

STUDIO 3B

STUDIO 4C

5

BUILDING ADMIN

7

JEROME ROBBINS
STUDIO 7A

DRESSING ROOMS

NEW PROFESSIONAL THEATRE

STUDIO 7B

DOROTHY AND LEWIS B
CULLMAN
STUDIO 7C

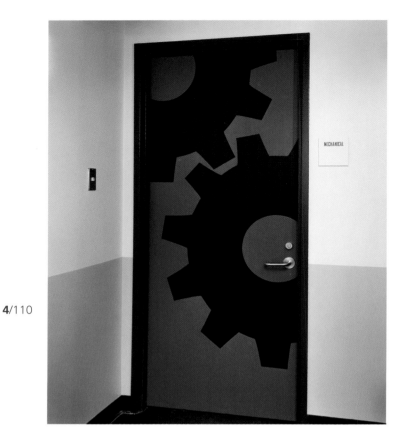

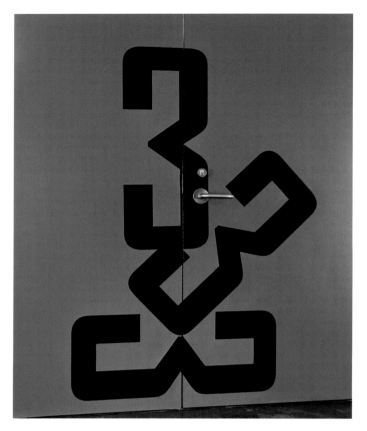

**Top/above** Form and function combine as every available surface area is incorporated into the studios' wayfinding system

**Opposite** Floor-based wayfinding inspired by performers' stage marks and by New Yorkers' habit of looking down as they walk

Based in New York, Charles Platt is a highly experienced architect and Partner at Platt Byard Dovell White Architects, the practice responsible for, among other things, the phenomenally successful New 42nd Street Studios building. Winner of multiple design awards, including a 2002 AIA National Honor Award, the building is a creative "factory" for the performing arts and was designed, recalls Platt, "somewhat in rebellion against the requirements of the City and State, as embodied in what was called the '42nd Street Development Project,' an offshoot of a New York state agency." Original guidelines required the "application" of signage and lighting. "From the outset we decided to make the building *represent* signage and lighting, rather than merely reflect it in the highly retro, artificial, and unimaginative way prescribed by the agency," he continues. "We wanted the building to *be lighting* and to *be signage* (night and day). It was especially important that the building integrate and represent this both inside and out." All of this was in addition, of course, to answering the program requirements of providing spaces and wayfinding for the studio's various elements. The resulting building—84,000 sq ft (7,800 sq m)—now serves dance companies and many other nonprofit groups with rehearsal studios, studio/reception halls, a 199-seat black box theater, known as The Duke on 42nd Street, and related administrative offices and support spaces.

In terms of the architect–designer relationship, "The architect," says Platt, "needs to set forth the artistic, social, and philosophical meaning of the proposed work and then engage in a continuing back-and-forth process with the designer, each commenting on, interpreting, and criticizing the other's work." Although, generally, he sees his role as that of a partner, it does depend both on the situation and the relationship that develops with the client. "Sometimes we hire the designer as a sub to us, in which case we are responsible and have to answer for the designer's performance, therefore, we take more of a leadership role and act as more of an arbiter."

At what stage the graphic designer becomes involved in a project varies from job to job too. "If graphic design issues are to play a significant part in the project, it is good to involve the designer early, whereas if it is merely 'wayfinding'-type signage, then later is often satisfactory and avoids revisions and wasted effort." That said, in Platt's opinion, graphics should be an integral part of a project, not applied to a finished, or almost finished, architectural design.

The signage system created by Paula Scher for the New 42nd Street Studios building is an excellent example of this thinking. Scher was brought in fairly early in what Platt describes as "the Design Development phase." "Looking back I would say that the relationship developed initially with some hesitancy, suspicion, and apprehension," he recalls. "Not having worked together before, neither of us knew what to expect." That said, Platt now cites Scher as one of his favorite collaborators, along with Chermayef & Geismar: "I like them both because of the extraordinary quality of their work and ease of communication."

The Studio building ranks as both Platt's favorite and most complex project to date. "'Perfection' (within a budget) was something that the client wanted, in fact insisted upon, and was willing to take almost infinite pains to get, sometimes at excruciating lengths," he says. "For the same reasons, this was our most difficult project."

As an architect, Platt finds himself collaborating with various consultants—structural, acoustics,

# TALKING POINT
## The Architect

lighting, and graphics—as a matter of course, although collaborators do vary with the project requirements, and according to availability. Then there is architectural design collaboration, which takes place entirely within the office. "Usually all four partners here have something to say and contribute. I tend to collaborate most with Ray Dovell, especially on large projects as we are the principal architectural designers, generally."

"For us, graphic design should be integral to the project and may involve much more than 'wayfinding,'" he concludes. "Alas, not every project involves, or allows for graphics."

# ECONOMY

"Technical skill is mastery of complexity while creativity is mastery of simplicity" E.C. Zeeman, mathematician, b.1923

## INTRODUCTION

Economy, whether financial, practical, or theoretical, is a challenge that every designer will face at some stage in their career, but for those working on large-content projects, such "limitations" are increasingly commonplace. The trick lies not in viewing these as creative constraints, but in embracing the challenges they present.

Rebecca Foster thrives on exactly this type of challenge. Given only a modest budget to design a range of information leaflets for The Portland Hospital, she used one system— a time schedule that allowed only a certain number of hours to be spent on each element of the design—to accommodate a dual need. Through this approach, she was able to ensure that the job was completed both on time and within budget.

While Foster knew the project was large, she was not initially asked to consider the overall task. Economy of information is not an ideal situation when dealing with large projects, but can be overcome. It is important to retain clear control of at least one area in order to manage the economy of big content effectively, whether this means knowing about a project in its entirety or, as in Foster's case, taking control of the project's time management.

Then there are the practical considerations of time and space. Stefan Sagmeister addresses both these in his infamous poster for the AIGA Biennial Conference in New Orleans. Faced with a vast amount of content and such a confined space, Sagmeister opted to simply write the information by hand, amendments and all.

Economy does not always have to be imposed on a project, however. There are also times when it is independently selected as the most appropriate solution. For example, when information cannot be efficiently communicated with words, such as when technical language is involved or when information has to be expressed in more than one language, the solution can be dramatically simplified by adopting a strong, visual language of symbols instead. Alexander Gelman describes this approach—stripping away the extraneous in order to reach a clear, elegant solution—as the process of Subtraction. This methodology is exemplified in the universal iconic language Gelman designed for Seiko Epson to replace the spelled-out words printed on the control panels and remote controls of its LCD projectors. Taken at face value, the resulting design solution seems simple, obvious even, but the process of Subtraction is rarely so.

From a purely design point of view, modernism considered stripping away inessentials and questioned what we mean by "decoration" and "style." Perhaps more importantly though, many "modernists," particularly following the World Wars, were also socially and politically motivated and believed that design could be put to use as a practical benefit to society. Lucienne Roberts agrees, but also warns against adopting the modernist aesthetic as a "style" without understanding the basic principles that underpin it. "I don't see much evidence of socially engaged work around me, but I do see minimal pieces of typography that are derivative of post-war Swiss design," she says. "Graphic design seems far too self-referential at the moment. If it continues this way it is totally self-destructive. Design only makes real sense when it is part of the rest of the world."

For Rebecca Foster, using only the essentials to convey a message has become a signature element of her work and not only guarantees that every part of the design has a purpose, but is also, she says, "a way of ensuring I have delivered the brief accurately without embellishing or hiding from a problem I didn't solve." When designing large projects, retaining a sense of economy is judicious. The structure of the design should be elegant and functional; extraneous areas will confuse the navigation and hinder understanding. Hierarchies also lose effect if too many levels are created. Limiting work to the times allocated on the schedule prevents a project from becoming lop-sided and ensures each stage of development is afforded equal attention. Thus, issues of economy are central to the successful management and design of big content.

Part of any designer's role lies in solving problems—in overcoming whatever limitations you are faced with in order to achieve the most effective solution. Economy, whether of time, space, money, or information, will only impede the design process if you let it. Sure, you can view this as a constraint, but as the following examples show, not only is it possible to overcome these constraints, but they often provide the foundation for some of the most innovative design solutions.

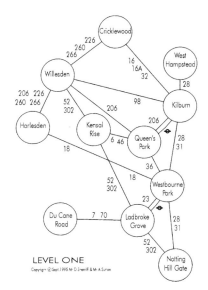

LEVEL ONE
Copyright © Sept. 1995 Mr D. Sherriff & Mr A. Sutton

**JOURNEY PLANNERS** Quickmap

**5/118**

Set up in 1999, Quickmap is the small, independent cartography firm responsible for producing the only inclusive subway, train, and bus map of central London. Rather than being highway-based, Quickmap's journey planners are developed using the capital's transport corridors as their foundation. Although they contain a lot of information, the way that information is presented—in a simply structured, pocket-sized format—makes it easy both to understand and to use.

"We develop our structures where you zoom in and out between detail and generality," says Andrew Sutton of Quickmap. "Computers do not always help in the initial stages, whereas drawing skills can give you a very important grounding from which you can then flesh out your ideas." The maps are designed using CorelDraw, and by creating different layers that can then be turned on or off to produce the different variations. According to Sutton, the primary aims of these maps are to simplify navigation around the capital and encourage more people onto public transport. By taking information out, rather than adding to it, and by making that information both user-oriented and a pleasure to use, Sutton hopes to encourage users to become more "competent travellers." "Understanding the basic structure and making that as simple as possible is something that doesn't always happen in the commercial world. It not only helps you define your argument, it also makes your thinking clearer to others." On this occasion, economizing on the amount of information and on the map's structure resulted in a clear, concise, and, most importantly, user-friendly design. In addition to their London planners, Quickmap also produced a Glasgow bus map commissioned by First.

**Opposite** Section of Quickmap's "All-in-One": inner London's only integrated bus, tube, and train system map

**Top** London by bus: basic
**Middle** Central London's nightbus routes

**Bottom** The "walk" map details key attractions and travel locations in central London

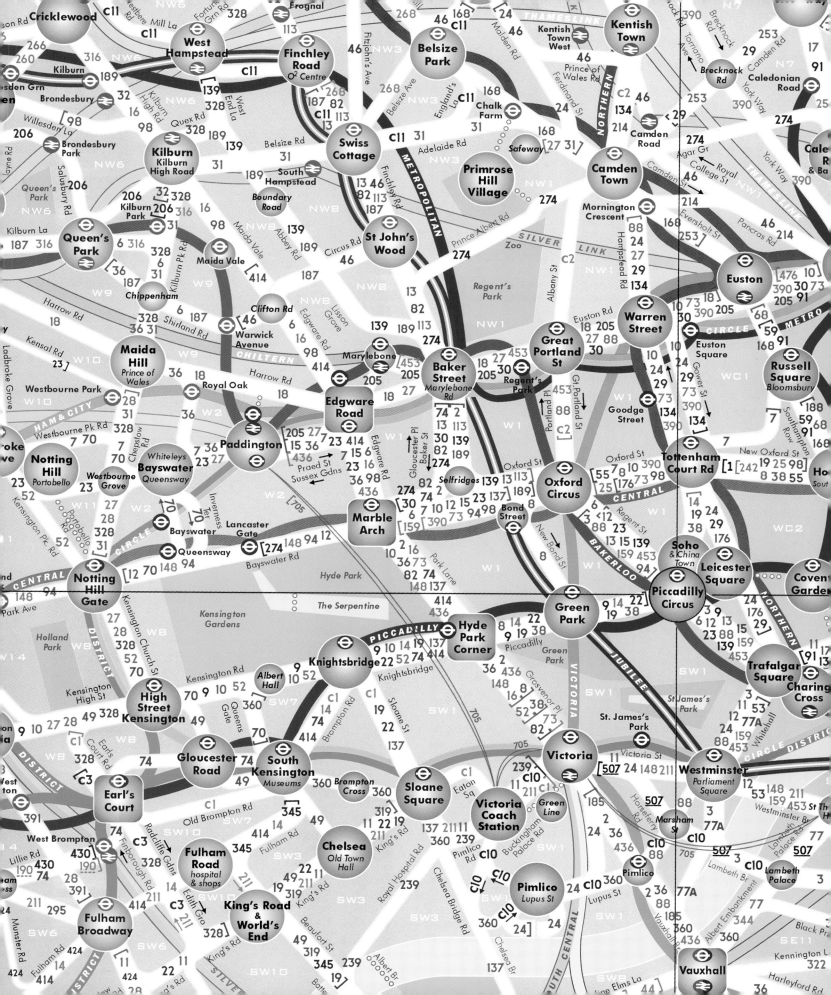

**AIGA BIENNIAL CONFERENCE POSTER** Sagmeister Inc.

When Stefan Sagmeister agreed to design a poster for AIGA's 1997 Biennial Conference in New Orleans, he had not anticipated the vast amount of information that needed to be included. "The client sent over a 24-page manuscript of copy to go on the back of the poster," he recalls. Unsure if this was even physically possible, he set about trying to organize the data into some kind of orderly fashion, but the sheer volume of information was just too much. If ever there was time to break the rules, this was it. "I was trying to make sense of the copy and how it would all work," he continues. "It became clear that with 80 speakers in two and a half days in eight auditoriums, and four things going on at the same time, this conference would be a happy chaos." And would the poster? "We tried to do the information graphics thing with different weight rules, color coding, etc. Then after a day or so we threw all that out and wrote it any which way." A chicken-foot typeface was designed using Photoshop, providing the Voodoo element, and then it was a case of all hands on deck as the entire studio set about writing the information onto the artwork by hand. Where information needed to be highlighted, the designers simply added their own doodles by way of extra emphasis. Subsequent corrections were easy to incorporate as they arrived because they could just be squeezed in or written on top of the existing artwork. On this occasion, the economy of space imposed by the poster format forced an original take on the management of large amounts of information, resulting in a highly recognizable and often-reproduced piece of work that has spawned much imitation since it first appeared in 1997. It is also important to note that this poster, aimed at the visually literate, was well suited to its audience—designers expecting unusual mental stimulation from the conference that the poster advertised.

**Top** The front of the 1997 AIGA Biennial Conference poster

**Above** The reverse of the poster: a work of art in itself

## THE PORTLAND HOSPITAL INFORMATION LEAFLETS Rebecca Foster

When Rebecca Foster was commissioned to redesign the printed material for The Portland Hospital, a private London hospital dedicated to women and children, her main objectives were to create a set of literature that didn't conform to the clinical stereotype of hospital literature and to ensure that the different visual elements—typography, color themes, icons, diagrams, photography, and illustration—complemented each other. "Each department wanted to retain their own character, but the overall feel of the literature had to reflect a strong cohesion in terms of its appearance," she says. The project included reworking the hospital's corporate literature and its departmental leaflets/brochures, consultant newsletters, advertising, and the children's club membership material. "I always started each new part of the project with a schedule and specified when proof and sign-off stages should happen. It was imperative that the client kept to my planned deadlines in order to meet the printer's deadlines." After reviewing the existing print material, it became apparent that new imagery was a must. Foster commissioned a photographer to document every department and floor in the hospital, resulting in a "visual encyclopedia" from which she selected images relating to the accompanying copy.

Working within a modest budget and to only a verbal brief, Foster was made aware of the scope of the project although she was not initially asked to consider the overall picture. Rather, each piece of print was requested as and when it became "urgently" required, as the job grew progressively larger. This is not an ideal situation in which to work, but by retaining clear control over at least one area—in Foster's case time management and scheduling—she was able to manage the project effectively. That said, because the project unfolded in this way, any issues arising from the first brochure could be addressed and thus forecast how the following pieces were structured. By generating the illustrations, diagrams, and icons herself, and by allocating only a certain number of hours to each element of the design,

she was able to keep the job on target and within budget. While some designers view a limited budget as a constraint on their creativity, Foster does not. "The issues arising out of a brief remain the same," she points out. "In this instance I would have created these visuals myself whatever size the budget was."

The main corporate brochure and leaflets required the careful positioning of images to correspond with the text, so a flexible typographic structure was developed underneath the image grid providing the axes for the layout. White space was also vital. "The white space became an inherent part of the design to reflect the more clinical side of the hospital and to provide a foil for the warmth of the photos." The newsletters, being denser in text, had a stronger typographic identity and layout, while the children's material was naturally more visual. Foster also set up strict style sheets as many of the jobs were repeats of a design. "I always work on top of my last artwork in order to maintain continuity in a series of brochures, for example. This allows you to always improve on the design and tweak the style sheets if necessary." Foster also keeps a drawn diary of her larger projects, and when working with large numbers of images always gives each image a quirky name. "It makes it much easier to picture the image quickly when making a choice—I don't worry what the repro house thinks!"

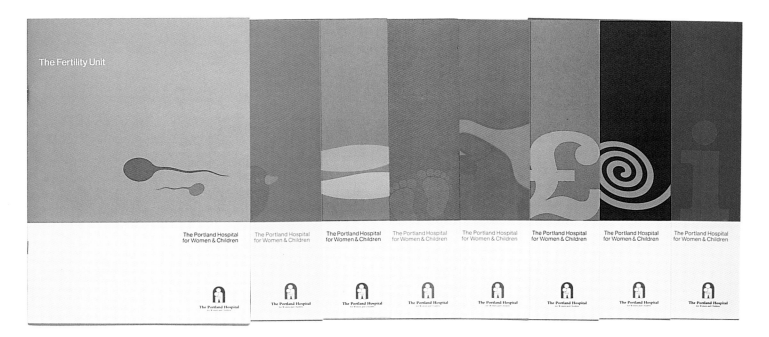

**Top** Initial sketches for the hospital's departmental leaflets
**Bottom** Covers of the interdepartmental leaflets, Each department has a specific icon and color. This helps identify different areas within the hospital and works as internal branding

**Middle** Foster began by processing the draft text manually, working out on paper the page plan and proportion of text to image per page, before using a trace pad to draw each page, indicating the position of text, headings, and images

**LEARNING JOURNEY** Atelier Works

Economy of information, implemented correctly, can provide a clear, concise design solution to large amounts of complex information. The UK's National Curriculum is an exhaustive document but through careful consideration, not only of the information at hand but also of the way it is to be used and by whom, Atelier Works were able to use this reductive approach to bring the information into the public domain for mass consumption.

The aim of *Learning Journey* was to take the National Curriculum (a vast document covering everything children learn at school between the ages of 5 and 16) and strip it back to produce a format that was easy to use, clear, and palatable for parents and children alike. "The reason this information all had to be recast and edited was that the audience (or rather, readership) was entirely different: parents (amateurs) rather than teachers (who are trained professionals)," says Quentin Newark. "We naturally assumed the average reader of the *Learning Journey* is not an educational expert, nor are they necessarily interested in the detail of how their child is being taught."

Produced for the Department for Education and Employment, the guides were divided into three age groups, each explaining exactly what schools teach at that age and why. In order to determine the required level and quantity of information, a set of prototypes were designed in various levels of detail, and tested on focus groups. The minimum level of information was felt to be more than adequate. "This was an important test because, given too much detail, too bureaucratic a tone, too worthy a book, the parents would just ignore it completely and the project would be a waste," continues Newark.

When designing the guides, it was important to create a clear physical structure—the way the booklet, and each subject, is organized is understood instantly. It was also vital to achieve the correct balance between reassuring the reader with enough

technical information to gain their confidence and remaining accessible through the presentation of that information. This was achieved through a combination of words, images, and typography, as Newark explains. "The language is very plain, devoid of jargon, hopefully like a good teacher! The images are a deliberate mix: Quentin Blake's funny drawings, photography of children of the right ages, very literal still-life photography of any props. The typography is simple; clear, big headlines, big folios, a friendly typeface (Triplex)." Atelier Works also introduced the idea of a series of learning "Tips"—activities that any parent can do with their child without any specialist knowledge or equipment.

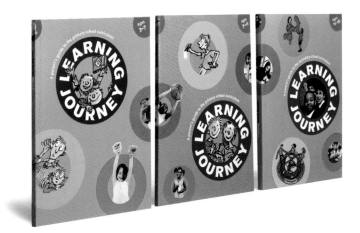

**Opposite** Initial thoughts and ideas for *Learning Journey*

**Top** Versions were created in large print, black and white, Braille (shown), and audio
**Bottom** Three booklets covering key stages (ages 3–7, 7–11, and 11–16) were produced

Landscape A5?
Cinematic for arranging the subject narrative.

Look at available matt web stocks 115gsm & up

Papers & finishes
obviously prefer matt as this is easy to read in all light conditions and picks up marks, can be written on, is alive. But is this regarded as cheap? by the en masse audience?

size:
as small as possible, pocket size purse/handbag

A5 made into square

issues of quantity of material each spread should make sense

A5

use as introductory guide for teachers!

typefaces? one for each subject? cover dark = English Futura = Maths Garamond = ??

VISUAL TONE
Halfway between a text book (authority) and magazine (accessibility)
Blend of the mechanics of these two forms:
strict type disciplined chunked text with free-edged illustrations
bars pull-outs arrows, devices.
Busy images, tete calm text.

Show photographs of parents & children - à la handbook or cookbook shows (implies) "this could be you" - identification - look to camera

splash of energy against verité

Tim Clark for photography (issues of permissions)

circle and arrow for captioning

circle folio?

Given the audience should obey convention in all navigational aspects: contents page, folios (big)

artwork? examples of coursework? or contrast photographs with illustrations

A5 also opens to A4 for photocopying

very tall? A4 divided in way, easily to photocopy certainly less usual

wiro becomes like a school-book less adult.

use falling dot as

Ensure the binding can open flat. Stitched?

circles throughout (font?)

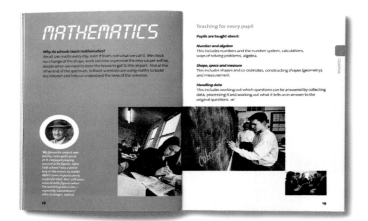

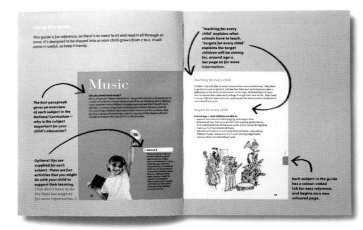

# 英文

英文課重點在於教學生掌握四種關鍵的技能，即「明晰的表述能力、傾聽別人發言的能力、仔細閱讀的能力、流暢書寫的能力」，掌握這些技能才能在學校學到更多的東西。英文能幫助學生創造性地表達自己的觀點、增強他們在公眾場合發言的自信、培養流暢的筆鋒。學生要閱讀世界各國的古典和現代散文及詩歌，分析作家們運用語言的本領並探索他們作品中揭示的社會和道德問題。

此年齡段學習英文的學生要閱讀大量的劇作、詩歌和書籍，既有虛構作品，亦有寫實作品，包括：

- 至少一部莎士比亞的劇作
- 其他重要創作家的作品
- 不同時代的小說和詩歌作品，包括當代作家的作品
- 外國作家創作的戲劇、小說和詩歌
- 寫實作品（例如日記、旅遊見聞、科學論文）

"英文對於我閱讀和分析文學作品以及自己的創造性寫作都起到很大的幫助。空閒時，我仍然寫文學作品，當然也喜歡大量閱讀。我覺得工作期間我時刻都在寫東西。學習英文能提高人們口頭交流和書面交流的能力——文學能把不同的人們帶到一起來：它能跨越國界，成為大家的共同話題。"
Heidi Gilchrist, 24 歲

## 8 年級的低谷

研究表明，8 年級的學生（13歲左右）學習興趣趨於低落。7 年級的孩子學習是有幹勁的，因為一切都很新鮮。9 年級結束時，學生開始選擇自己的主修科目，考慮「中等教育普通證書」(GCSE) 的考試以及參加全國統一課程測試。

在此之間的 8 年級學生就沒有這些重要關卡。為了提高學生的學習熱情，家長可以帶孩子參加一些既有趣味又與學習有聯繫的活動（例如，去有教育意義的地方旅遊、看戲或看電影、租借和學校的學習有關的錄影帶）。

**6  7  8  9  10**

# 數學

我們每天都會用到數學，只不過是我們不稱其為數學而已。在商店我們要檢查店員找回的零錢對不對，計算新地毯價格有多貴，確定何時動身去機場。請到更重要的計算，聰明的科學家們正是運用數學來建立電腦互聯網、幫助我們認識宇宙的規律。

學生們能學到：

- 數字和代數。這包括數字和數字系統、運算、解題方法、代數
- 形狀、空間和測量。這包括各類形狀和坐標、構造不同的形狀（幾何）、以及測量
- 處理數據。這包括哪些問題能透過收集資料並對其進行整理和分析來解答，並從中悟出道理

學生們能學會怎樣以數學的方式來思考問題。這一年齡段的孩子已能解決比較複雜的問題，包括需要分若干步驟來思考的問題，發展連貫推理的能力。

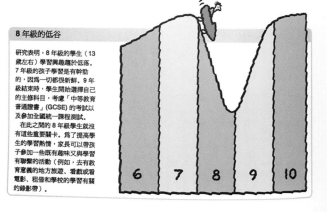

"我當初最喜歡的科目就是數學：我的數學成績很出色。我特別喜歡玩數字遊戲。中學畢業後，我當上了硬工，數學對我的工作反倒沒有特別重要的用處。可是我仍然喜歡電視上的數字遊戲——特別愛看 Countdown 節目！"
John Grainger, 退休工人

第 3 階鍵階段 (key stage 3)：11 至 14 歲的兒童學習起點座

**Top left** Spread from the 11–16 age-group book, explaining what will be taught
**Top right** Using this guide: an explanatory spread showing parents how the book works

**Above** As the guides had to be accessible to a range of socioeconomic groups, a tabloid version was designed and produced in nine foreign languages, including Chinese

## SEIKO EPSON UNIVERSAL ICONIC LANGUAGE Design Machine

In 1997, Japanese, hi-tech consumer product giant Seiko Epson commissioned Design Machine to design a universal iconic language to replace the verbal messages regularly printed on the control panels and remote controls of its LCD projectors. "At that time Epson used spelled-out words to indicate the different functions for the buttons," explains Alexander Gelman. "They were using seven different languages to accommodate each country that the product was exported to. Our brief was to replace all those languages with an internationally understood visual language of symbols." This is an excellent example of how large amounts of information can be successfully managed and expressed through reduction.

The process began by studying the manual and making initial sketches. Templates were then constructed using Adobe Illustrator. As the final design was to be silk-screened over the dark surfaces of the equipment, it was vital to ensure that the icons were bold and bright enough to be easily understood. Establishing the most appropriate metaphor for each function was the most complex part of the process. "When I began to study the list of functions I realized that the words didn't mean much by themselves without explanation. In order to understand the meaning, one had to either be familiar with the language of technical metaphors or simply use the manual as a key. In a sense, they were sort of verbal icons. Visual icons also require initial explanation, but no translation is necessary when it comes to national languages." It took three weeks to identify the appropriate metaphors and render the icons.

For Gelman, the most important aspect of information design lies in the accessibility of information and ease of use, achieved through reducing unnecessary information and steps, and through economy of means. "When a large amount of information is divided and organized into smaller groups, it is easier to absorb and understand." He also highlights the

importance of common sense. "Sometimes theories blur the reasons and initial goals. I'm always trying to find the shortest path to the solution, back to common sense."

In *Subtraction: Aspects of Essential Design*, Gelman's philosophy is possibly best described in Baruch Gorkin's introductory essay entitled "The Art of Giving Up." "After a meditative look–read, one comes to a realization that, to Gelman, the essence of the creative process is not in the discovery of the unknown. Rather it is in the willingness to give up something known."

Design Machine's philosophy, "that better communication is attained through the discovery of what is essential in the message," was reflected in this project too. "The necessity of using seven different languages was subtracted. This led to unification and economy," concludes Gelman.

**Following page** Design Machine's universal language of symbols meant that there was no longer the need to use seven different languages

## RESTART: NEW SYSTEMS IN GRAPHIC DESIGN Christian Küsters

*Restart* is a design publication that uses a strict system of grids to organize the space and the information housed within it. In this case, the systems set in place early on are what dictate the final design. By taking the time to implement an innovative system at the start, in a sense, the book is almost able to design itself. This method of economizing on what would traditionally be termed "the design process" works to save time and ensure continuity. "Once the system was set up, certain decisions were taken care of," explains Küsters. "Practically speaking, it was, at times, a bit difficult due to the fact that we could not 'program' each box to display a particular version of the font. When text changes occurred we had to restyle the whole page."

Throughout the whole book, the type is set in Univers according to a grid system devised by Adrian Frutiger's 1957 diagrammatic display of the typeface. Frutiger arranged all 21 versions of his font family in a grid, the position of each being decided by its relative weight and style.

A second grid system was then devised, operating independently from the first, to organize the images. This illustration grid is constructed from the dimensions of the international standard for 'A' series paper sizes, while a third grid, based on the length and width measurements of these paper sizes, ensures that the placement of the images on the page is also predetermined. As a result, the size of each image bears a relationship to the grid on that particular page. The cover title is set in every version of Univers used in the book, overlaid one top of the other, while the individual chapter titles have been created through "the collision of Univers fonts, the composition of each being determined by the type used in the boxes on the same horizontal line.

Designing this system was set up for this particular context, so to use exactly the same system again would not make much sense," continues Küsters. "But from a conceptual point of view it helped

me to progress as a designer. In the future I would like to move on from there. Conceptually, I could use the same starting point, but would inevitably arrive at a visually different outcome."

*Restart* is just one example of how design and aesthetics can be embedded into a creatively formed system that, in turn, creates the design. Thus, the system IS the design.

**Top** Chapter opener from *Restart*: the titles that appear throughout the book are rendered in a selective collision of Univers fonts
**Right** An abstraction of the original Frutiger diagram used as a text system

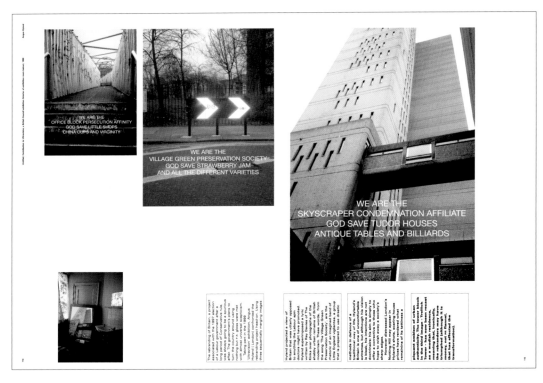

**Top** Diagram showing the second grid system used to organize the images. The illustration grid is based on the 1925 DIN (Deutsche Industrie Norm) paper system, so all the illustrations are deliberately sized to fit between A3 and A8 (c. 11¾ x 16½in and 2 x 3in)
**Above** The final page, with images and text in place

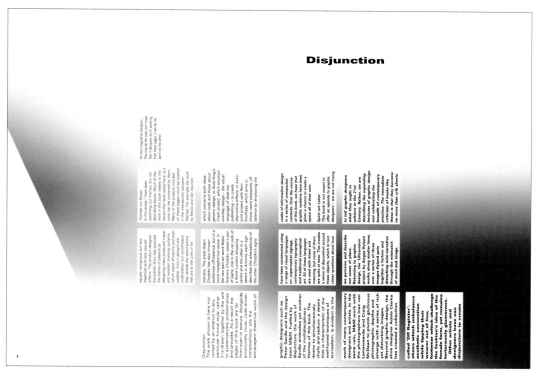

**Top** Diagram showing when the text boxes end. The boxes gradually get darker indicating the direction of the text flow. The text is intended to be read in the book at a right angle
**Above** The final page layout

**5**/132 A visual representation of the English language, the Plumb Design Visual Thesaurus became an instant hit for its information design and innovative use of technology when it was launched in 1998. The application was created using Plumb Design's Thinkmap visualization software.

Simple, quick, and easy to use, the Visual Thesaurus changes the experience of using a thesaurus or dictionary through the use of a different interface. "The advantages of this approach," says Plumb Design's Michael Freedman, "depend somewhat on the use. Creative professionals looking for ways of naming products, educators teaching language arts, students learning English, all find the Thinkmap approach more appropriate for their tasks." One of the main objectives in designing the application was to create a publicly available database to demonstrate the Thinkmap technology to a broad audience. "We wanted to build a site that could show the interrelationships between words and meanings typically obscured by alphabetical representations and traditional interfaces (lists, tables, etc.). When we learned about WordNet, a lexical reference system developed by the Cognitive Science Laboratory at Princeton University, we realized that we had found a data set full of rich content and interesting relationships."

In March 2002, the New York–based design company decided to formally rethink the product, launching Version 2.0 in October of the same year. "We knew all along that the Visual Thesaurus was only utilizing a portion of the enormous resources in the WordNet database," explains Marc Tinkler, Plumb Design's Chief Technology Officer and the inventor of Thinkmap, "so we sought ways to better explore the depths of this information while maintaining the application's simplicity and elegance. The new Visual Thesaurus unlocks the complexities in our language and shows visually how and why words are related."

"We worked to bring out more of the relationships that are present in the database, revealing the richness of the data without overwhelming the viewer," continues Freedman. "If there is one idea to take from our work, it's that when designing a user interface, the approach needn't be clinical or overly scripted. By trusting the user to forge his or her own path, and providing infinite options, you can design an interface that not only respects the user, but gives him or her a reason to return again and again to see what unfolds."

**Left** The Plumb Design Visual Thesaurus clusters words around shared meanings and offers sample sentences for using a word with that meaning

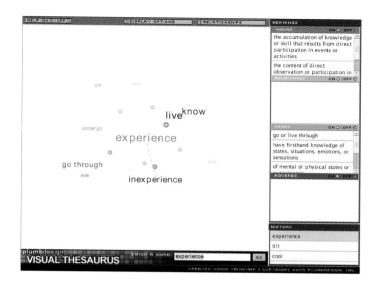

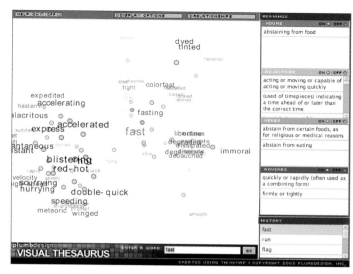

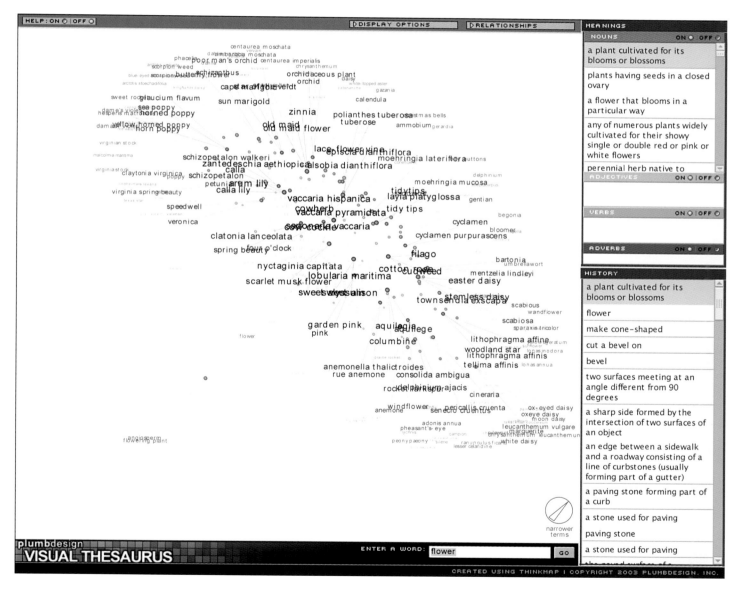

**Top left/above** Users can broaden and narrow searches interactively by selecting parts of speech or type of relationship among the words displayed

**Top right** Color, shape, and rollover displays enhance the usefulness and aesthetic of the visual representation

**PETER VAN DIJCK** Information Architect, Freelance, New York

As a discipline, information architecture may still be in its infancy, but it already plays a crucial role in the development of successful web design. However, the role of the information architect is not to be confused with that of the visual designer. Where a visual designer is concerned with visual balance, layout, typography, and visual effectiveness, information architects work on the invisible structure behind a website, developing taxonomies and controlled vocabularies, site structures, and wireframes. "You don't immediately see this structure (you only experience it as you navigate through the site), but it has a great influence on your user experience," says Peter Van Dijck, a New York–based information architect specializing in metadata and international information architecture.

Once the basic structure of a website has been laid out, the more detailed work can begin with the development of the page structure in a page-layout diagram or wireframe. This is where visual design comes in. Van Dijck always tries to work closely with visual design on this part of the process. "Sometimes, designers prefer to be simply handed a finished wireframe," he comments, "but the best ones are highly interested and involved in creating this themselves."

It is also essential, he says, for all members of the team to have a thorough understanding of the user if a project is to succeed. Having a separate usability team or simply doing a few isolated usability tests, however, is not enough; everyone, including the programmers and the visual designers, needs to be involved in both user research and testing. "This can be hard to do, especially if you are starting with a team that isn't focused on user needs. But the pay-off is big. The website will actually be useful and the development process simpler because decisions are evaluated on business goals and user goals, rather than the personal preferences of the project manager—or whoever happens to have the best debating skills."

One of the main challenges for the information architect is accommodating the needs of multiple users within one interface design. "The first step, and one that often gets skipped, is to define your audiences separately," says Van Dijck, though he is quick to point out that this audience analysis has a very different purpose to that carried out during the market research stage. "You have to group your users by how they use the website, not by how you can sell to them," he continues. "Different problem, different solution."

The next stage involves retaining this focus in order to avoid what Van Dijck calls "the elastic user." "In a typical meeting, designers can be discussing user needs, but nobody really knows which user they are talking about. There is no such thing as 'The User'. There are only specific audiences, and almost every website has more than one." One increasingly popular way to create user definitions is through the use of personas, a technique pioneered by Alan Cooper, and described in his book *About Face: The Essentials of User Interface Design*. Cooper develops two to five archetypical users for a project, called personas, and writes success scenarios for using the website for each persona. The design process is then centered on these personas. "Designers are no longer allowed to say: 'The user needs to …' Instead they refer to the names of their personas: 'Bob needs to …'. This method, says Van Dijck, has been adopted by many information architects, and is generally found to be very successful.

In designing the structure of a site, the main objective is to make navigation painless, enjoyable even, for the user, while supporting the business goals. After developing a profile of the users and the business goals, the information architect then needs to understand the

# TALKING POINT

## The Information Architect

content, which is where the content audit comes in. "You have to understand that, when organizing large amounts of content, there is no one best structure that is independent of the users or the business goals. If you don't understand your users, you can't organize your content because you don't know how it will be used." Developing such an understanding, he goes on to suggest, can then determine how the content is organized. Van Dijck points to the International Children's Digital Library, whose interface allows children to combine a number of different organization schemes when searching for books, as an example of this principle. "So if a child wants to find 'a happy book that is a true story,' the interface and categorization schemes allow for that.

"When you start actually organizing content, your two best friends are sticky notes and walls. Sticky notes are useful to organize information, and walls are useful to hang results on. I know information architects who go as far as ordering special movable walls at the beginning of a large project."

Once the organization systems are in place, these can then be translated into an interface (navigation widgets and labels). "This is where the organization

system meets the user experience. If the organization system is based on an understanding of the user, then it will provide a positive user experience. If it isn't, the user will suffer. A typical example is the website that is organized around a company's structure; the different departments or brands it has. Users normally don't care about how a company is structured; they have their own goals. The user experience on those sites often isn't a happy one."

The exact definition of the information architect's role is still a varied one but, concludes Van Dijck, as we find out how to develop large websites effectively, the roles will become more defined. "Some information architects will specialize in specific roles (developing taxonomies, for example), others will prefer the more strategic work. Whether the title of 'information architect' will stay around, that's anyone's guess right now."

# INFORMATION DESIGN

"It is a very sad thing that nowadays there is so little useless information" Oscar Wilde, author and playwright, b.1854

**INTRODUCTION**

Information kiosks, data displays, listings, charts, diagrams, schedules, timetables, forms, reports, and manuals all come under the umbrella of information design and often involve large amounts of complex data. The task of the information designer is to transform this data into easily digestible units, thus optimizing the user experience. "Information designers are very special people who must muster all of the skills and talents of a designer, combine it with the rigor and problem-solving ability of a scientist or mathematician, and bring the curiosity, research skills, and doggedness of a scholar to their work." (Terry Irwin, design consultant and educator.)

Many would regard this as the most challenging field of graphic design, because it requires the designer to think innovatively and systematically at the same time. As users we rely on this type of design daily, but many are already turned off by the very nature of the information being presented. For the designer, navigating these challenges and presenting this information in a form that is attractive and functional is where the real challenge lies. Although there are many conventional solutions to how this type of information can be presented, today's designers, if they are to succeed, need to look beyond the accepted norm by developing graphic systems that are both fresh and modern, that challenge convention yet still achieve their primary objective.

This field of graphic design is often taken for granted, largely because we don't think of things like bills and timetables as being "designed" as such. Most people own a street map or rely on a train or bus timetable to get them to and from work; we all open our bills and expect to be able to see instantly exactly how much we owe and to whom—yet without graphic design it simply would not be possible to convey this type of information in a useful and informative way. "When the design of information is left to chance, the result," says Erik Spiekermann, "is information anxiety." Well-executed information design can be a very powerful force, however, such as the 3-D Flythrough Maps designed by International Mapping Associates and used in the analysis and mapping of international boundary disputes brought before the International Court of Justice (ICJ) in The Hague.

Choice of format can make a big difference to how information is both designed and consumed. i+ kiosks present a variety of information interactively on-screen, allowing the user to tailor the service to their own needs, as opposed to the traditional bus timetable that has a singular function designed to serve many different users.

A variety of different formats can also be used to present the same information, such as the numerous A–Z editions now available, while the traditional printed annual report offers a very different experience when produced digitally and presented on-line.

Digital information design has opened up a new world of possibilities for presenting information, but there are a number of practical considerations to be taken into account. The web continues to serve primarily as an information medium, but that is not to say that the "classically trained" information designer can simply transfer his skills from page to screen. The way in which information is accessed and consumed on the web is a completely different experience from anything that has gone before and must be treated as such. This challenges graphic designers to come up with new and innovative solutions across a range of areas. Corporate websites are also big business for web designers as large companies strive to update their web presence. For the designer, coping with such a large amount of raw data requires systems, but incorporating features such as automation, databases, and scripting must all be considered early on as they need to be implemented from the start. Creating the optimal user experience remains the goal for every information designer, working in print or on-screen.

In designing for the web, the role of the graphic designer is multifarious. Preparing and working to a comprehensive brief and accurately assessing and preparing a time schedule for the production process (including testing time on both Mac and PC) will help set parameters for both client and designer in terms of content and execution respectively. In addition, a "web style sheet" showing key information such as maximum file size, text, graphics, background, hyperlinks, and browsers, will ensure that all the technical aspects of the job have been covered before the design process begins. Having, at the very least, a basic knowledge of the web and its workings, not to mention the specialist design tools available, are all prerequisites, but creative vision remains the driving force that separates the designers from the technicians. Working in a team alongside specialist practitioners is becoming the norm in digital information design: developing a large-scale site often requires the skills of a combination of creative disciplines.

Information architecture is a relatively new field in web design that focuses on structure. If not working alongside an information architect on the design of a large website, the designer would do well to familiarize themselves with the discipline. Information architects currently occupy a variety of roles in the web development process, depending on the type of project they are working on. Typically they work on the structure of a website, sometimes from a strategic perspective, sometimes more from an implementation point of view. The information architect is responsible for defining the content and functionality of a site and developing organizational systems, as well as working with the visual designer to develop the interface. Developed jointly by the visual designer and the information architect, wireframes allow the interface design to be viewed without showing the distracting aesthetics of the visual design. These wireframes indicate all the interface elements (such as buttons, links, and content) and the relationships between them, allowing the designer and information architect the space to focus solely on the structure and design of the user interface.

At a time when we are constantly bombarded with increasing amounts of information across a wide range of different formats, the clear communication of data is crucial. Readability and legibility are perhaps most pertinent in this field of design, where what constitutes readability differs from user to user. Few designers are afforded the luxury of knowing exactly who their end user is, but in the case of British Gas, the redesign of their gas bill by Corporate Edge addressed this issue by implementing a new system that creates a customized bill depending on the type of customer.

A final point in the discussion of information design: designers cannot simply be expected to walk in and "design," particularly when dealing with such vast amounts of, often complex, data. It is only by ensuring that the designer is brought on board at the beginning of a project, providing them with the necessary time to fully understand the information, that they can hope to successfully understand and, in turn, execute it.

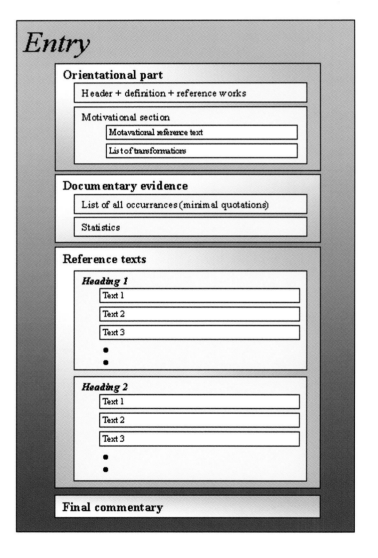

**DICTIONARY**

Front matter

Entries

Entry

Entry

Entry

○
○

Back matter

**Entry**

Orientational part

Header + definition + reference works

Motivational section

Motavational reference text

List of transformations

Documentary evidence

List of all occurrances (minimal quotations)

Statistics

Reference texts

*Heading 1*

Text 1

Text 2

Text 3

●
●

*Heading 2*

Text 1

Text 2

Text 3

●
●

Final commentary

**DIE FACKEL WÖRTERBUCH DER REDENSARTEN** Anne Burdick

**6**/140  The *Fackel Dictionary: Idioms* is based on the writings of Viennese social critic Karl Kraus. Designed by Anne Burdick for the Austrian Academy of Sciences (AAS), the 1,056-page volume is the first of three derived from Kraus' literary journal, *Die Fackel*, published between 1899 and 1936.

Burdick was an outsider to the world of linguistics and lexicography and, not speaking the language of the book, to that as well. Burdick's need for understanding and constant questioning at such a basic level forced the client to reconsider some of their original assumptions. "The way that I saw my position in this whole project was to understand the structural relationships between the different parts," she continues, "not specifically what they're saying, but how they work within the dictionary structure as a whole."

Within literary and academic circles, the design of a text is traditionally a secondary consideration, but not on this occasion. "He [Kraus] paid a lot of attention to the typography and layout of his journal, so that was the real challenge for this dictionary," says Burdick. "We had to come up with a way of having the material from *Die Fackel* be an actual image of the pages of *Die Fackel*." This was achieved, in part, through the *Fackel* spine, which corresponds to the width of the original journal. Within the dictionary, original *Fackel* excerpts are represented in two ways, *Fackel* images and *Fackel* texts (translated into the typographic style of the dictionary), all positioned within the *Fackel* spine that runs down the center of each page.

**Top/bottom** Original explanations of the dictionary's structure and individual entries put together by the AAS for Burdick at the start of the project

**Opposite top** Fragments of Burdick's on-line discussion with the AAS, in which web pages were used to "show and tell"
**Opposite bottom** AAS's working version of the dictionary marked up with identifiers and comments in order to explain the dictionary to Burdick

This is only one of many possible ways to visualize the relationships between the various parts—on a macro level. It is not a proposal, just a discussion piece.

I wish this book were a web site. (I look forward to conceiving of this as a web site.) The relationships can be sewn vertically and horizontally. With the book we are somewhat limited to linear movement, but with some variation.

This diagram is about visualizing the positions of the various parts in relation to the header/original idiom.

Any comments?

Hanno: What is #2 in this image?
what is its' content and its' role?

Initially it was vital that Burdick understood the structure of the journal, both graphically and linguistically. "I did early rough sketches trying to get at the understructure of the different parts and understand in terms of linguistics what they [the client] were trying to do," she says. "I spent easily six months engaged in this email dialogue having it explained to me. Ultimately breaking it down into documentation versus interpretation was something that I put forth and came out of my understanding of how each aspect of this dictionary operates."

Burdick designed the dictionary by working with a single "average" entry to create a Quark template into which the content could then be input. "It took a year from beginning the process of just trying to talk about it to refining it to the point of having an immaculate template that could anticipate any entry and didn't have to go back and be reworked," she recalls.

Burdick did travel to Vienna to present the book cover and paratexts, and worked directly with the client for two weeks to resolve any problems that had arisen as they worked with her template. Though created primarily as a reference tool, the dictionary also had to have a leisurely quality, making it accessible to anyone interested in Kraus or linguistics. This meant ensuring that the design was very accessible and not confused by the complexity of its content. The finished dictionary has clearly achieved this, but it was a complicated process.

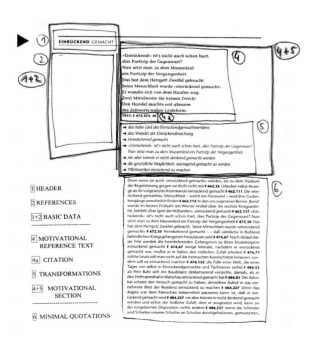

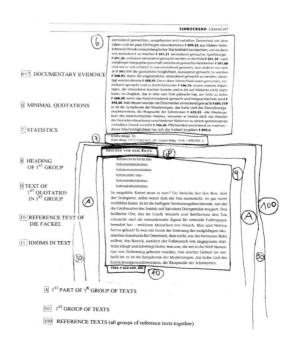

Following, please find descriptions of the overall approach of the two design directions for the text-dictionary portion of the Fackellex:
**Design Direction #1: FIELDS** and **Design Direction #2: SPINE**.

On this page I will introduce the general conceptual approach and the elements and strategies that the two directions share in common. At the bottom of this page you will find links to view the particulars of each design direction.

### Printing Specifications
Both design directions utilize an A4 format, one that allows enough room to reproduce entire pages from Die Fackel, if necessary. They are each designed in two ink colors, black and red, with a cream-colored varnish or lacquer as a third color.

### Design Concept
Both design directions arise from a similar approach, one that treats the page in a topographical manner. The various elements of the Fackellex are assigned regions on the page's surface, visually mapping the interrelationships between them. This strategy serves to reinforce the connections--in a diagrammatic way--as well as to give different kinds of information their own identity and "place".

### Die Fackel text
Those passages from *Die Fackel* that utilize visual form and layout as a part of the semantics of the text have been recreated as images of the original pages, as we had discussed. Since it is neither necessary nor efficient to treat every passage in this manner, all other passages that do not rely on visual form are typeset as straight text. All such text appears in a single font, Century Oldstyle. The size remains consistent throughout, with a second, smaller size that is used only when such a shift occurs within original Fackel texts.

Importantly, in both design approaches, all text taken from *Die Fackel* is given its own field, one that is not violated by other textual elements.

### Controlling Texts
I refer to all text that serves to categorize or supplement the selected Fackel texts as "Controlling Texts." In each design direction, these are delineated by their placement in relation to the original Fackel texts and/or by typeface and additional graphic elements.

Click on one of the names listed below to view pages and detailed descriptions of the attributes of each.

## Design Direction #1: FIELDS

This approach works with three fields that serve as spaces/containers for the various modes of text.

**a-space:** Fackel text only.

**b-space:** Controlling texts. The b-space contains those textual elements that serve to situate each individual Fackel quotation. It includes all headers, citations for the minimal quotations, and reference text headings, links (other idioms in the texts) and citations.

**c-space:** Supplemental texts. This space includes all supplemental information or information from outside sources: i.e. the commentary and the (other) dictionary definitions. This space also provides the book with its navigational elements, for it contains a repetition of the header and the Fackellex indices.

## Design Direction #2: SPINE

With this approach, a central column or spine contains the Fackel text. The outside left and right columns are used to separate the kinds of actions that the Fackellex performs on the original Fackel texts. Linear graphic elements help to diagram the inter-relationships between various parts of the Fackellex.

**a-space:** Fackel text only. The column width is slightly larger than the original Fackel pages, in order to provide a text-space for both Fackel page images and "straight" text, making them somewhat equivalent to one another.

**b-space:** Documentary actions. The b-space contains those textual elements that serve to index, classify or quantify the idioms and the individual Fackel quotations. This column includes the (other) dictionary definitions, all citations for the motivational text, the minimal quotations and reference texts, as well as the links (other idioms in the texts) for the reference text sections.

**c-space:** Interpretive actions. This space includes all textual information that represents editorial judgement calls, interpretations that demonstrate your unique perspective within the conventions of lexicography. This column contains the commentary and reference text grouping/headings.

**breakdown of** Spread #1:

1. reference text from previous entry.

2. links for reference text at right

3. motivational text

4. header

5. citation for motivational text

6. transformations

7. minimal quotations

8. documentary evidence

9. citations for minimal quotations at right

10. dictionary definition

11. header (appears in red on the first page of a new entry)

12. commentary

**breakdown of** Spread #2:

13. continuation of previous page's minimal quotations + their citations

14. reference text header (group #1)

15. citation + links for reference text at right

16. quotation from Die Fackel. This shows an image of a page from Die Fackel. The image of the page is differentiated by a thin white line and a 10% tint.

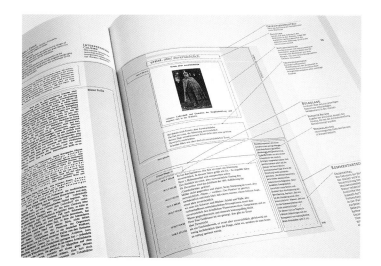

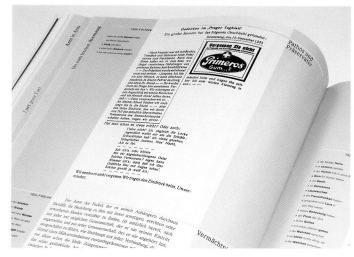

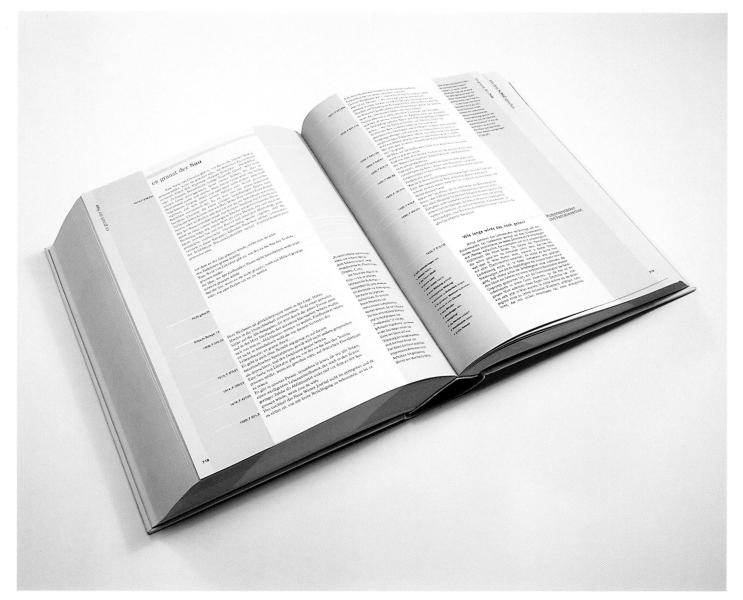

**6**/144 The design of the British Gas bill had remained largely unchanged since the 1960s, but in a project spanning three years, the design team at Corporate Edge transformed an impersonal, difficult-to-understand demand for payment into a personalized, highly effective communications tool.

The opportunity for change arose when British Gas opted to reorganize its billing system and IT support infrastructure by amalgamating its 12 previously independent regional billing systems into one. Before introducing the "bill of the future," Corporate Edge helped British Gas redesign the original bill as a temporary measure and, at the same time, test out the new system.

A number of design concepts were considered, such as the *Letterbill*, which combined a personal letter of correspondence with a bill. However, extensive customer research revealed that a traditional tabular format was preferred for presenting the actual billing information, so a bill was developed that combined the concept of the *Letterbill* with the existing format to present the data. This concept was then subjected to further customer research before the design was refined to develop a range of bill stationery, including reminders and statements, to meet the needs of individual customers. Research also showed that customers typically read bills in a very different way from any other document, starting at the bottom to see how much they owe and working upward to see how the figure has been calculated.

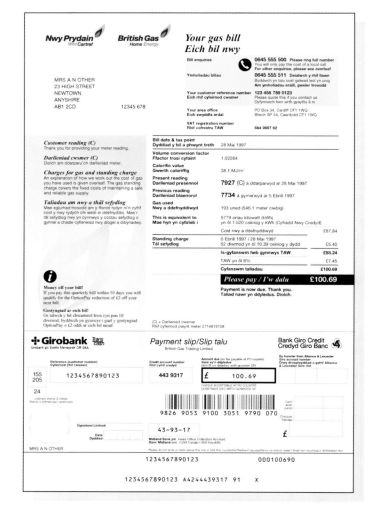

**Above** Bilingual Welsh bill with a message advising customers how to save money

## Project Aims & Objectives

- Present customer information in a clear and concise manner to a standard that represents best practice in bill/statement design and production

- Reduce errors, customer confusion, and clearly present gas calculation and charges in a legible and informative manner

- Transform the bill from a "demand for payment" into a communications and marketing platform

- Improve the image of British Gas as a modern, forward-looking, and technologically advanced company

- Improve the effectiveness of direct marketing literature sent with the bill

- Integrate the bill with other communication and advertising programs

- Accommodate the increase in information while cutting down on the amount of paper used

- Meet all legal, regulatory, and operational standards and maintain cash flow and customer payment cycles

- Create a platform for future business developments, e.g. electricity

The complexity of the project meant there was a lot more than simply print and production to be considered, however. Modern formatting software also had to be evaluated by British Gas and any necessary changes to the database output explored. A full cost and benefit analysis was then carried out, including the cost of the technical solution and any additional design work, as well as any costs that would be incurred as a result of staff training and communication. In addition to consulting various official bodies (Ofgas, the Gas Consumers Council, Citizens Advice Bureau, RNIB, and Age Concern) the team also had to make numerous presentations within British Gas itself before the designs were accepted.

In total, a family of 11 items was developed, including bills, statements, and final demands, with each item based on an understanding of how customers read, interpret, and pay their bills. A total of 560 marketing messages were also developed, along with the ability to utilize them on any bill type in any geographical area. This allowed each customer to receive an individually tailored bill, while at the same time building a strong one-to-one marketing relationship.

The project was completed both within budget and to the timescale agreed.

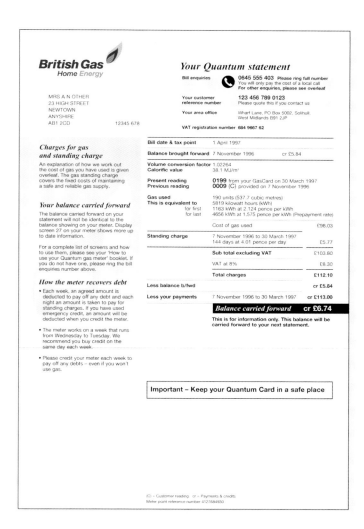

**Above** Quantum statement featuring specific customer information

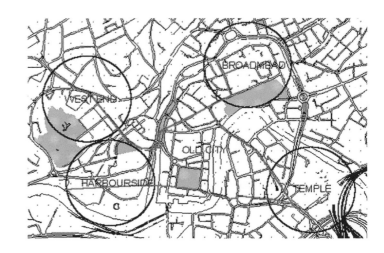

## BRISTOL LEGIBLE CITY MetaDesign London

The Bristol Legible City project involved a range of different projects created by a multitude of organizations, individuals, and collaborators all working to a common agenda—to create an open, easy, and connected user-centric environment for locals and visitors alike. The project's core development team included council officers, urban planning designers, information and identity designers, public art consultants, and traffic engineers, with MetaDesign London taking responsibility for information and communications design. Led by Tim Fendley, this team alone consisted of up to 12 people at any one time.

With major regeneration and development schemes occurring in three areas (Harbourside, Temple Quay, and the Broadmead Shopping Centre), a strong information and wayfinding strategy was required to link Bristol's main city-center neighborhoods together. This was achieved through the use of directional signs, on-street information panels with city and area maps, visitor information identity and arts projects, among others. Fundamental to the success of such a vast project is effective coordination and communication. Agreeing upon and working

to a clear brief and establishing a set of guiding principles that can be referred back to throughout the project ensures that all those involved remain focused for the duration.

With existing signs making it increasingly difficult to navigate through the city center, it was decided to replace these separate, and in some cases obsolete signs with one consistent citywide system, designed specifically to aid wayfinding and encourage walking. Funded by both Bristol City Council and street furniture brand Adshel, the pedestrian sign system was introduced in spring 2001. It consisted of directional signs and monolith-shaped map panels. To identify certain points, a series of public art pieces were also commissioned. One of the main aims of the sign system "was to create a solid, authoritative identity that holds together throughout the whole system," explains Fendley. "If a system has integrity, the information will be looked at and valued."

Being able to think like an everyday person, argues Fendley, is the most effective way to design for public places. "The use of user-scenarios at an early stage set the scene for the focus of the

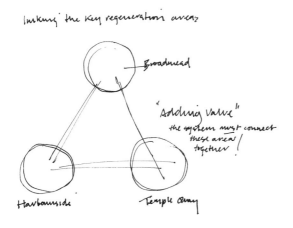

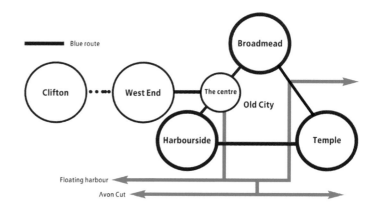

**Above left/right** Phase one of the initiative focused on the main pedestrian route, known as the Blue Route. These early sketches show the relationship between the key areas, linked together by the Blue Route

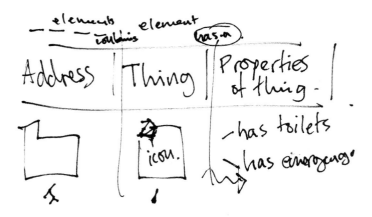

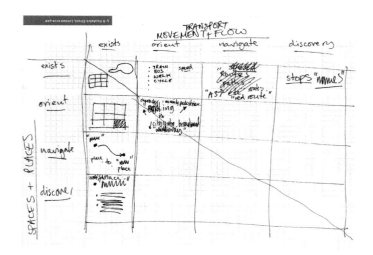

solutions later on. The design process is always iterative—improving and adding to basic concepts until the finished article matches the vision in terms of quality and appropriateness."

Creating a single identity for such a variety of users and user groups was achieved through the implementation of a component-based identity framework consisting of a specially created typeface (Bristol Transit), colors, icons, pictograms, a mapping system, and product design, used consistently on all new information and introduced as part of the initiative. The color blue was used to bring together more disparate elements, such as the arts projects.

Limiting the number of symbols and actual amount of information on any one sign ensures the user is not subjected to information overload. "As soon as you see more than three to five choices, you don't look," says Fendley. "An integrated visual language of names, colors, and typestyles is a method of providing a level of familiarity and trust that a particular message is relevant and accurate." The Legible City mapping system consisted of two

types of maps: a diagrammatic map of the city center and a more detailed "heads-up" map of the immediate area. Developed and stored digitally, all the maps were constructed using layers, making them easily adaptable for a range of different uses, such as a walking map, arrival maps, and maps for brochures and communications.

**i+ points** More than 19 i+ points located around Bristol's city center provide real-time electronic information at street level, with direct access to bus timetables and individual journey planning, tourist information, links to live rail information, local authority websites, and news. Created and managed by Cityspace, these touch-screen kiosks provide free, local, easy access to digital services. Designed with ease of access in mind, the touch screen and intuitive user interface mean that the i+ information points are equally accessible to those with and without on-line experience. The i+ information points also have a national feed to the data boards at all train stations. "All this information is swilling about out there, you've just got to tap into the right cable and then display it in the right way with the right

**Top opposite/left/right** An early sketch from the "ideas phase" addresses the different situations that the system had to overcome. Ideas phase: testing initial concepts and methods for orientation, navigation, and locating key amenities

**Above** The set of colors and icons developed for Bristol Legible City formed part of a consistent universal language of information. Internationally recognized symbols were used wherever possible

type, and suddenly it becomes really relevant. Get it wrong and it looks dull. Simple as that."Obtaining the information is one thing, but being able to pare it down so that it's appropriate at a local level is another. "It's all about tagging. You've got to design with systems to make it work. You can't provide location-based services if you haven't got the editors. The editors can be automatic, in fact they have to be in order to make it commercially viable, but initially the information has to be input manually."

Bristol Legible City was awarded both the Regional Planning Award and the Royal Town Planning Institute Award for Innovation in 2002.

ABCDEFGHIJKLMNOPQRSTUVWXYZ
abcdefghijklmnopqrstuvwxyz
ABCDEFGHIJKLMNOPQRSTUVWXYZ
abcdefghijklmnopqrstuvwxyz

**Top left** i+ information point
**Top center/right** Bristol Legible City street signage. To add coherence and optimize legibility, a flexible color palette was developed around the color, Bristol blue

**Above** Adapted from the award-winning Berlin information system, the Bristol Transit Typeface is highly readable. Tests to assess outdoor readability showed that white-out text is more readable from a distance, and that lower-case letters aid the recognition of words

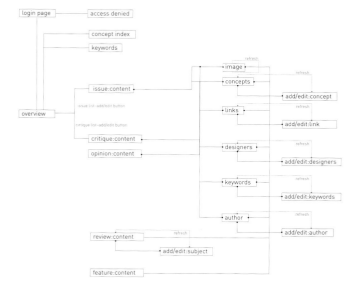

## EYE MAGAZINE WEBSITE Artificial Environments

Designed by Artificial Environments (AE), the *Eye* magazine website is an excellent example of how the efficient management of information can lead to the successful execution of a website that is user-friendly, aesthetically sound, and easily managed. "Having a thorough understanding of the content producer's working practice and the requirements of its audience is key to the design of a successful site," says Tom Elsner of AE. "Thinking in user scenarios is very useful. The actual understanding of the complex connections between pieces of content and how they can be used is a key to a lot of design problems."

Work on the *Eye* website began by developing a brief, together with the client, at the beginning of the project, which was then divided into five key stages: Planning, Design, Development, Testing, and Content.

**Planning** During this phase, AE worked with Quantum Publishing to establish a site map and define the details of the functional specification document; both had to be confirmed with an approved signature by both parties.

**Design** This involved AE translating the design elements from *Eye* magazine so that they could be used in the digital medium, working closely with Nick Bell on designing the look of the website using AE's experience in translating and further developing ideas from printed media into a successful digital format.

**Development** AE went on to develop a customized system to enable the easy updating of content on the website. This phase also included building the designed templates as HTML pages.

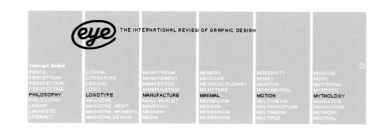

**Top/above** Elsner's initial thoughts: these were later integrated into the specification document

**Above** *Eye* website index

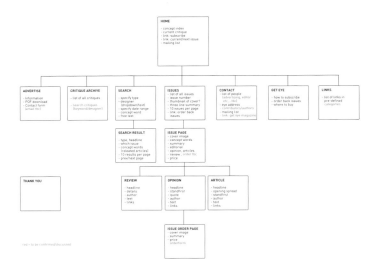

**Testing** The *Eye* website was developed for browsers Version 4 or higher and the interactive concept index was developed using Flash 5, providing experience with a high level of interactivity and user feedback.

**Content** At this stage, the team at *Eye* input and published all the necessary content required for a successful launch on the site.

**Launch** Providing a simple-to-use, sophisticated content-management system was key to the site design. "We spent a lot of time looking at the client's internal work processes and we designed the system around those." It took the form of a browser-based system that the staff at *Eye* can easily use to input features and reviews, and create keywords and designer references, allowing the majority of the content to be managed

on-site. It has two levels of functionality: adding content, and approving and "launching" content. For all the static sections on the site, the team designed sample layouts and text suggestions before sending out "request for content" documents describing the type and format of content they expected.

The site's structure developed from the need to create an archive of back issues, which forms its core. It was also important to create a design that strongly emphasized the connections between the different pieces of content, and allowed multiple ways of accessing and browsing. This was achieved by designing an "enhanced" version of the traditional search engine that not only shows the user part of the content structure (as search options) but also allows each piece of content to be viewed in context. Content can also be viewed/browsed via the site's

**Top left** Sketch for the functional specifications document, developed during the planning phase of the project

**Above/opposite bottom** Screenshot, taken from the *Eye* website: understanding the complex connections between pieces of content was key to the design

  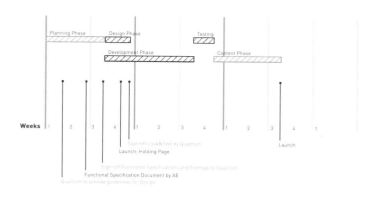

"concept index" located on the home page. The layout and visual design of the site were developed alongside the redesign of *Eye*'s print format. "It was important not to separate the content from the navigation too much and the bar element provided a very interesting solution as it is part site navigation, part contextual navigation, and part contextual information/content," says Elsner, referring to the site's most important visual element, the "central" bar.

Setting up systems prior to beginning the design process can make large projects easier to manage, but time and budgets often take precedence. "We developed the database and backend systems first, and content was entered as the site design developed." This should have allowed the team to develop and test the design, and quickly identify any problems.

"Unfortunately this didn't happen because entering the content took months and actually happened after the site was finished."

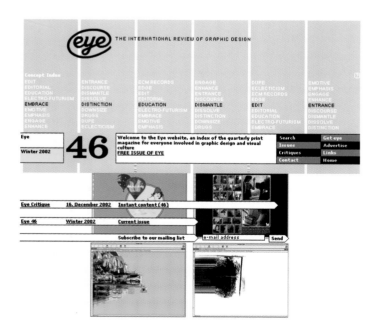

**Top center** A simple, easy-to-use, browser-based Content Management System allows the majority of the content to be managed on-site by the client themselves

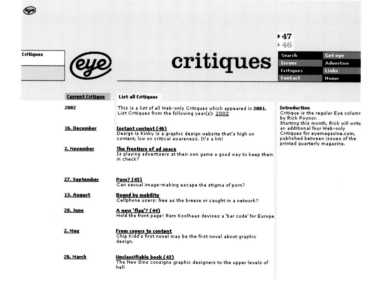

**Top right** The schedule: on this occasion the content phase was scheduled at the end of the project, allowing technical development to be carried out in a short period of time

## THE A–Z STORY The A–Z Map Company Ltd

A–Z Maps are one of the largest independent map publishing companies in the UK, currently publishing over 328 titles, including sheet maps and atlases in both black and white and full color and covering nearly all of the major cities and conurbations in Great Britain. Formats range from large-scale street plans of towns and cities to small-scale road maps of the whole country.

All the A–Z maps are based on Ordnance Survey (OS) Mapping as this was, and remains, the most accurate survey of towns and cities in the UK. In addition to the basic OS structure, the maps are updated regularly using information provided by the Local Authority Visits & Extensive Field Survey, Post Office Address File (PAF), The Highways Agency, and County Councils.

The A–Z Map Company was set up by Phyllis Pearsall, MBE, in 1936 who, having noticed that the Ordnance Survey Maps of London had not been revised since the end of the First World War, took it upon herself to publish a street atlas of London that was up-to-date and easy to read. Prior to the war there were just two staff—one draftsman employed to draw the maps and Mrs. Pearsall herself, who dealt with all the indexing, printing, selling,

delivering, and accounting. She also undertook the task of compiling the actual information, mostly by walking the streets.

Prior to the introduction of computers, each street name or village name necessitated making up a record card containing details of its physical location on the map together with its county, postcode, etc. These cards were then manually alphabetized (hence the name A–Z) and subsequently typeset into a page format for inclusion in the book or on the reverse of the sheet map. Before the introduction of digital mapping, the maps were drawn in ink on paper and tracing paper and the text hand-lettered onto the same drawing (a speed of ten words per hour was considered average!). The introduction of computers in 1991 means that today all A–Z map production is handled digitally. The maps are designed using layers to create distinctions between the levels of information, allowing the process to be efficiently managed. Using MicroStation, the basic skeleton of the map is digitized over the OS map. Each design file has up to 63 levels, allowing features such as street names and buildings to be included as separate layers. Once the required information has been correctly positioned, any remaining details are masked

**Top (entire row)** Updating the maps and surveying new roads is also vital; it is carried out using a Digital Global Positioning System (DGPS). Each point received from the Global Positioning System (GPS) represents one second in time

The GPS points are then converted to lines and the names attached and labeled in the database. These revisions are carried out using MapInfo MID/MIF files. The new road center lines can then be used to update the original mapping

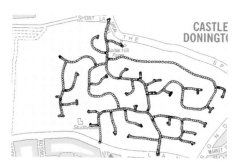
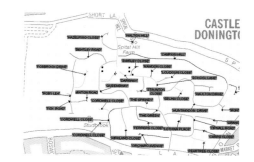

rather than removed, allowing them to be reinstated if required. Finally the base map is removed and a "feature table" used to construct the lines and infill to the roads. This is a highly detailed hierarchical structure that includes the weight of line, color, what it should mask, and on which levels the elements are to be found. It is the input of this information that transforms the map into the familiar A–Z format.

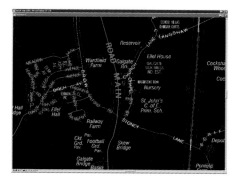
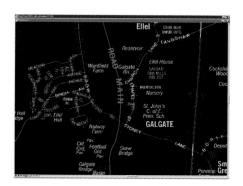

**Above (entire row)** Using MicroStation, the skeleton map is digitized over the Ordnance Survey map, and outer road casings are constructed. Once all the required information has been correctly positioned, any remaining details are masked and the base map removed

**Above** MicroStation menu box

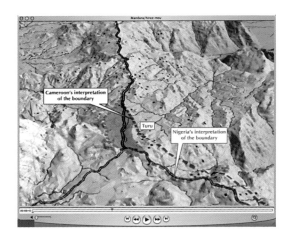

## 3-D FLYTHROUGH MAPS International Mapping Associates

International Mapping Associates (IMA) has built up a strong clientele in the field of boundary litigation. In 1993, IMA designed and implemented the first interactive map presentation ever used in proceedings before the International Court of Justice (ICJ) in The Hague. Today the company produces 3-D terrain models from DEM data, creates animated "virtual tours" over digital terrain models, and incorporates segments from videotape into their in-court presentations.

The analysis and mapping of international boundary disputes, such as the Nigeria/Cameroon Land and Maritime Boundary dispute (pictured), is a highly specialized skill that not only requires a thorough understanding of the cartographic sciences, but also the ability to present this information in an easily comprehensible format. For Bruce Daniel, Director of Design at IMA, having the ability to design and bring clarity of focus to these maps in the face of today's data onslaught is where the real challenge lies.

In these cases, IMA's clients are the law firms representing countries before the International Court of Justice in The Hague. This was part of a land boundary issue, so in order to show this to the court and to help with the judges' comprehension of the issue, IMA decided to present an animation flythrough map of a certain border area. "This is an example of where we had to bring together lots of different data and actually create and bring form to that data in order to exemplify the case." Using this approach enabled the designers to give the presentation a level of three-dimensionality, allowing it to be visually understood without the need for an interpreter. Daniel's directions are "Keep it simple and keep it multilayered so that visually you can take in just the macro-field or focus in on the detail."

The planning and preparation of the presentation took place over a six- to eight-month period with final amendments taking place right up until the last minute, so much so that IMA actually set up an office in The Hague during the case. There were a number of steps along the way. Beginning with a flat paper map that was scanned and digitized, elevations were then also digitized and vector lines added to mark the roads and boundaries. Once this information had been input into a 3-D program and carefully considered, the designers were able to identify the path they wanted to follow. The final presentation was then timed to work in tandem with the speech.

Working with such large amounts of complex data also puts the designer at risk of what Daniel describes as "data overwhelming the product." "It's not only the different sources of cartographic data, it's the sheer number of pixels that have to be rendered." Obtaining the correct balance between what can be achieved and what is actually required is a skill in itself. "You have to make design decisions along the way armed with the knowledge of the end result. It's not just the overwhelming amount of source material and technical data, it's the amount of digital processes that you also have to be aware of and so design accordingly.

"It's a question of getting the right balance for what you are trying to sell. As designers, we want to be able to take a large amount of complex data and put it through a visual filter that makes it simple to understand."

**Top** Still from an animated flythrough showing the border area in 3-D representation using Natural Scene Designer (3-D modeling software) to render the area as an animation

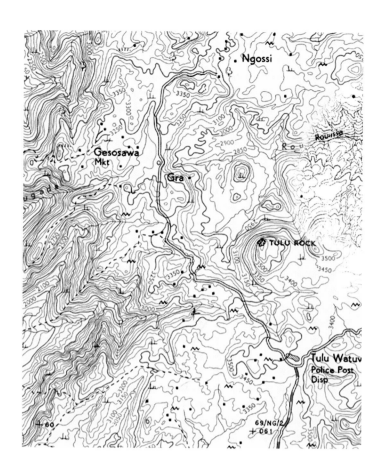

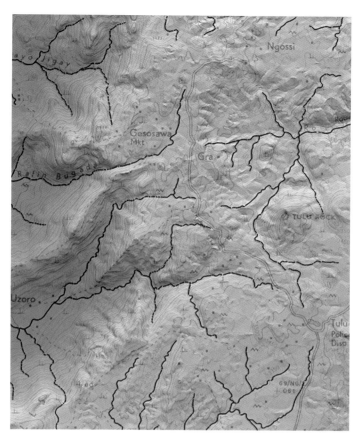

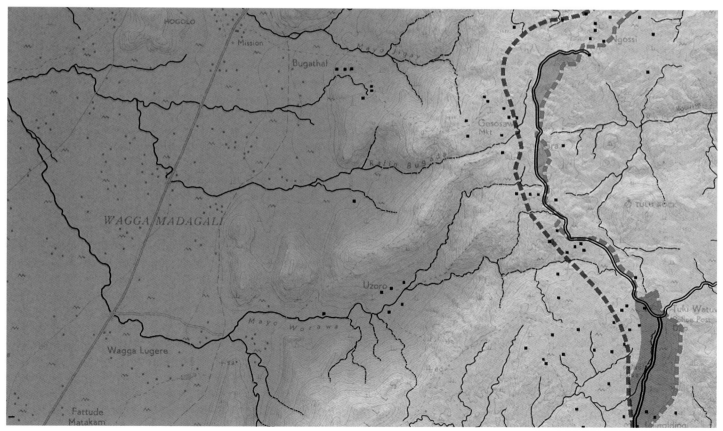

**Top left** Merging of the British and French topographic maps of the border area between Nigeria and Cameroon

**Top right** Layering of shaded relief, elevation color ramp, and topography
**Above** With the addition of linework and cartographic information

# CONTACT DETAILS

**Marcus Ainley Associates**
The Studio
10 Frognal Lane
London NW3 7DU, UK
T +44 (0) 20 7435 3411
E design@marcusainley.co.uk

**The Offices of Anne Burdick**
2367 Addison Way
Los Angeles
California 90041, USA
T +1 323 666 7356
E web@burdickoffices.com
W www.burdickoffices.com

**Ralph Appelbaum Associates Inc.**
133 Spring Street
New York
New York 10012, USA
T +1 212 334 8200
E cherylheld@raany.com
W www.raany.com

**Erik van Blokland**
**LettError Type & Typography**
Molenstraat 67
2513 BJ The Hague
Netherlands
E erik@letterror.com
W www.letterror.com

**Irma Boom Office**
Kerkstraat 104
NL-1017 GP Amsterdam
Netherlands
T +31 20 627 1895
E irmaboom@xs4all.nl

**Cahan & Associates**
171 Second St., Fifth Floor
San Francisco
California 94105, USA
T +1 415 621 0915
E general@cahanassociates.com
W www.cahanassociates.com

**Lana Cavar**
**Cavarpayer**
Berislaviceva 14
10 000 Zagreb
Croatia
T +385 1 4872 425
E studio@cavarpayer.com

**Henrique Cayatte**
Rua Coelho da Rocha, 69 – Atelier 6
1350-073 Lisboa
Portugal
T +351 21 392 9850
F +351 21 392 9858
E henrique@cayatte.pt

**Ian Chilvers**
**Atelier Works**
The Old Piano Factory
5 Charlton Kings Road
London NW5 2SB, UK
T +44 (0) 20 7284 2215
E ian@atelierworks.co.uk
W www.atelierworks.co.uk

**Corporate Edge**
149 Hammersmith Road
London W14 0QL, UK
T +44 (0) 20 7855 5888
W www.corporateedge.com

**Bruce Daniel**
**International Mapping Associates**
1276 N. Palm Canyon Drive, Suite 107
Palm Springs
California 92262, USA
T +1 760 318 2500
E bdaniel@ima-maps.com
W www.ima-maps.com

**Allison Druin**
**Institute for Advanced**
**Computer Studies and College**
**of Information Studies**
**University of Maryland**
College Park
Maryland 20742, USA
T +1 301 405 7406
E allisond@umiacs.umd.edu
W www.umiacs.umd.edu/~allisond

**Tom Elsner**
**Artificial Environments**
Suite 80–82 The Hop Exchange
24 Southwark Street
London SE1 1TY, UK
T +44 (0) 20 7407 2581
E monitor@ae-pro.com
W www.ae-pro.com

**Roger Fawcett-Tang**
**Struktur Design**
The Rookery
Halvergate
Norfolk NR13 3RZ, UK
T +44 (0) 1493 701 766
E mail@struktur.co.uk
W www.struktur-design.com

**Tim Fendley**
**AIG: Applied Information Group**
26:27 Great Sutton Street
London EC1V 0DS, UK
E info@aiglondon.com
W www.aiglondon.com

**Alan Fletcher**
12 Pembridge Mews
London W11 3EQ, UK

**Rebecca Foster Design**
54 Cassiobury Road
London E17 7JF, UK
T +44 (0) 20 8521 8535
E design@rebeccafoster.co.uk

**Orna Frommer-Dawson**
**John and Orna Designs**
27 Belsize Lane
Belsize Mews Studio
London NW3 5AS, UK
T +44 (0) 20 7431 9116
E mail@johnandornadesigns.co.uk
W www.johnandornadesigns.co.uk

**Alexander Gelman**
**Design Machine, Co. LLC**
648 Broadway
New York
New York 10012, USA
T +1 212 982 4289
F +1 212 982 1260
E gelman@designmachine.net
W www.designmachine.net

**Geographers' A–Z Map**
**Company Limited**
Fairfield Road
Borough Green
Sevenoaks
Kent TN15 8PP, UK
T +44 (0) 1732 781 000
W www.a-zmaps.co.uk

**Getty Images Headquarters**
601 N. 34th Street
Seattle
Washington 98103, USA
T +1 206 925 5000
W www.gettyimages.com

**Graf Editions**
Elisabethstr. 29
D-80796 Munich
Germany
F +49 (0) 89 271 59 57
W www.graf-editions.de

**Michael Johnson**
**johnson banks**
Crescent Works
Crescent Lane
Clapham
London SW4 9RW, UK
T +44 (0) 20 7587 6400
E info@johnsonbanks.co.uk
W www.johnsonbanks.co.uk

**Christian Küsters**
**CHK Design**
2nd Floor
21 Denmark Street
London WC2H 8NA, UK
T +44 (0) 20 7836 2007
E studio@chkdesign.demon.co.uk

**J. Abbott Miller**
**Pentagram Design**
204 Fifth Avenue
New York
New York 10010, USA
T +1 212 683 7000
E info@pentagram.com
W www.pentagram.com

**John Morgan**
115 Bartholomew Road
Kentish Town
London NW5 2BJ, UK
T +44 (0) 20 7485 7637
E john@morganstudio.co.uk

**Plumb Design**
157 Chambers Street
New York
New York 10007, USA
T +1 212 285 8600
W www.plumbdesign.com

**Quentin Newark**
**Atelier Works**
The Old Piano Factory
5 Charlton Kings Road
London NW5 2SB, UK
T +44 (0) 20 7284 2215
E quentin@atelierworks.co.uk
W www.atelierworks.co.uk

**Omnific**
The basement
9 Compton Terrace
Islington
London N1 2XD, UK
T +44 (0) 20 7359 1201
E info@omnific.co.uk

**Rob Petrie**
**The Kitchen**
52–53 Margaret Street
London W1W 8SQ, UK
T +44 (0) 20 7291 0880
E rob@thekitchen.co.uk
W www.thekitchen.co.uk

**Quickmap Limited**
PO Box 12
London SE5 9PN, UK
T +44 (0) 20 7813 3397
E info@quickmap.com
W www.quickmap.com

**Lucienne Roberts/Bob Wilkinson**
**sans+baum**
T +44 (0) 20 7490 8880
E sans@dircon.co.uk

**Stefan Sagmeister**
**Sagmeister Inc.**
222 West 14 Street, #15a
New York
New York 10011, USA
T +1 212 647 1789
E ssagmeister@aol.com

**Paula Scher**
**Pentagram Design**
204 Fifth Avenue
New York
New York 10010, USA
T +1 212 683 7000
E info@pentagram.com
W www.pentagram.com

**Studio Myerscough**
28–29 Great Sutton Street
London EC1V 0DS, UK
T +44 (0) 20 7689 0808
E post@studiomyerscough.demon

**Omar Vulpinari**
**Fabrica**
T +39 0422 516235
E fabrica@fabrica.it
W www.fabrica.it

**The Wall Street Journal**
200 Burnett Road
Chicopee
Massachusetts 01020, USA
T +1 800 568 7625
E wsj.service@dowjones.com
W www.services.wsj.com

**John Weir**
E info@smokinggun.com
W www.smokinggun.com

# INDEX